Smokehouse Associates

The St
Editec

Published by The Studio Museum
in Harlem

Distributed by Yale University Press,
New Haven and London

Contents

Director's Foreword

During the socially impactful, politically fervent, and historically profound years of the late 1960s and early 1970s in the United States, the artists William T. Williams, Melvin Edwards, Guy Ciarcia, and Billy Rose formed the Smokehouse Associates, a visionary artist collective that brought community-oriented public art projects in the form of vivid, abstract murals and sculptures to the empty walls and lots of Central and East Harlem. The Smokehouse collective and The Studio Museum in Harlem came into being in the same place and at the same time: at the height of the civil rights movement in 1968. Similar to the collaborative spirit embraced by the diverse group of artists, community activists, and philanthropists who founded the Studio Museum, the Smokehouse artists were wholeheartedly committed to collectivity, community, and art made by artists of African descent. Half a century later, Smokehouse's pioneering accomplishments still resonate deeply with our enduring belief in the power of art as an agent of change—both within and outside of the museum—in Harlem and beyond.

Smokehouse's painted walls didn't simply bring art to the streets of Harlem. They absorbed and reflected Harlem's energy: its color, music, storefronts, people, and the clothes of passersby. Williams, Edwards, Ciarcia, and Rose enlisted input from members of the community at all points of the collective's projects, even asking, Did they want to pick up a brush and help? Smokehouse's commitment to the belief that art can and does change our quality of life for the better so beautifully aligns with the Studio Museum's mission to serve as a vital link between artists and the community in Harlem.

William T. Williams, who first envisioned Smokehouse, played an integral role in the foundation of the Studio Museum. He brought to life not only this extraordinary collective but also our signature *Artist-in-Residence* program, which continues to this day. He brilliantly saw a residency as yet another way to integrate artists into the Harlem community. In 1969, Williams organized one of the Museum's first exhibitions, *X to the Fourth Power*, which celebrated the work of four artists, including himself and Melvin Edwards, who were creating innovative, large-scale abstract work. Edwards, a pioneer in Black American sculpture, was also an important member of the Studio Museum's community during this period. Like Williams, he has been included in numerous exhibitions at the Museum as well as in our permanent collection. Williams, Edwards, and the entire Smokehouse collective consistently challenged the limits of abstraction and its capacity to speak to the world around us. Along with the other members, Williams wisely documented the group's work, and his preservation of these records has made it possible for audiences today and in the future to witness it so fully in these pages.

Inspired by the spirit of their collectivity, I want to acknowledge all those responsible for this magnificent publication, which brings together Smokehouse's history, the words of its artists, and rarely seen images of its work. Thank you to the artists: Guy Ciarcia; Billy Rose; and Melvin Edwards, who served on our board for nearly twenty years; and William T. Williams, who is influential in so much of the deeply important and foundational work that the Studio Museum performs today. Ashley James deftly facilitated the wonderful and illuminating roundtable with William, Melvin, and Guy that is transcribed here, and Charles L. Davis II and James Trainor contributed essays that poetically reveal the artistic, architectural, social, and city landscapes in the 1960s and 1970s during which Smokehouse arose. The generous support of halley k harrisburg and Michael Rosenfeld Gallery over the years has helped to bring this publication to life. Alexander Gray Associates also provided much-appreciated support.

At the Studio Museum, thanks go to Eric Booker, Assistant Curator and Exhibition Coordinator, who expertly spearheaded this book project, editing the volume and contributing the rigorous, thoughtful opening essay. Since 2017, when the Studio Museum presented *Smokehouse, 1968–1970*, an exhibition that first presented this compelling documentation to our audiences, Eric has worked to bring the history and indelible contributions of the Smokehouse Associates to the larger world. His invaluable scholarship, together with that of his co-contributors, uncovers the unsung achievements of Smokehouse, inviting even more participants into their incredible collaboration. I must also thank Habiba Hopson, Elizabeth Karp-Evans, Meg Whiteford, and numerous other colleagues who worked tirelessly to bring this publication to life. Profound thanks are due also to our Trustees at the Studio Museum, who I am honored to work with and who continue to ensure that legacies such as Smokehouse's achievements are safeguarded for the future.

The story of the Smokehouse Associates neither starts nor stops within these pages. May this book serve as a worthy archive of and tribute to their generous, deeply expansive, and visionary work in public space.

Thelma Golden
Director and Chief Curator
The Studio Museum in Harlem

Acknowledgments

What came before? This question has guided the Smokehouse project since the very beginning. The culmination of five years of research, questions, and conversations, *Smokehouse Associates* became a way of looking back in order to look forward. Artists of African descent have consistently made space for themselves and their communities in spite of institutional exclusion, creating a radical legacy that has shaped our present. The Studio Museum is an embodiment of this. So too is the Smokehouse Associates. As the Museum embarked on *inHarlem* in 2016, a set of initiatives that envisioned what a museum could be without walls, the ideals of Smokehouse's public art projects—community, collaboration, change—have remained ever present.

The acknowledgments for this volume must begin with William T. Williams, the artist who first envisioned Smokehouse. Williams's many intellectual and artistic contributions live at the heart of the Studio Museum's mission, on which his collaboration and commitment to arts education have left an indelible mark. Along with his fellow Smokehouse members—Melvin Edwards, Guy Ciarcia, and Billy Rose—Williams did what many Black artists have had to do: he preserved his own history. His archives and memories have been integral to the preparation of this publication and to our understanding of Smokehouse today. I am grateful for his commitment to safeguarding this history, his generosity in sharing documentation, and his unwavering support over the years. Thanks also go to Pat Williams, his wife, who was there more than fifty years ago to lend her support as Smokehouse imagined its abstract environments in Harlem, and whose collaboration today has added immeasurably to this book.

I first met Melvin Edwards when he and William came to the Museum in 2017 to share their memories of working in Harlem. The generosity I experienced then has proved constant ever since. I am grateful for Melvin's time and dedication to the history of Smokehouse. When I reached out to Guy Ciarcia, I found someone whose commitment to Smokehouse has been steadfast since 1968. His accounts and home video footage of the group's work have been invaluable. Robert Colton, who generously provided photographs of the collective's work in Harlem, was equally dedicated. To each of these artists, thank you for your trust, care, and collaboration in bringing this history forward.

This book builds on the critical scholarship of many curators, artists, historians, and intellectuals, including Dore Ashton, Julie Ault, Frank Bowling, Susan E. Cahan, Mary Schmidt Campbell, Adrienne Edwards, Darby English, Okwui Enwezor, Tom Finkelpearl, Mark Godfrey, Kellie Jones, Miwon Kwon, Suzanne Lacy, Lucy Lippard, Courtney J. Martin, Julie Mehretu,

Lowery Stokes Sims, and Zoé Whitley. I am also grateful to Michel Oren for his support as well as his in-depth interviews and initial study of Smokehouse, which created an important historical foundation.

A project of this scale could not exist without the support and guidance of many at the Studio Museum. Thelma Golden, Director and Chief Curator, immediately recognized the importance of the Smokehouse Associates to our collective history. I am deeply grateful for and inspired by her incisive questions, guidance, and trust. I want to thank curatorial colleagues past and present—Connie H. Choi, Amarie Gipson, Habiba Hopson, Yelena Keller, Hallie Ringle, and Legacy Russell—for critical conversations that shaped this project and for advocating for this book's creation. I am particularly grateful to Connie and Legacy for their ongoing support and guidance.

Approaching the work of Smokehouse is a complex task. Research was made even more challenging during the height of the COVID-19 pandemic. Former Studio Museum and MoMA Curatorial Fellow Lilia Rocio Taboada expertly navigated this work during a tumultuous period and contributed greatly to the project. Her work was continued by former Mellon Curatorial Fellow Elana Bridges, with additional support from Curatorial Intern Noa Hines, whose contributions to the chronology have made a lasting mark. Habiba Hopson, Curatorial Assistant, Permanent Collection, made numerous contributions. Her coordination of this book has been both essential and exemplary.

This publication was also shaped by the collective efforts of the editorial and design teams. Elizabeth Karp-Evans, Director of Media, Communications and Content, lent her expertise and guidance at every stage of the process. Meg Whiteford, Editor, provided critical feedback on every text, while copy-editor Joanna Ekman ensured a level of precision this history deserves. Alex Lin and his team at Studio Lin designed a visually arresting book, reflecting the vibrancy of Smokehouse itself.

I am grateful to Charles L. Davis II and James Trainor for their insightful and expansive essays, which enrich the legacy of Smokehouse. Their contributions, both on and off the page, continue to inspire. I also thank Ashley James for her illuminating introduction and deft facilitation of the artist roundtable. These essayists, together with the participating Smokehouse artists, have made significant additions to the historical record.

My profound thanks go to the Graham Foundation for Advanced Studies in the Fine Arts and the Terra Foundation for American Art for their support of this project. Jodi Hanel, the Museum's Director of Development, and Ayanna Ingraham, former Grant Writer, were instrumental in securing these pivotal grants. Other staff across the Studio Museum have also held the Smokehouse project at various points in its life. Thanks are due to

Sydney Briggs, Gina Guddemi, Elizabeth Gwinn, Chloe Hayward, Ginny Huo, Daonne Huff, Shanta Lawson, Chayanne Marcano, Mimi Reeves, Evans Richardson, and Nico Wheadon. Outside the Museum, Thomas (T.) Jean Lax, Bernard Lumpkin, Suzanne Randolph, John Tain, and Eugenie Tsai provided much-appreciated support.

This book would not have been possible without the unwavering commitment and close collaboration of halley k harrisburg and Michael Rosenfeld Gallery. I am also grateful for the support of Alexander Gray Associates.

Finally, there are those whose support extends far beyond this project. Gabriel Burkett, your critical eye, encouragement, and love continue to model partnership and creative collaboration. To my parents, Connie and John: thank you for creating a space in which to flourish.

Eric Booker
Assistant Curator and Exhibition Coordinator
The Studio Museum in Harlem

"A work of art it seems to me has to have a life
that can encompass a larger body of people."

—William T. Williams, 1988 7

An alternative history challenges the present. In the case of the Smokehouse Associates, an artist collective whose abstract works were rooted in the revolutionary change of the 1960s, the group's plurality evades classification and disrupts canonical art histories. At once participatory, environmental, and abstract, Smokehouse's vibrant painted walls and sculptures constituted a synthesis of social and aesthetic innovations. The group's abstract and environmental strategies created a universal dynamic, ensuring democratic participation. Working in direct collaboration with members of the community, it instilled a sense of pride and possibility in Harlem. More than fifty years later, Smokehouse's public projects remain entirely distinct.

The extraordinary photographs in this volume vividly capture abstract environments that no longer exist. Carefully maintained for posterity in the archive of the artist William T. Williams, these images become central to the reparative process of inscribing Smokehouse's counterinstitutional practices within art history. Although we can no longer experience these walls firsthand, the photographs reveal a sense of unlimited potential. Smokehouse holds an exciting proposition: abstraction as an invitation, public art as a means of social change.

The Associates

Envisioned by Williams, in 1968 the Smokehouse Associates began developing participatory public art projects in Central and East Harlem that transformed the urban landscape through vibrant, abstract geometric murals and sculptures.[1] The collective comprised four members: Williams, Melvin Edwards, Guy Ciarcia, and Billy Rose, a young artist who left the group within the first year.[2] They believed art could seed change. Emphasizing the participatory process,

1. Various sources have incorrectly referenced 1967 as the year that the collective formed.

2. Rose met Williams at Pratt in Brooklyn, where each earned a BFA. The artists reconnected when Williams returned from completing his MFA at the Yale School of Art. Williams was interested in the intergenerational possibilities that Rose's participation offered the group. The young artist became interested in community work through Smokehouse and soon left the group to devote himself to his own community in Bedford-Stuyvesant.

the artists completed approximately nine projects in the Harlem community over the course of three summers, from 1968 to 1970. The group borrowed its name from the Southern vernacular "smokehouse," a simple structure where meat is smoked and stored for times of need. The name suggested the collective's philosophy—art as a form of sustenance. Williams's family hailed from rural North Carolina, and his cousin, the playwright Walter Jones, suggested the name during one of their many conversations in the artist's SoHo studio.Fig 1 Williams shared a Southern upbringing with Edwards, who was raised in the Fifth Ward of Houston, Texas. The notion of working collectively—a means of cultural production rooted in African diasporic traditions—defined the group's process and sense of extended family. That Smokehouse's membership was never listed signifies the collective's expansive nature and egalitarian ethos. The artists chose the semi-anonymous term "Associates" to acknowledge the many collaborators who would help them achieve their work outdoors: architects, community workers, poets, playwrights, graphic designers, city planners, photographers, lawyers, and musicians, among many others.

While attending the Yale School of Art from 1966 to 1968, Williams was interested in applying his elite arts education to communities traditionally excluded from arts institutions. Having previously worked in community centers and after-school programs as a student at the Pratt Institute in Brooklyn, the artist maintained a deep commitment to social services and group interactions.[3] His adviser at Yale, the painter Al Held, was pushing the formal and spatial capacities of painting through monumental geometric abstractions. The abstract artist Knox Martin taught a course titled "The Great Creator," which demonstrated how to work collaboratively to realize art on an environmental scale.[4] While immersed in these

3. Williams began working in this capacity at the age of twenty, when he received a license from the New York City Board of Education to teach after-school programs.

4. William T. Williams and Michel Oren, 1988, Michel Oren interviews with artists, 1979–1991, Archives of American Art, Smithsonian Institution, 8. While Williams did not take this course, it demonstrates some of the ideas that were in the air.

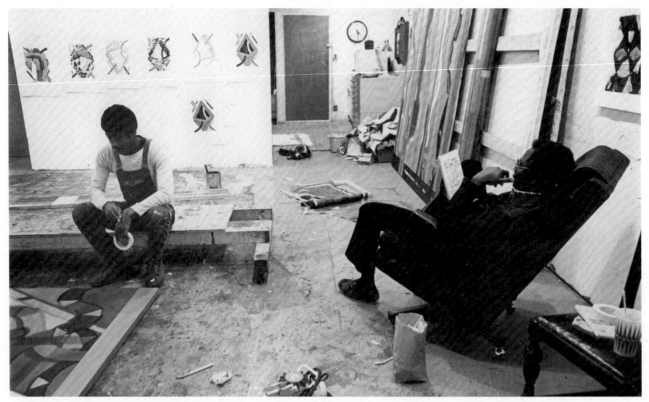

Fig 1. William T. Williams and Walter Jones in Williams's SoHo studio, New York, c. 1970–74

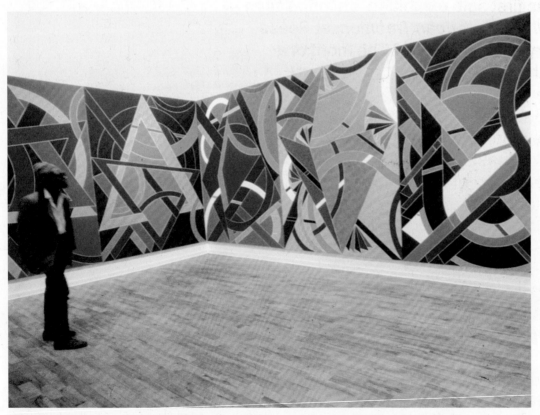

Fig 2. The playwright Edgar White takes in *William T. Williams: One Man Show* (installation view), Reese Palley Gallery, New York, 1971

Smokehouse: Abstract Potential 10

ideas within the academy, Williams lived off cam-pus, maintaining a connection with New Haven's Black community. These contrasting realities—between his lived experience and the ideas from the cloistered halls of academia—influenced Williams's outlook and artistic practice. Upon graduating from Yale in 1968, he moved back to New York City, where he had lived as an adolescent, with a commitment to decentralize the arts.

In New York, Williams began creating monumental abstract paintings whose physical and emotional presence charted a unique path in an art world dominated by Color Field painting, Pop art, and Minimalism. His rigorous compositions challenged these canonical self-referential modes of abstraction by incorporating his own biography, African diasporic traditions such as the quilt-making he witnessed growing up in the South, and the experimental and improvisatory jazz he gravitated toward in New York. In 1971, Williams presented his first solo exhibition, an installation titled *Overkill and American Tradition*, at Reese Palley Gallery in New York.Fig 2 The motif of a diamond within a box anchored each work. The geometric forms pressed against the formal and physical boundaries of the canvas, seemingly extending beyond the frame. Pulsating with movement and tension, Williams's compositions refracted the energy of the city and the social upheaval of the era. Their spatial volumes and discordant colors created a maximal environment. The paintings were hung edge-to-edge, forming a mural-like configuration that enveloped the viewer. The polyrhythmic sounds of free jazz filled the space, as Ornette Coleman and John Coltrane played from a stereo the artist had placed in the gallery.

Melvin Edwards moved to New York from Los Angeles in 1967. At the recommendation of Held, he and Williams met at a party for the artist George Sugarman and soon bonded over

"progressive notions about art and life."[5] Edwards had been developing his own sense of a socially engaged abstraction through his "Lynch Fragments," an ongoing body of work begun in 1963 in response to the racial violence he witnessed in Los Angeles. In the series, composed of found and manipulated metal pieces, Edwards formulated a unique language, drawing on the social, cultural, and material histories of the African diaspora, as well as the legacy of violence and labor inflicted upon its peoples, thereby expanding the tradition of modernist sculpture.[6] Edwards continued his artistic activism in 1966 by participating in the construction of the Los Angeles Peace Tower, a sixty-foot abstract sculpture built by an interracial group of artists to house paintings in protest of the Vietnam War. Following a July 1968 residency at the Sabathani Community Center in Minneapolis, Edwards created his first outdoor painted sculptures, showing them in one of the Walker Art Center's first outdoor exhibitions.[7] The project was an important turning point for the artist, marking the introduction of bold primary shapes and colors into his work. The architectural scale of Edwards's subsequent public sculptures, *Homage to My Father and the Spirit* (1969) and *Double Circles* (1970),[Fig 3] encouraged viewers to walk through and around them, taking in their anamorphic compositions from one angle to the next. The interplay between burnished stainless steel and brightly colored forms reflected the light and colors of their urban context, subtly changing with the time of day and position of the viewer.[8]

Guy Ciarcia met Williams while earning his BFA at Pratt. As an Italian American, he was deeply influenced by the Italian Renaissance and its traditions of art and architecture. Ciarcia taught in the school system of his hometown of Trenton, New Jersey, in a predominately Black community, and connected with the other members over their shared commitment to broadening access to the arts.

5. Melvin Edwards and Michel Oren, 1988, Michel Oren interviews with artists, 8.

6. See the exhibition catalogues *Melvin Edwards: Sculptor* (New York: The Studio Museum in Harlem, 1978); *Melvin Edwards Sculpture: A Thirty-Year Retrospective, 1963–1993* (Purchase, NY: Neuberger Museum of Art, 1993); and *Melvin Edwards: Five Decades* (Dallas: Nasher Sculpture Center, 2015).

7. Edwards's early outdoor installation led the way for the Walker's efforts to create a public sculpture park, which eventually resulted in the founding of the Walker Art Center's Minneapolis Sculpture Garden in 1988, in partnership with the Minneapolis Park and Recreation Board. See the Walker Art Center Archives.

8. *Homage to My Father and the Spirit* was commissioned by the University Art Museum (now the Herbert F. Johnson Museum) at Cornell University, where it still stands today. *Double Circles* is one of three sculptures located at Bethune Towers in Harlem. Commissioned by the New York City Housing Authority and sponsored by Kreisler Borg Florman, the sculpture stands alongside works by Daniel LaRue Johnson and Todd Williams. See Leigh A. Arnold, "Catalogue of Public Sculptures," in *Melvin Edwards: Five Decades*, 180–89.

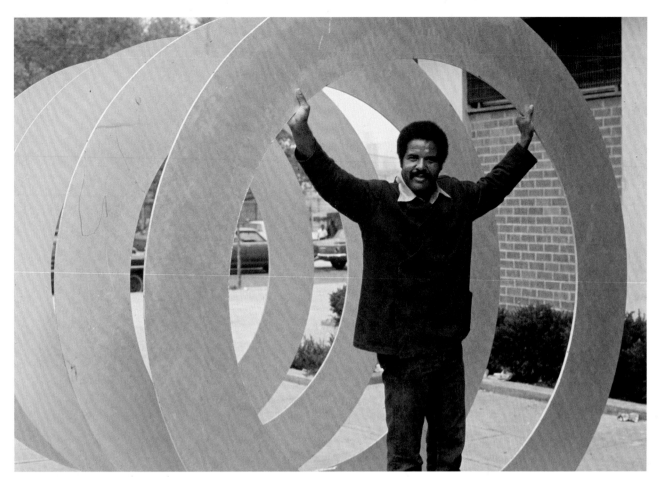

Fig 3. Melvin Edwards with *Double Circles* (1970), Harlem, New York, c. 1979

Smokehouse allowed him to develop his painting practice, which subsequently included a series of abstract murals that the artist made in Trenton.[9, Fig 4]

The art historian Michel Oren, who conducted crucial interviews with each member of the collective in 1988, noted that Smokehouse could equally be inscribed in the histories of African American abstract painting, the Black Arts Movement, late 1960s idealism, and Harlem. Pointing to the "history of artist-community relations in modern times," he encapsulated the dilemma of contextualizing the group's multidimensional approach.[10] The Smokehouse Associates by turns belonged to all of the histories Oren cited. The group's collective approach, community focus, and use of abstraction encourage a broad study, if only to properly address a unique body of work that existed across social, aesthetic, and environmental lines.

Seeds and Roots

The period in which Smokehouse was active was defined by a sense of urgency and unrest. The "long, hot summer of 1967," as it became known, saw 159 cities across the United States erupt in riots as African Americans revolted against racial injustice and urban decay.[Fig 5] In November 1967, at the Annual Meeting of the Southern Regional Council, the psychologist and social activist Kenneth B. Clark delivered an address titled "The Present Dilemma of the Negro," which described a litany of intolerable conditions in the ghetto:

1. Criminally inefficient and racially segregated schools;
2. Dehumanizingly poor housing;
3. Pervasive job discrimination and joblessness;
4. Shoddy quality of goods and high prices in local stores;

9. Ciarcia would continue to be inspired by the collective's work, later using found and discarded materials to make sculptural assemblages and outdoor works.

10. Michel Oren, "The Smokehouse Painters, 1968–70," *Black American Literature Forum* 24, no. 3 (Autumn 1990): 509–31.

Fig 4. Guy Ciarcia with his daughter Gaea in front of his mural in Trenton, New Jersey, 1970

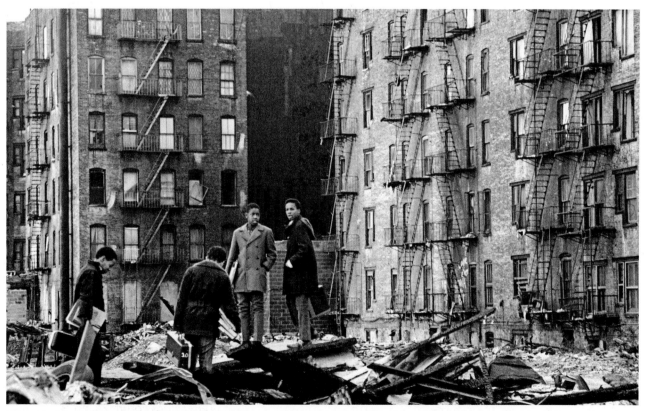

Fig 5. *Young Musicians*, 5th Ave. at E. 110th St., Harlem, New York City, 1970

5. The dirt, filth, and stultifying drabness of ghetto streets and neighborhoods;
6. And the adversary relationship between police and residents of the ghettos.[11]

Clark's organization, which later became HARYOU-ACT (Harlem Youth Opportunities Unlimited—Associated Community Teams), aimed to reverse the negative effects of these conditions on teenagers through a series of empowerment programs created by and for the Harlem community.[12] The Arts and Culture program, which included among its teaching artists Romare Bearden, Betty Blayton-Taylor, and Arnold Prince, instilled a sense of pride and possibility in its participants. Students created collaborative mosaics and sculptures in the vacant lots that proliferated across Harlem.[13] Through such projects, HARYOU-ACT encouraged participants to become agents of change rather than relying on less effective, outside agencies. The program laid an important foundation for the arts in Harlem, the traces of which can be seen in Smokehouse as well as The Studio Museum in Harlem.[14]

It is not surprising that the Smokehouse Associates was formed the same year that the Studio Museum opened to the public in 1968. Williams played an instrumental role in each. At Yale, he proposed creating an artist-in-residence program in a local neighborhood, an idea that would later be realized as the Studio Museum's *Artist-in-Residence* program. By working in this context, artists would internalize aspects of the surrounding community, thus making work that was relevant to its people. Creating a space for artists to develop and share their ideas within the community in turn led to an exchange between artists and the public, and further, a means of museum access for everyday people.[15] As the Studio Museum took shape amid wider calls for integration in the art world, Williams met

11. Kenneth B. Clark, "The Present Dilemma of the Negro" (Annual Meeting of the Southern Regional Council, Atlanta, November 2, 1967). Clark founded the Harlem Youth Opportunities Unlimited (HARYOU) and served as Director and Chairman of the Board in its planning stages from 1962 to 1964. Formed with the support of Mayor Robert F. Wagner, the Harlem Neighborhood Association, and the President's Committee on Juvenile Delinquency and Youth Crime, HARYOU undertook a study of the effects of poverty and delinquency in the neighborhood to produce a plan to address it throughout Central Harlem, culminating in the 1964 report "Youth in the Ghetto: A Study of the Consequences of Powerlessness and a Blueprint for Change."

12. HARYOU focused on five areas: community action, education, employment, special programs, and arts and culture. In 1964 it became HARYOU-ACT, merging with a similar initiative developed by Adam Clayton Powell known as the Associated Community Team (ACT). See Susan E. Cahan, "Electronic Refractions II at the Studio Museum in Harlem," in *Mounting Frustration: The Art Museum in the Age of Black Power* (Durham, NC: Duke University Press, 2016), 13–30.

13. Known as vest-pocket parks, these interstitial lots were rehabilitated under Mayor John V. Lindsay and Parks Commissioner Thomas P. Hoving as one of the administration's efforts to revitalize the City. See Cahan, 1–18.

14. Williams references a 1956 meeting with Jacob Lawrence, who taught at the Five Towns Music and Art Foundation in Nassau County, as the first time he met a professional artist. This experience would shape his own ideas on art and community in the coming years. Conversation with the author, May 5, 2022.

15. Williams, in "Black Artists and Abstraction: A Roundtable,"

Eleanor Holmes Norton, an influential lawyer at the American Civil Liberties Union, and Carter Burden and J. Frederic Byers III, members of the Museum of Modern Art's Junior Council.[16] Norton, Burden, and Byers had been in conversation with Betty Blayton-Taylor and Frank Donnelly, a social worker and Junior Council member, about the ideas that HARYOU-ACT had been implementing throughout Harlem.[17] As they developed a museum for the neighborhood, they asked Williams to come on board as a part-time staff consultant to realize his idea for an artist-in-residence program.[18] His original vision continues to guide the Studio Museum's program to this day.

Protest and Politics

As Black artists and activists fought for representation in the art world, their calls were ensnared within debates over what constituted "Black art."[19] Acutely aware of the tense political climate in which the Studio Museum was formed, Williams envisioned his second proposal, Smokehouse, as an entirely separate project. While both the Studio Museum and Smokehouse were rooted in the idea that artists had vital roles to play in the community, the collective's intentional positioning outside of the institution maintained an important autonomy for the group amid such debates. The few instances when Smokehouse conveyed its intentions in writing (in documents reproduced throughout this volume) demonstrate the singular path it managed to forge as an integrated abstract art collective. An examination of the political complexities of the moment illuminates how distinct this path was.

Like many of its peers, Smokehouse has been relegated to the periphery for its pursuit of an abstract idiom. With Black nationalists calling for an art that clearly conveyed messages of Black empowerment, figuration became the visual

in Kellie Jones's foundational exhibition catalogue *Energy/ Experimentation: Black Artists and Abstraction 1964–1980* (New York: The Studio Museum in Harlem, 2006), 120.

16. Williams and Oren, Michel Oren interviews with artists, 12. Established in 1949, the Junior Council was a group of volunteers invested in extending MoMA's reach through various programs. By the mid-1960s, the Junior Council became increasingly involved in educational and communal outreach initiatives aiming "to extend the museum beyond its own walls" in order to increase the public's access to modern art. The council often acted as a conduit for other groups, funding various community-oriented projects and participating in forms of support as the museum tried to engage people of color and a wider public amid the civil rights movement. For a discussion of the Junior Council's activities as they relate to Black cultural history, see Charlotte Barat and Darby English, "Blackness at MoMA: A Legacy of Deficit," in *Among Others: Blackness at MoMA*, ed. English and Barat (New York: Museum of Modern Art, 2019), 15–99.

17. For a detailed account of the Studio Museum's formation and important precursors such as HARYOU-ACT, see Cahan, *"Electronic Refractions II."*

18. Charles E. Inniss to William T. Williams, October 4, 1968, William T. Williams Archives.

19. For an introduction to the complex debates that unfolded in the late 1960s and early 1970s, see Raymond Saunders, *Black Is a Color* (self-published, 1967); "The Black Artist in America: A Symposium," *Metropolitan Museum of Art Bulletin* 27, no. 5 (January 1969); Frank Bowling's essay series "Discussion on Black Art," *Arts Magazine* 43–44 (April 1969–January 1970); and Tom Lloyd, *Black Art Notes* (self-published, 1971).

language de rigueur among many Black artists. Despite mounting pressures, as art historian Kellie Jones clarifies, Black abstractionists "were committed to equality, but they were equally committed to their right to aesthetic experimentation."[20] Artists such as Williams and Edwards defined individual styles that synthesized an urgent social awareness with aesthetic rigor. The collective's assertion of a democratic, participatory space that could play a transformative role in society might be regarded as a form of protest in a period rife with hegemonic discourse. Rather, Smokehouse should be considered as part of a spectrum of grassroots strategies employed by Black artists and activists of the time. The social services of the Black Panthers, who aimed to generate self-determination and pride by providing free meals and clothing, along with health and education programs, correspond to Smokehouse's methods of communal empowerment. Nevertheless, the Smokehouse artists were neither "political" in the conventional sense nor "apolitical," as Black nationalists might have labeled them; Smokehouse's work challenges the false dichotomies that have calcified history.

In 1967 the Visual Arts Workshop of the Organization of Black American Culture (OBAC) created the Wall of Respect in Chicago, a collective effort portraying images of Black heroes throughout history.[Fig 6] The mural became a statement of cultural pride and a site of congregation for events and performances. The Wall of Respect provided a model for artists of color across the country as they sought to create murals that represented their communities in the absence of museum representation.[21] While OBAC's collective strategy, outdoor work, and unifying spirit parallel those of the Smokehouse Associates, the latter group fundamentally rejected the use of social realist imagery, instead identifying the liberatory potential of abstraction.

20. See Kellie Jones, "To the Max: Energy and Experimentation," in *Energy/Experimentation*, 14–34. Jones deftly explains how Black abstract artists "did not fall wholly into one camp or style, but rather their works were hybrids formed in unique, individual languages of abstraction" (14).

21. For an in-depth history of this iconic South Side monument, see Abdul Alkalimat, Romi Crawford, and Rebecca Zorach, *The Wall of Respect: Public Art and Black Liberation in 1960s Chicago* (Evanston, IL: Northwestern University Press, 2017). For a look at the community mural movement, see James Prigoff and Robin J. Dunitz, *Walls of Heritage, Walls of Pride: African American Murals* (San Francisco: Pomegranate, 2000), and Janet Braun-Reinitz and Jane Weissman, *On The Wall: Four Decades of Community Murals in New York City* (Jackson: University Press of Mississippi, 2009).

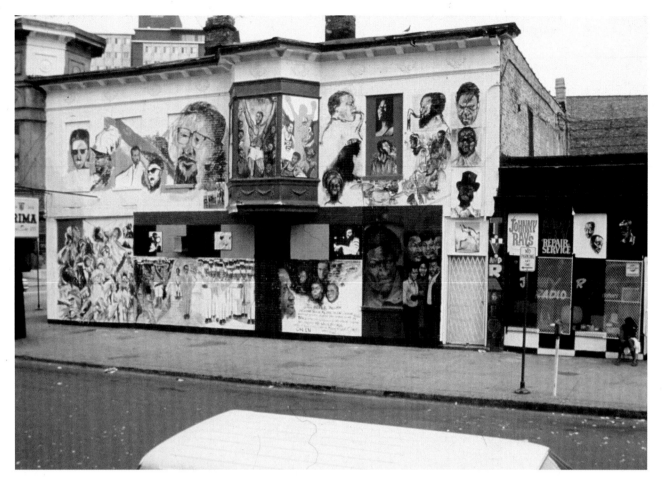

Fig 6. *Wall of Respect*, 1967

Edwards explains that it was "better if the work were not figurative in order to...let the message be the change rather than put information out which said why the world needed changing." By changing the physical environment, Smokehouse could make it "visually and aesthetically better and therefore more human."[22] Acting as a vehicle for change rather than illustrating the solution, abstraction offered a new form of liberation.

Smokehouse's philosophies on the transformative potential of abstract art recall what the art historian Darby English refers to as "alternative practices of dissent" employed by Black abstract artists throughout the late 1960s and early 1970s.[23] Identifying how their written and artistic statements diverged from conventional politics, English resuscitates an array of political registers that Black abstractionists functioned within. The Smokehouse Associates remained above the political fray. Explaining that the members did not bring a political perspective to their work, Williams says they were "just providing resources, and we were willing to function as an extension of [the community's] ideas."[24] Nonetheless, Smokehouse belongs to a vibrant movement of artistic dissent evident through more explicitly political peers such as the Black Emergency Cultural Coalition (BECC) and the Art Workers' Coalition (AWC). These groups, made up of artists and arts professionals, called for integration in the art world and advocated for the rights of artists, renegotiating the artist's relationship to the institution in the process.[25] Black artists in particular became activists or organizers by necessity in order to claim space for creative freedom within a field that routinely denied them critical attention and exhibition opportunities.[26] Lucy Lippard, a member of the AWC, explains that these challenges to institutional dominance "were attempts to replicate the primary functions of the museums themselves," in which artists took up

22. Edwards and Oren, Michel Oren interviews with artists, 5.

23. Darby English, "Introduction: Social Experiments with Modernism," in *1971: A Year in the Life of Color* (Chicago: University of Chicago Press, 2016), 13. English describes how Black abstract artists forged connections between political culture and modernism through their work and exhibitions amid a period rife with racially segregationist discourse.

24. Williams and Oren, Michel Oren interviews with artists, 6.

25. For a discussion on the BECC's influential response to *Harlem on My Mind*, see Bridget R. Cooks, "Black Artists and Activism: Harlem on My Mind, 1969," in *Exhibiting Blackness: African Americans and the American Art Museum* (Amherst: University of Massachusetts Press, 2011), 53–86.

26. Jones, "To the Max," 25.

issues of "access, publicity, distribution, display, and interpretation" to fill the voids left by institutions.[27] Collectives such as the AWC, BECC, OBAC, Smokehouse, and others envisioned these alternatives outside of museums altogether, renewing a sense of agency, possibility, and social relevancy in public space. The street was charged: it was a stage, a site of conflict, and a place of radical possibility for artists working to decentralize the arts. Smokehouse's transcendent approach exemplified this uncontainable spirit. As Edwards says, "We stepped beyond protest to construct something new."[28]

Resident Energies, Qualitative Possibilities

In a rare 1970 feature in *Industrial Design*, the Smokehouse artists state, "In all cases what is most important is to leave room for the residents' energies."[29] In keeping with the collective's integrated approach and underlying humanism, Smokehouse created spaces that amplified the social, visual, and architectural elements inherent to city life. Its projects were community affairs. Before beginning work on a site, the group identified ministers, politicians, block associations, or other local leaders to consult on the community's needs and potential locations. In the absence of a presiding local agency, the group acted as the organizers, galvanizing the surrounding community around a project. Once a site was selected based on its architectonic qualities and communal potential, and permission was secured from the building's owner,[30] the collective photographed the area to produce a series of visualizations that conveyed its plans to the community. Designs were created by each member and then modified during group discussions. Among Smokehouse's collaborators was the graphic designer Pat Williams, Williams's wife, who created the collective's photographic mock-ups.[31] Once an initial

27. Lucy Lippard, "Biting the Hand: Artists and Museums in New York since 1969," in *Alternative Art New York, 1965–1985*, ed. Julie Ault (Minneapolis: University of Minnesota Press; New York: Drawing Center, 2002), 97.

28. See "In Conversation: William T. Williams, Melvin Edwards, and Guy Ciarcia," moderated by Ashley James in this volume (see p. 182).

29. Suzanne Slesin, "Begin with a Lot," *Industrial Design* 17, no. 3 (April 1970): 51. The Smokehouse artists were wary of how their efforts might be misconstrued in the press. As a result, such documentation is scant.

30. The artists reference a few instances where it was nearly impossible to secure permission. In these cases, owners were usually pleased with the completed work. The collective's reputation in the neighborhood and generous way of working with the community likely played a part in these positive responses. See "In Conversation" (see p. 192–93).

31. The process involved stripping the artists' designs into positive photographs of each location to produce vibrant composite images illustrating the group's vision.

design was selected, the artists began with a single wall, keying adjacent walls off the first. Williams likened this process to that of a jazz band, with each member improvising to form a visual rhythm across the space.[32] Process took precedence over design. An uneven wall or a line painted in the wrong direction by a resident inflected the process and shaped its outcome.

Young people and the elderly appear often in Smokehouse photographs, many of which were taken by the artists or the photographer Robert Colton.[33, Fig 7] Smokehouse hired residents to help clean out and paint each site, encouraging youth involvement in the arts and providing revenue for participants with money they raised through private donors and city agencies. Rooted in Williams's educational outlook, the collective nurtured a continuous thread between young and old that sustained the familial bonds of a community, thus ensuring its future. In the face of degrading social and environmental conditions, this form of collaboration created "an element of time and emotional investment and ultimately a kind of self-pride in achievement" among residents, who embraced Smokehouse projects during and after production.[34]

The collective's murals on 120th Street at Sylvan Place, a vest-pocket park lined with dilapidated benches, is an early example of its work. Drug users and people in need of housing occupied the park, driving away residents. Smokehouse reinvigorated the site by transforming its walls using elemental geometric forms and colors, inviting a broader public in. Two perpendicular walls were painted a luminescent silver with abstract forms that danced across the surface. Bands of red and yellow ricocheted down and across one; a central yellow-and-black chevron appeared on the other, anchored by a horizon of colored bands. The silver metallic paint produced an illusory effect, widening the space

32. Williams and Oren, Michel Oren interviews with artists, 11.

33. Colton and Williams were close friends. They attended Pratt together, along with Ciarcia.

34. Williams, in Williams and Oren, Michel Oren interviews with artists, 3.

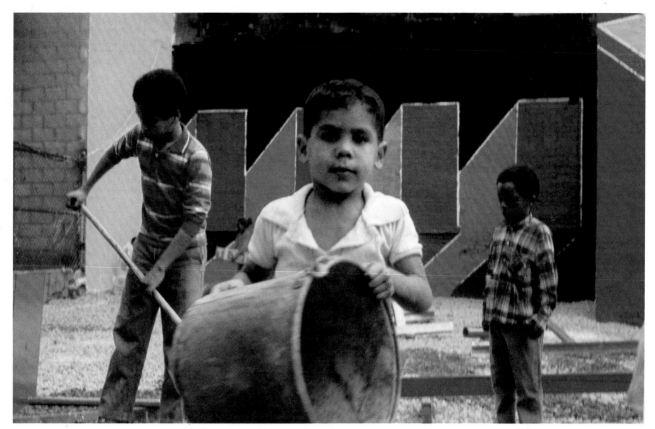

Fig 7. A group of children help at the minipark, E. 121st St. between 2nd and 3rd Aves., c. 1969. Artwork created by Smokehouse Associates

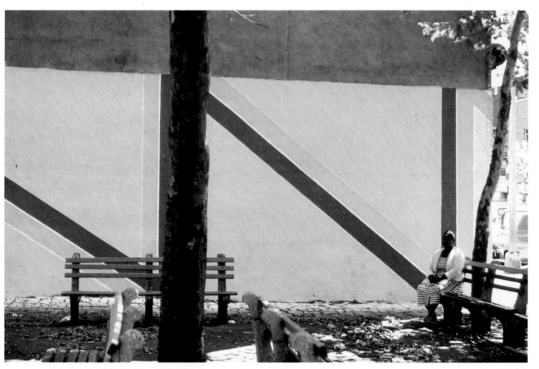

Fig 8. A woman rests beside Smokehouse's yellow and red zigzags, Sylvan Place, E. 120th St. between Lexington and 3rd Aves., c. 1968. Artwork created by Smokehouse Associates

so that the walls seemed to open up into the city. Smokehouse effected a perceptual change, not only visually, but through a "restoration of presence and care."[35] The City registered this renewal and eventually repaired the benches and began trash pickup.[36] In one photograph, a woman sits peacefully on a restored park bench—one of the first residents to experience the "qualitative possibilities" that Smokehouse generated through its work.[37, Fig 8]

Smokehouse's socially integrated model structured their abstractions, contrary to common misconceptions that nonrepresentational art is devoid of content. The multiplicity of everyday life—the space, buildings, people, politics—found its way into the work. The artists carefully keyed their hard-edged forms to the movement and geometries of the city. The colors they saw in neighborhood shop signs, storefront displays, and residents' clothing directly informed their bright compositions, refracting the exuberance of Harlem life. Colton's wife, Camille Colton, often secured sign paint for the group through donations from industrial suppliers, which the artists would deliberately leave on-site. When residents used it to paint fire hydrants, stoops, or their own spaces, the collective viewed this as a sign of success—people were changing their own environment.[38] Practical decisions informed the artists' formal and conceptual approach. Rarely did they paint higher than fifteen feet off the ground—the height of their ladder—maintaining a connection to the surrounding community at street level. By keeping things within reach, artists and residents alike were able to safely participate in a mural's creation without the use of scaffolding. In order to preserve the visual continuum of the block, the designs optically unfolded from one wall to the next, for passersby to enjoy as they moved through the city. Smokehouse's paintings "grew out of the environment" rather than being imposed upon it.[39]

35. Edwards, in Edwards and Oren, Michel Oren interviews, 18.

36. Smokehouse's renewal reverberates to the present moment. The site at 120th Street and Sylvan Place is now the East Harlem Art Park. In 1985 Jorge Rodriguez, a former Studio Museum artist in residence, installed the sculpture Growth at this location—the first project to be completed under the City's Percent for Art program.

37. See Smokehouse Associates, "Smokehouse," in the exhibition catalogue Using Walls (Outdoors) (New York: Jewish Museum, 1970), unpag. See also n. 40 below.

38. Williams and Oren, Michel Oren interviews with artists, 24.

39. Guy Ciarcia, in Guy Ciarcia and Michel Oren, 1988, Michel Oren interviews, 2.

Many of the public art programs we know today were shaped in the 1960s, a vibrant period marked by the various efforts of artists, public advocates, and city agencies to revitalize the urban environment. Yet within this period, Smokehouse remains distinct for its transverse approach. Although the artists shared a nonrepresentational language with their contemporaries at City Walls, Inc., a mostly white mural collective formed in 1967, the latter group largely focused its well-funded and well-documented activities downtown, where individual members created monumentally scaled murals on the facades of commercial buildings.[Fig 9] The Smokehouse artists viewed this work as enlarged studio designs that reflected the individual artist's ego.[40] Many modernist abstract murals and sculptures throughout the late 1960s and 1970s were realized on a monumental scale with little regard for local context. Although these projects and their organizers attempted to alleviate the harsh effects of modernist architecture on the city's inhabitants, they functioned as autonomous objects, much like paintings or sculptures in a museum or gallery. Installed throughout the city in privately owned public plazas or corporate buildings, such projects were divorced from their surroundings.[41]

In contrast, Smokehouse's strategies echo the site-specificity of the Department of Cultural Affairs' Creative Arts Workshop Program, an initiative that included one of the collective's earliest works, on 123rd Street and Lexington Avenue. Led by Doris Freedman, an ardent supporter of public art and the first Director of Cultural Affairs under Mayor John V. Lindsay, the Creative Arts Workshop Program featured a wide network of community-driven cultural activities aimed at revitalizing the city.[42] As August Heckscher, Administrator for Parks, Recreation and Cultural Affairs, explains in the program's 1968 publication

40. In 1970 the Jewish Museum brought together Smokehouse and City Walls for the exhibition *Using Walls (Outdoors)*, recognizing the two groups as the leading art collectives changing New York City's public spaces. In the catalogue, each group contributed an artist statement. Joan K. Davidson, President of City Walls, explained how the community was strengthened "by the artist's perception, his imagination, his critical eye, his humanity." Meanwhile, writing as a collective, Smokehouse wrote that it was "encouraging and heart warming" to see artists working in the public realm, but that "one cannot bring formalist problems to a public audience and expect meaningful participation" (see p. 49). The catalogue crystallizes the differing strategies of these two groups, whose common interests in public space and abstraction diverged in process and approach.

41. For an in-depth discussion on officially sanctioned and community-oriented public art models in New York City, see Miwon Kwon's essay "Sitings of Public Art: Integration vs. Intervention," in Ault, *Alternative Art New York*; and Tom Finkelpearl, "Introduction: The City As Site," in *Dialogues in Public Art* (Cambridge, MA: MIT Press, 2000).

42. Freedman provided critical support to Smokehouse. When the group encountered obstacles, as when they tried to paint a mural on the side of a firehouse, she helped move the project along. Williams describes Freedman as the medium between uptown and downtown dynamics: "Without her efforts, Smokehouse could not have existed." Conversation with the author, March 18, 2021.

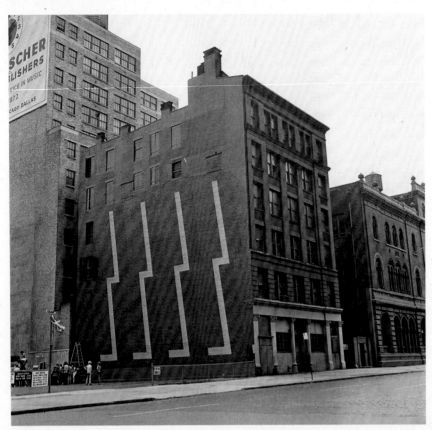

Fig 9. A mural by City Walls artist Robert Wiegand, Astor Place, New York City, 1968

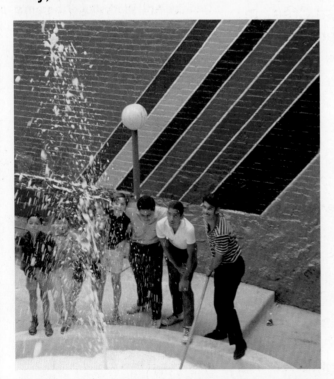

Fig 10. A mural forms a kaleidoscopic backdrop for a group near a fountain, E. 123rd St. and Lexington Ave., c. 1968. Artwork created by Smokehouse Associates

Street Art/N.Y.: A Photo Essay, local artists in residence offered inner-city youth the opportunity to "relate an artistic form to their own cultural traditions" with workshops in dance, music, theater, visual arts, creative writing, and poetry.[43] The artists in residence shared a belief in community-driven art but were linked only by the City as a funding agent.

The presence of a vibrant block association on 123rd Street laid a physical and conceptual foundation for Smokehouse's project. Photographs show community members at work and play among a series of interconnected, architecturally designed spaces.[44] The efforts of the block association resulted in the construction of a fountain and an adjoining basketball court, which Smokehouse then amplified by introducing kaleidoscopic diagonal bands on silver walls. In one, a group radiantly poses beside a fountain in front of a completed wall—a picture of pride and possibility in a once-dark corridor of the city.[Fig 10] Among the many artists in residence featured in the City's Creative Arts Workshop that summer, and indeed within the efflorescence of public art in the late 1960s more broadly, Smokehouse remains singular in its communitarian approach to abstraction.

To Create Beyond the Boundaries

Edwards's artist statement for *5+1*, a 1969 exhibition of six Black abstractionists at the State University of New York at Stony Brook, reads: "It is necessary to be free enough to create beyond the boundaries of any esthetic and make that freedom plastically manifest. To improvise is the only real and constantly dynamic revolutionary way to be."[45] His statement reflects an expansive methodology shared among many artists of African descent in the late 1960s. The aesthetic boundaries that Edwards references likely refer to his race, medium, and subject—all pervasive constraints for

43. *Street Art/N.Y.: A Photo Essay* (New York: Parks, Recreation and Cultural Affairs Administration, 1968), unpag. Listed among the Creative Arts Workshop Program's artists in residence that summer were Randy Abbott, Director of the Studio Museum's Film Workshop, and David Henderson, co-founder of the Umbra Poets Workshop. Smokehouse appears as "William Williams, Mural Workshop of Central Harlem" in the book (see p. 47).

44. I am grateful to James Trainor for piecing together a more complete picture of this site through his own research.

45. Melvin Edwards, untitled statement, in Frank Bowling, *5+1* (Stony Brook: State University of New York at Stony Brook, 1969). The exhibition was organized by Frank Bowling, with Lawrence Alloway and Sam Hunter, and its title referred to the five abstract American artists in the show—Melvin Edwards, Daniel LaRue Johnson, Al Loving, Jack Whitten, and William T. Williams—and Bowling, who was the only non-American artist and critic.

Black artists.[46] The artist's call for an improvisatory and revolutionary way of being also summons the emergence of free jazz, which simultaneously arose in the 1960s and broke with past musical conventions through an "experimental impulse."[47] The abstract compositional structure of free jazz provided a sonic modality that paralleled Black abstract art as a means of reconsidering history, material, process, and form. The artist Frank Bowling, who curated *5+1*, identified "Black art" as having an awareness of "traditional African artistic expression and thought," and an inherent and astute ability to rearrange and redirect the "things of whatever environment" Black people are forced into.[48] This convergence in abstraction of the social and cultural, the experimental and improvisatory, released Black artists from serving as the subject of their work. In her 2015 essay "Blackness in Abstraction," Adrienne Edwards describes Black abstraction as emphasizing blackness itself as the "material, method, and mode," insisting upon its multiplicity.[49] Fluid and unfixed, it is not bound by a singular narrative or identity. Rather, its creative and experimental nature precipitates a revolutionary way of being. We might consider Smokehouse's capacious abstractions through this lens.

Several months before *5+1*, Williams had organized the exhibition *X to the Fourth Power* at the Studio Museum.[50] The show was the first of several in which Williams, Edwards, and the painter Sam Gilliam would show large-scale abstract paintings and sculptures together.[51] Williams also included Steven Kelsey, a white abstract artist he knew from Yale, in the exhibition. These exhibitions had no immediate connection to Smokehouse as a collective, although Williams and Edwards were involved in the group at the time. Yet, as we attempt a holistic consideration of Smokehouse's aesthetic accomplishments, the exhibitions provide an illuminating analogue, illustrating how the artists' work together as a collective, like their individual

46. See Jones, *Energy/Experimentation*; and Mark Godfrey, "Notes on Black Abstraction," in *Soul of a Nation: Art in the Age of Black Power*, ed. Mark Godfrey and Zoé Whitley (London: Tate Publishing; Los Angeles: The Broad, 2017), 147–92.

47. Among the genre's innovations was collective improvisation, where "the division of labor between soloist and accompaniment" was obscured, producing a maximal sensory experience. Guthrie P. Ramsey Jr., "Free Jazz and the Price of Black Musical Abstraction," in Jones, *Energy/Experimentation*, 73.

48. Bowling, "Notes from a Work in Progress," in *5+1*, unpag. Bowling was a powerful advocate for his artistic peers. As a foreigner who came to New York, the artist was able to push past identity or political affiliations in his criticism, building a compelling and complex dialogue around Black abstract art.

49. Adrienne Edwards, "Blackness in Abstraction," *Art in America*, January 5, 2015, artnews.com/art-in-america/featuresblackness-in-abstraction-3-63053/.

50. Opening in June 1969, this was the second exhibition at the Studio Museum. The title of the show, a mathematical equation, *X to the Fourth Power*, hinted at the radically expansive potential of abstract art and served as a precursor to Bowling's *5+1*. See James R. Mellow's exhibition review, "The Black Artist, the Black Community, the White Art World," *New York Times*, June 16, 1969.

51. After *X to the Fourth Power* and *5+1*, the three artists would show together again in *Interconnections: Edwards, Gilliam, Williams* (Wabash Transit Gallery at the School of the Art Institute of Chicago, 1972); *Extensions: Gilliam/Edwards/Williams* (Wadsworth Atheneum Museum of Art, Hartford, CT, 1974); and *Resonance: Williams/Edwards/Gilliam* (Morgan State University, Baltimore, 1976).

practices, existed at the intersections of painting, sculpture, and the environment, pushing abstraction beyond its canonical boundaries.

Much has been written on this generation of artists, the exhibitions that forged their careers, and Black abstraction. While Smokehouse certainly belongs within this storied history, the nature of the group—an integrated, semi-anonymous collective that worked outdoors—has made them easy to overlook. The curator Okwui Enwezor observed that collectives tend to emerge in times of crisis or periods of upheaval, which force the reevaluation of production methods, the nature of art, and the position of the artist. Such collective work "complicates modernism's idealization of the artwork as the unique object of individual creativity."[52] In turn, these cooperative artistic models tend to emphasize the social character of a group, minimizing its artistic or aesthetic import.[53] However, in the case of Smokehouse, its aesthetic invention and unique application of an environmental abstraction must be acknowledged.

Recalling the long history of public art, the Smokehouse artists have cited the geometries and architecture of African societies such as the Ndebele people of South Africa, Mexican muralism, and the Renaissance as sources of inspiration for their work outdoors. These influences operate on a frequency similar to that of their own collective and participatory design. Indeed, Non-Western, Eurocentric, and Harlem vernaculars alike exist within a continuum rather than in a hierarchy. This broad view of visual culture is reflected in Tom Finkelpearl's observation that "the history of art is the history of public art."[54] Finkelpearl reminds us that while premodern structures such as pyramids or iconic cathedrals may seem akin to museums today, these works of art were intrinsic to use and place when they were first made.[55] This alternative view of art's contexts disrupts what we know as the fixed, academic version of Western art history

52. Okwui Enwezor, "The Artist as Producer in Times of Crisis" (presentation, Almost Real: Art & Social Change, European Cultural Foundation, March 11–14, 2004).

53. Enwezor.

54. Finkelpearl, "Introduction: The City as Site," 15.

55. Finkelpearl, 15.

(in all of its exclusions and divisions), and lives at the heart of strategies employed by Smokehouse. Despite the preceding tenets of modernism, abstraction could be, and indeed had always been, rooted within a social context.[56]

As he created more environmental work, Edwards constructed a series of site-specific installations composed of chain and barbed wire—materials charged with constraint and brutality—for exhibitions throughout 1969 and 1970.[Fig 11] For *X to the Fourth Power*, he created *Pyramid Up and Down Pyramid* (1969), stretching lengths of barbed wire across the corner of the gallery, delineating alternating pyramids within the space.[Fig 12] These spatial works conversed with aesthetic principles of Minimalism and the attendant dematerialization of Conceptual and Process art—themselves movements that blurred artistic boundaries. Yet Edwards's invocation of the African diaspora, through his use of poetic and material language, broadened the art historical framework in which he found himself.[57] The artist's sociopolitical strategies at once engaged with these contemporary movements and evaded art historical rigidity. Referencing the lack of distinctions between abstraction and realism in the visual cultures of Africa, the artist asserts the two are one and the same—an approach rooted in universalism.[58]

While not a member of Smokehouse, Gilliam shared "a certain aesthetic collegiality" with Edwards and Williams that began with *X to the Fourth Power*.[59] Among his contributions to the exhibition was *Restore* (1968), a monumental beveled-edge painting. Pouring paint directly onto unstretched canvas, Gilliam allowed the medium to flow and stain the raw material in the tradition of the Washington Color School. Folding the wet canvas and leaving it to dry produced improvisatory abstractions, cosmic fields of color with spatial and painterly depth that pushed beyond any one school of thought.[60] This dimensionality was furthered by

56. For an illuminating discussion on the social and vernacular origins of abstraction, including the Southern Black American abstraction of the Gee's Bend quilters, Muslim aniconism, and West African polyrhythm and fractal patterns, see manuel arturo abreu's decolonial project, "An Alternative History of Abstraction," Discrit, online lecture, May 16, 2020, discrit.net/programs/an-alternative-history-of-abstraction.

57. Edwards recreated *Pyramid Up and Down Pyramid* a year later for his 1970 solo exhibition at the Whitney Museum of American Art in New York. Writing in the exhibition pamphlet, he states, "I am now assuming that there are no limits and even if there are I can give no guarantees that they will contain my spirit and its search for a way to modify the spaces and predicaments in which I find myself." *Melvin Edwards: Works* (New York: Whitney Museum of American Art, 1970), unpag.

58. Edwards and Oren, Michel Oren interviews with artists, 7.

59. Mary Schmidt Campbell, "SAM GILLIAM: Journey Toward Red, Black, and 'D'," in *Red & Black to "D": Paintings by Sam Gilliam* (New York: The Studio Museum in Harlem, 1982), 9.

60. See Jonathan P. Binstock, *Sam Gilliam: A Retrospective* (Berkeley: University of California Press; Washington, DC: Corcoran Gallery of Art, 2005).

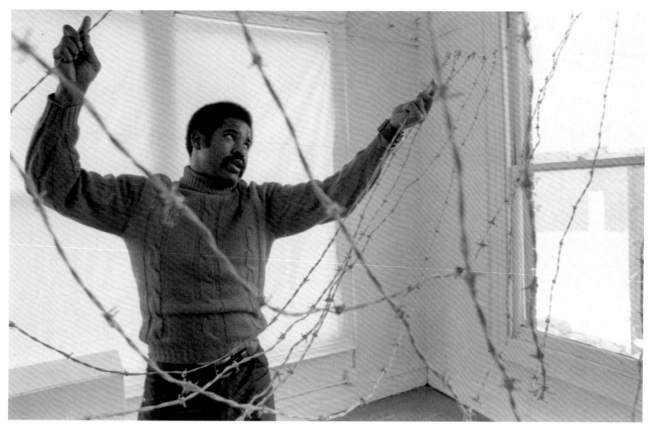

Fig 11. Melvin Edwards constructs a sculpture with barbed wire in an empty studio space, New York, NY, February 20, 1970

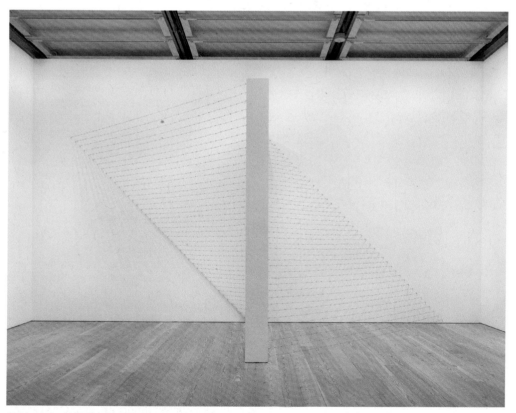

Fig 12. Melvin Edwards, *Pyramid Up and Down Pyramid*, 1969/2017

Booker

angled stretcher bars, which, once the canvas was stretched, produced sloped panels that appeared to protrude from the wall. Gilliam's subsequent "Drape" paintings, which he began making in 1968, released the canvas from their stretcher bars altogether. The artist suspended these monumental works from the ceiling and walls, creating billowing, painterly environments. Able to achieve new arrangements in color, form, and space with each installation and fostering interaction between object and viewer, the paintings recall the experimental and improvisatory spirit that permeates the period. Gilliam began to realize these works outdoors—installing his "Drape" paintings on the facades of museums and laying them across the landscape—jettisoning structure once more to join art with the wider world.[Fig 13]

At the request of the Studio Museum, Williams included several of his "Diamond in a Box" paintings in *X to the Fourth Power*. Whereas the work of his peers physically interacted with the environment, Williams's vigorous abstractions provided a "stabilizing force,"[61] suggesting the contours of the space and the implications of the turbulent moment in which these artists found themselves.[Fig 14]

In their drive to create work that was unconfined—by race, canonical histories, institutions, or medium—the artists in these exhibitions, like Smokehouse as a collective, made "freedom plastically manifest," in the words of Edwards's *5+1* artist statement. Sensing the deconstructive potential of free jazz, Black artists "found a parallel in their own interest in abandoning stretcher bars, flat surfaces and brushes."[62] This was a revolutionary improvisation in the fullest sense, a constant reconfiguration of histories, materials, and processes that generated a literal and conceptual openness in the work, driven by the social and formal innovations of Black abstraction. While collaboratively made, Smokehouse's environmental abstractions find kinship in the individual strategies of these artists.

61. Williams, quoted in Hobey Echlin, "Spirit and Chance: The Informed Lifeline of William T. Williams," *Metro Times* (Detroit), July 6–12, 1994.

62. Godfrey, "Notes on Black Abstraction," 169. Writing on the same group of artists, Kellie Jones also notes: "The social connotations of this body of work also appeared in its environmental and public aspects; many of the pieces were crafted with the idea of encompassing the viewer, which came from a desire to share this vision, to have people connect with this energy." "To the Max," 24. This impulse was shared with other Black abstract artists working in the period, including Al Loving, Joe Overstreet, and Howardena Pindell.

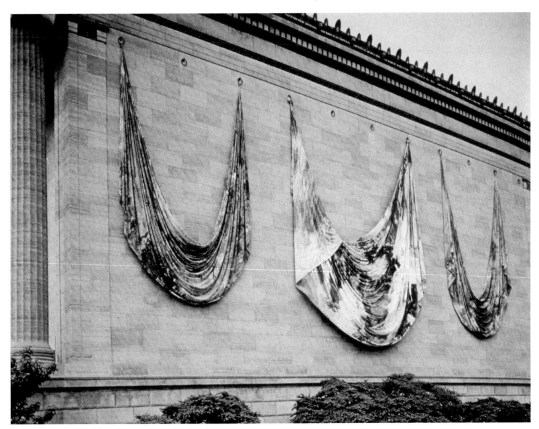

Fig 13. Sam Gilliam, *Seahorses* (installation view), 1975. Acrylic on canvas, dimensions variable

Fig 14. William T. Williams in his studio with *St. Paul*, 1970, c. 1970–74

Smokehouse completed one of its most ambitious projects in the summer of 1969. With the help of the 121st Street block association, the group painted seven consecutive walls along a series of interconnecting vacant lots between Second and Third Avenues.Fig 15 The project featured the collective's only sculptures: abstract forms resembling Edwards's painted sculptures, which were composed of objects the artists sourced from a local plumbing store and welded on-site. Yet another example of the group's creative reuse of materials and space, Smokehouse's sculptures appeared to spring forth from the industrial environment. Acting as the group's fundraiser, Williams gradually secured support from increasingly high-profile donors.[63] The MoMA Junior Council, whose members he had met through his involvement at the Studio Museum, underwrote Smokehouse's expansive vision for the site.[64] Once a garbage-strewn lot, the space became a geometric minipark.

A vivid archive of images depicting the 121st Street project forms the largest body of documentation on Smokehouse, providing critical insight into the collective's hands-on process. Ciarcia can be seen painting four rectangular forms beneath four broken windows. Children watch as Edwards assembles sculptures that, once completed, would become dynamic objects for play. Photographs taken from above the site, or from the vantage point of a sculpture spiraling off the ground below, capture the dynamic nature of Smokehouse's environment as one might have experienced it in living color.[65] Cumulatively, these images illustrate the collective's potential.

Once Smokehouse had completed several sites, its work became recognizable to community members, city agencies, and private donors alike. This led to more projects, greater resources, and,

63. David Rockefeller was a donor. He had witnessed the collective's work nearby while working at the Volunteers in Service to America (VISTA) office in Harlem.

64. The Junior Council was eager to support projects in light of the pressure that MoMA faced from the AWC and others. Williams wrote the Junior Council: "It would be unfortunate if this project would have to terminate because of the Museum's escalating social-political problems. It should be understood again that Smokehouse Associates will not take part or allow ourselves to be used as a political level to ease pressure being applied to the Museum by certain groups." The Council supported the project anonymously with $10,000, acting as a distributing agent for private donors including the Celeste & Armand Bartos Foundation and the John R. Jakobson Foundation. The funds allowed the group to secure materials and lay down gravel. Celeste Bartos and Barbara Jakobson were supporters of Smokehouse and Williams's work, having visited a number of sites that the group completed. Junior Council Records, [Series V: Events and Projects 1952–1986.V.37], Museum of Modern Art Archives, New York. (See p. 43–44 in this volume for a reproduction of this correspondence.)

65. One of several photographers in the archive, Robert Colton has said that he attempted to replicate the transformational nature of the work in his photographs. Conversation with the author, September 20, 2020.

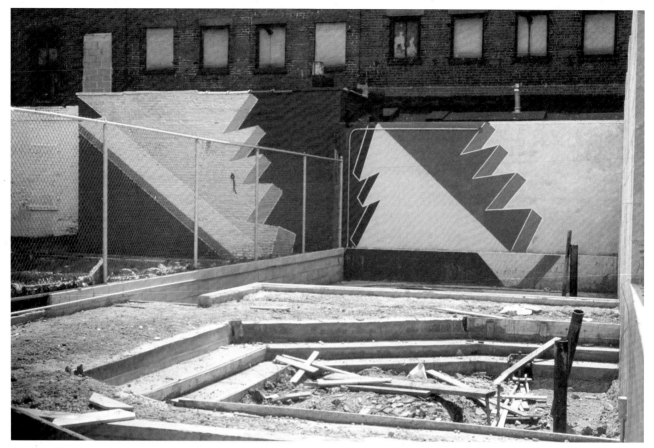

Fig 15. The in-progress minipark, E. 121st St. between 2nd and 3rd Aves., c. 1969. Artwork created by Smokehouse Associates

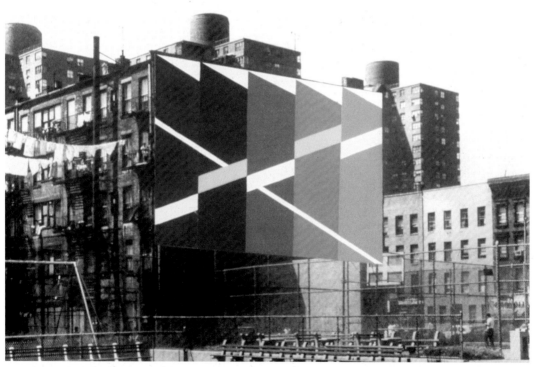

Fig 16. A photographic mock-up of an unrealized mural in Harlem, New York City, c. 1970. Artwork created by Smokehouse Associates

in turn, further change in Harlem. As part of the Department of Cultural Affairs' Neighborhood Street Festivals program, the 121st Street block association staged a celebration around the completed park in 1969. The program enlisted coordinating artists to work with the community in the weeks leading up to a festival, listening to residents' ideas and helping them organize the event. Walter Jones, who is listed under "Smokehouse Productions" in the festival flyer, staged a play with the help of the City's mobile Festival Truck.[66] Equipped with a sound system, lighting, a stage, space dividers, and a street fountain, the truck allowed residents and artists alike to see the street "as a space to sculpt and transform," resulting in highly creative festivals that grew directly out of the community.[67] The 121st Street project exemplifies Smokehouse's "totally integrated social scheme," which the collective achieved through considering community life at every level.[68]

As Smokehouse's aspirations grew, so too did their awareness of the systems that limited their work. In 1970 the group created nine mock-ups for monumentally scaled abstractions to be sited near schools throughout Harlem and presented them to the Board of Education.[Fig 16] A departure from their intimate street-level environments, these architectonic projects aimed to wrest control from a city that was rapidly expanding with little concern for the people of Harlem. Brightly hued geometries are stacked or tumble down the sides of buildings, evoking the spatial anxieties of the dense city grid. The group intended to bring awareness to the overwhelming presence of architecture and the effects it had on the light and movement of city dwellers. Although these works remain unrealized, the plans reflect Smokehouse's vision for change at the fundamental levels of society, while pointing to the group's eventual conclusion.

66. At the invitation of Doris Freedman, Williams served as a consultant for the Festival Truck while the concept was being assessed by students at Yale University. The artist suggested that the truck's design should follow the concepts being developed by each community.

67. *Neighborhood Street Festivals: New York City* (New York: Parks, Recreation and Cultural Affairs Administration, 1969), unpag.

68. Dore Ashton, "Introduction," in *Using Walls (Outdoors)*, unpag.

The artists began to realize that creating paintings on preexisting walls could only achieve a certain level of change within the community. They believed this type of work needed to be integrated into the planning of the city itself through a holistic approach to art and urbanism that would bring artists, architects, and city planners into meaningful collaboration to address the needs of society.[69] Although Smokehouse had set change in motion, the artists recognized that the health, education, jobs, and housing of a community needed to follow in equal measure. The funding and infrastructure required to achieve this integrated vision were beyond their means.[70] Further, the artists began to shift their time and energies as they pursued their individual practices, teaching, and family lives. By the end of 1970, the collective concluded its work in Harlem. Williams explains, "In essence, the active part stopped, but probably the most important part started in terms of how do you spread these ideas so that many artists are trying to do things?"[71]

Smokehouse's groundbreaking contributions are evident today. The artists' emphasis on process as the means of change exists within a constellation of community-oriented strategies variously called "social practice" or "new genre public art" (a term later coined by Suzanne Lacy in 1995).[72] Such art cultivates the space between the artist and audience, an unknown relationship "that may itself become the artwork."[73] Artists of African descent in particular have been attuned to the ways that art can be employed to transform historically underserved Black communities. The theorist and poet Fred Moten suggests that this approach is born of a refusal to accept the violent acquisition and displacement of colonization. His question "Has black social life ever been anything other than the constant practice of questioning ownership?" illuminates the decolonial roots of social practice and

69. Edwards referenced Brasília, the Brazilian capital designed and built under the direction of Oscar Niemeyer in the 1950s, as an attempt to integrate human society with the design of the city, albeit imperfectly. Edwards and Oren, Michel Oren interviews with artists, 5. The National Endowment for the Arts would combine its Visual Arts and Design Programs in 1982 to foster this type of collaboration, though the process remained unbalanced in practice.

70. Williams and Edwards traveled to Washington, DC, in 1977 to meet with Patricia Roberts Harris, then the Secretary of Housing and Urban Development. Accompanied by the painter Ed Clark, who had provided the introduction, and the architect Joe Black, they proposed integrating art into public housing as a means of humanizing the spaces that tenants live in. Though percent-for-art programs had been in effect throughout the United States for nearly two decades, the policy was not adopted in New York City until 1982. The artists' proposal did not move forward, and they chose not to pursue the professional avenues that such planning and policy entailed.

71. William T. Williams, unpublished excerpt of interview with James Prigoff and Robin J. Dunitz, September 3, 1999, William T. Williams Archives. (Most of the interview was published in Prigoff and Dunitz, *Walls of Heritage, Walls of Pride: African American Murals*).

72. See Suzanne Lacy, *Mapping the Terrain: New Genre Public Art* (Seattle: Bay Press, 1995); Tom Finkelpearl, *What We Made: Conversations on Art and Social Cooperation* (Durham, NC: Duke University Press, 2013); and Pablo Helguera, *Education for Socially Engaged Art: A Materials and Techniques Handbook* (New York: Jorge Pinto Books, 2011).

73. Lacy, 20.

collectivity, underscoring insurgent forms of Black experimentation.[74]

In 1993 the artist Rick Lowe identified the community-building potential of a block and a half of row houses in Houston's poverty-stricken Third Ward. Working in collaboration with six other artists, he renovated the structures to create Project Row Houses, an organization that has grown to provide studios and exhibitions for artists, cultivating enrichment throughout this historic community. More recently, in 2021, the artist Kevin Beasley purchased an overgrown lot in the Lower Ninth Ward of New Orleans. Sowing a community garden for a neighborhood that has been disproportionately affected by Hurricane Katrina, Beasley has invested in the land, igniting change and creating a space of potential for the surrounding community.

The work and vision of the Smokehouse Associates may have outpaced changes at the societal level, but the group's transformational spirit endures. For a brief but vibrant period, the collective freed art from institutional restrictions, bringing change directly to Harlem residents. Its importance lies in its multiplicity, its crossing the boundaries of artistic activism in the late 1960s, abstraction, and communal collaboration. The exuberant photographs that remain are traces of the group's radical potential, a visual coda brimming with possibility.

74. "Fred Moten, Theaster Gates & Adrienne Brown in Conversation on Art, Space, & Poetics" (Center for the Study of Race, Politics and Culture, University of Chicago, May 20, 2020).

Archival Reproductions

Excerpts from Michel Oren interviews with artists

ARTIST IN RESIDENCE

Mural Workshop, Summer 1968

Introduction and Aims

There is a beginning of an Art Community in Harlem, but it remains
amorphous and more or less isolated from the larger Harlem Community.
It is the aim of the Artists In Residence program to help crystallize
this community as well as teach young prospective artists to recognize
their talent and to use it in a constructive manner. In addition, Artist
In Residence will provide a way for artists to involve themselves in
community development. The April, 1968, issue of Art Gallery magazine
provided a list of 125 artists, of which 15 live and work in the Harlem
Community. Harlem street exhibits consistently show a number of unrecog-
nized, self-taught artists of promise. While some of these artists are
older, mature people, there are a number of adolescents among them,
young men and women aged 13 to 19.

To introduce art and artist to the Harlem Community and to rehabili-
tate the community environment through the use of art are ambitious,
long-range goals.

Williams submitted a preliminary proposal to the Museum of Modern
Art's Junior Council outlining his vision for a ten-week project run by
artists in residence that would inspire Harlem youth through the creation
of outdoor murals. This document represents some of Williams's initial
goals for Smokehouse, which, like his *Artist-in-Residence* program at the
Studio Museum, was committed to bridging artists and communities.

The Summer Workshop

Our summer workshop will use local and national artists to paint large outdoor murals. These murals will not only improve the general community environment, but through the use of serious, high-level art, promote community pride and interest, and train young artists through an apprenticeship program.

Artists of some national recognition will be hired on a one week basis to design and execute murals and to supervise the young apprenticed artists in their work. It will be a mutual exchange, and the young apprentice will receive help in both planning and executing works of art from beginning to end, while at the same time having a continous relationship with a series of working artists. The participating artists will come from New York, and have been trained at major art schools in the country and at present are working and teaching at major colleges and art schools.

The program will run for a ten week period beginning July 1, 1968. William T. Williams will be the Co-ordinator and Director of the program, on a full-time basis for the full ten week period. Four professional artists will be hired as "Artist In Residence" for the execution of each mural. Five young local artists will be hired to design and execute murals, and serve as assistants to the "Artist In Residence." It will be a small, intimate community of artists working and learning from each other through the summer months in the streets of Harlem. Hopefully, there will be, in addition, thousands of sidewalk gallery goers.

BUDGET

Personnel:

One full-time director, co-ordinator, at $175 per
wk. for ten weeks $1,750.00

Four Artist In Residence at $175 per. wk. for one
week each $700.00

Five young local artists - professional fees for
murals at $75 each per. wk.. for one wk. $375.00

One professional sign painter and rigger $175.00

 Total - $3,300.00

Equipment and Supplies:

160 gallons of Jet Dry paint @ $5 per gallon $800.00

Brushes, turpentine, paint remover $200.00

Miscellaneous supplies (tape, chalk, nails,
saws, hammers, etc.) $100.00

Rental of professional riggs and ladders $500.00

Lumber $100.00

 Total - $1,700.00

Total budget - $5,000.00

SMOKEHOUSE ASSOCIATES 654 BROADWAY NEW YORK, N.Y.

Painting, sculpture, images, objects, things, places, ideas,
accidents, actions, reactions, adjustments, artist, non-artist,
people, persons.
Artist as social people, persons, making adjustments.
Flat, small enclosed, anti-life spaces, moving toward open units
of time, space in flux, illusions, anti-flat surfaces, non-static
involvement both physically and mentally.
Our efforts will be toward creating a space which through the use
of images, non-images, objects, optical completions, object flux
and image flux will allow one to experience space as a post
religious event, devoid of utilitarian purpose.
A. Using all natural environmental strucutres as fixed points
in space which must be incorporated in all total unit ideas.
B. Using all commercial messages and signs as necessary public
information which must be incorporated in all total unit ideas.
C. We will attempt to save all existing community graphics or
objects, so that some familiar images will be recognizable. This
project will of necessity be planned and created with the knowledge
that people and persons will live in and about the unit ideas once
we have gone.
It should be understood that we are not creating a playground or
attempting to manufacture prototypes for recreation spaces. We
are _not_ relinquishing our assumed roles as artist but attempt to
broaden its western definition. We chose to seperate our studio
egos from this project and work collectively.
One of our main concerns will be trying to reach some definitive
ideas about scale. It is our thought that the mere enlargement
of studio ideas and images will not resolve public environmental
problems. We seek not a quantitative solution but a quality
answer.

 SCALE

 HUMAN SCALE.
 HUMAN EXTERIOR SCALE.
 ARCHITECTURAL SCALE.
 URBAN ARCHITECTURAL SCALE.
 SCULPTURE SCALE.
 PAINTING SCALE.

 AS AN INTER-RELATED PROBLEM CENTRAL TO ALL ARTS.

 SCALE AS A PSYCHO-SOCIAL INFLUENCE.
 SCALE AS A POLITICAL IMPLICATION.
 SCALE AS A NATIONALIST DEVELOPMENT.
 SCALE IS ART.

Page 1 of two pages

Through poetry on scale, space, and the role of the artist, Smokehouse
articulates its expansive concepts for working in the built environment.
The group's reference to studio egos likely responds to contemporaries
such as City Walls, Inc. Its firm stance on collaborations with MoMA and
request to review all publicity reflects the politically charged period in
which the collective worked.

It would be unfortunate if this project would have to
terminate because of the Museums escalating social-political
problems. It should be understood again that Smokehouse
Associates will not take part or allow ourselves to be used
as a political level to ease pressure being applied to the
Museum by certain groups. Because of this it is our wish and
understanding (second meeting) that all publicity will be
cleared with Smokehouse Associates before release. Also, all
documents, slides, recordings, etc......remain the property
of Smokehouse Associates. We submitted this document with the
understanding that its contents will not go beyond those persons
directly involved with the project at the Museum of Modern Art.

Because of the changing nature of this project it is impossible
to reach a concrete budget at this time. The following budget
is a very rough estimate of cost. A detailed accounting will
be kept during the execution of the project.

Smokehouse Associates. Commission: $5,000.00

Purchase of materials(paint, steel,
brushes, bolts, etc.....) $3,600.00

Rental of equipment. $ 400.00

Services, fees. $1,000.00

Total $5,000.00

Page 2 of two pages

July 29, 1969

Mr. William Williams
Smokehouse Associates
654 Broadway
New York, New York

Dear Mr. Williams:

The Junior Council accepts the terms of the "Smokehouse
Associates" 121st Street Project as proposed in your lucidly
detailed letter. We agree to your group's administration
of the project, recognize your sensitivity to publicity and
feel strongly that the parties involved provide a unique
opportunity to generate artistic "quality" for our urban
landscape.

In connection with a distribution of funds for the project,
the Junior Council respectfully submits the following proposal:

 Step 1: $1,500.00 down payment on commission
 2,000.00 simultaneous payment for materials
 to be subsequently accounted for.
 ─────────
 3,500.00 Subtotal
 Step 2: 1,500.00 additional commission when project is
 50% completed.
 Step 3: 3,000.00 or some portion thereof for additional
 materials and service to be forwarded
 following an accounting of same.
 Step 4: 2,000.00 final commission upon completion of project.

 $10,000.00 Total

It might be pointed out that the above project is being financed
anonymously by intrigued individuals who seek no vested interest
and have only good wishes for your success, and that the only role
of the Junior Council is that of disbursing agent on their behalf.

In this letter, MoMA Junior Council member Barbara Jakobson formally
approves Smokehouse's proposal for the 121st Street minipark.
A longtime proponent of Williams's work, here Jakobson addresses the
collective's concerns with the Museum amid the rising pressures that
MoMA faced from groups such as the Art Workers' Coalition (AWC).

Archival Reproductions

If our proposal meets with your approval, please sign this
and return the enclosed copy to the Junior Council.

Sincerely yours,

Barbara Jakobson

Mrs. John R. Jakobson

(Signature for Smokehouse Associates)

BJ/bt

(Date) 8/1/69

WILLIAM T WILLIAMS

A Photo Essay
STREET ART/N.Y.

During the summer of 1968 workshops in dance, music, theater, visual arts, film-TV, creative writing and poetry were set up in churches, community centers, social clubs, and storefronts in inner-city areas around New York City. Directed by local artists-in-residence, these workshops reached hundreds of our teenagers, providing a focus for them to relate an artistic form to their own cultural traditions. Whole blocks and neighborhoods became involved in the creation of wall murals, films and plays.

It is our hope that this photo essay will convey the many possibilities and opportunities that creative training in the arts holds for all citizens, and the new quality of life, of richness and relevancy, that participation in the arts can yield. If we can find means to support the artist in-residence, he can take on a role that is at once revolutionary and creative.

This project was made possible through a matching grant from the National Endowment on the Arts. Mrs. Doris Freedman, as Director of the Department of Cultural Affairs, was responsible for the program and it is due to her imagination and drive that it was carried through so successfully.

August Heckscher
Administrator
Parks, Recreation and
Cultural Affairs Administration

"...The community is the core we start with, for they will be living with our works when we leave." William Williams

Artists-in-Residence

VISUAL ARTS
Maureen Conroy and David Murphy, South Bronx Community Art Workshop
Amanda Means, Creative Arts Workshop on East 104th Street
Tejumola, Studio "O", Bedford Stuyvesant
William Williams, Mural Workshop of Central Harlem

DRAMA/MUSIC/DANCE
Vinie Burrows, Drama Workshop in Central Brooklyn
Gordon Duffey, Block Opera Project, New York City Theater Workshop
George Espada, Gut Music Hall
Maryat Lee, Soul and Latin Street Theater
Michael Babatunde Olatunji, Olatunji Center of African Culture
Pearl Primus, Ethnic Dance Workshop
Pedro Santaliz, New Poor Theater of America
Ollie Shearer, New York Music Center
Enrique Vargas, Gut Theater

FILM
Randy Abbott, Harlem Studio Museum Film Workshop
Ernest Dunkley, Communications Workshop, Bedford-Stuyvesant
Herb Golzmane, Brownsville Community Council Film Projects

POETRY
David Henderson, Umbra Workshop
Tom Weatherly, Afro-Hispanic Poets Workshop

Shirley Sarnoff, Workshop Coordinator

In a year of escalating tensions between local residents and law enforcement, the Department of Parks, Recreation and Cultural Affairs sponsored a series of arts workshops in collaboration with local artists in residence to support programs made by and for communities in need. Smokehouse appears as the "Mural Workshop of Central Harlem." The group received funding for its project at 123rd Street and Lexington Avenue.

Archival Reproductions 47

Department of Parks
City of New York
Arsenal, Central Park

for release

Upon Receipt

FIRST OUTDOOR MURAL BY CONTEMPORARY NEW YORK ARTIST TO BE PRESENTED

On Sunday, August 18th, a gigantic 75 by 86 foot outdoor mural, designed by artist Robert Wiegand, will be officially welcomed at Astor Place (intersection of Astor Place & Lafayette Street), announced August Heckscher, Administrator of Parks, Recreation and Cultural Affairs. A celebration in the parking lot at the site, beginning at 2 P.M., will mark the unveiling as Mr. Weigand signs his wall painting and a plaque is mounted identifying the painting, titled "...in the Astor Bar," as a public work. Mrs. Doris Freedman, Director of the Department of Cultural Affairs, will represent the city at the ceremonies.

The completion of this outdoor mural, the first under the auspices of the Department of Cultural Affairs, is another attempt by the Department to enrich the cultural environment of the city by the utilization of neighborhood space. Its first major effort was the "Sculpture in Environment" show last fall. Two murals at Sylvan Place on 121st Street between Lexington and Third Avenues, were recently completed and a number of walls were painted in a vest pocket park on 123rd Street between Lexington and Third by Harlem youngsters in the Inner-City Workshop Program, under the supervision of artist William Williams.

The Department of Cultural Affairs is now planning to develop a program of mural painting by professional artists into a city-wide project which will unite artist and community in the creation of neighborhood landmarks and community beautification. Plans include additional works by the Harlem artists, and two wall murals to be painted by Jason Crum in a vest pocket park at 29th Street and Second Avenue. Remarks Commissioner Heckscher: "The creation of neighborhood landmarks by contemporary New York artists who use the images and materials of our time opens up exciting possibilities for transforming our city."

Mr. Wiegand, whose work is an abstract of red and yellow diagonals on a green ground, has presented five one-man shows in New York and participated in over 30 group shows. #702 8/13/68

FOR INFORMATION ON PARKS DEPARTMENT EVENTS, PLEASE DIAL 755-4100

For information:
Mary Perot Nichols
REgent 4 1000

1-1-1-50M-1027067(67) 346

The Parks Department announces Smokehouse's walls at Sylvan Place and 123rd Street and Lexington Avenue (appearing under William T. Williams and youth from the Inner-City Workshop Program), and a large mural by Robert Wiegand of City Walls at Astor Place. While the press release officially documents the collective's work for the first time, unlike Wiegand, Smokehouse does not receive a plaque or unveiling ceremony.

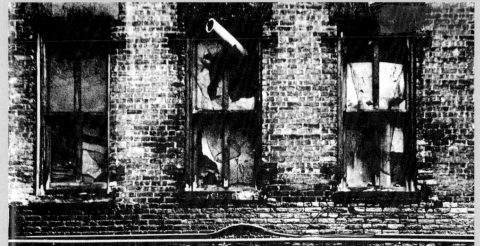

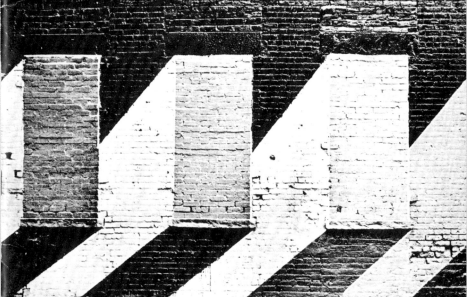

Smokehouse

It is both encouraging and heart warming
that artists have decided to venture into
public forms of art. Thus, the restricted
boundaries of museum and gallery walls
are being opened up to the public.
 But. . .
 But. . .
It is our belief that all city wall paintings
executed thus far are decorative, lacking in
scale and irrelevant as a public art form.
These projects do not have the power,
scale or conviction that commercial
billboards have. They have in essence been
studio problems which were inadequate in
the studio, and became visual atrocities as
public forms. One cannot bring formalist
problems to a public audience and expect
meaningful participation.
 Most city wall paintings have not
understood the difference between scale
and size. They have relied on color intensity
and sheer mass for impact. It should be
apparent that the city environment itself is
a great deal more powerful than the
isolated wall paintings.
 We, the Smokehouse Associates, believe
that there is a necessity to separate one's
studio ego from public forms. Meaningful
public environmental solutions will come
from collective efforts on the part of
painters, sculptors, architects, writers,
planners, etc. Those persons who have
expertise in many interrelated fields must
be called upon to resolve a total urban
condition.
 Smokehouse Associates was originally
formed in 1967, as a means to deal with a
gap between art and audience. Our original
membership was limited to painters and
sculptors, but it quickly became apparent
that we had to expand our membership to
include other related expertise. Our
composition now includes architects,
writers, actors, photographers, graphic
designers, community workers, city
planners, lawyers, and poets. We admit that
the projects we have completed are by no
means an answer, but a qualitative
possibility.

Smokehouse Associates

In 1970, the Jewish Museum organized *Using Walls (Outdoors)*,
an exhibition showcasing the two leading public art collectives
transforming New York City: Smokehouse and City Walls. While both
groups employed abstraction, the artists' statements included in the
catalogue delineate their opposing methods on scale, community
involvement, and collectivity. Smokehouse is incorrectly cited as
forming in 1967, a year before it actually began.

WTW: Coming in as a diverse group, we had to deal with how they were going to accept us, given the time it was, given the political context. We had to win their trust that we were indeed trying to function as visual artists, we were not bringing a political perspective to what we were doing. What we were just providing were resources, and we were willing to function as an extension of their ideas. We were not willing to function as an extension of political ideas, though. In other words, as a group of artists, we bring a basic aesthetic to whatever we're doing. We were not willing to paint political slogans. We felt if someone wanted to do that it would be far more vital if they did it directly. We would show them how and where, etc., but to do it ourselves, that would have not been… we wouldn't have had… it would have been dishonest on our part to do that. Political art is always more powerful when you can get indigenous people to do it. To bring it from the outside, we would be functioning as provocateurs and that's not what we wanted to do. Do you see what I'm trying to say?

MO: I do see, I'm not sure why you're…

WTW: Well, what we wanted to do is give people the incentive and the know-how to do that if they wanted to do it. We always shared our information: "This is where we went to get the resources to do this. This is how we're doing this." And we were very active in the whole teaching process: "If you want to do this, this is how to do it--A,B,C,D,E,F,G." When we left, our expectation was that some of those people would have interests and say, "Well, hey, this thing is very effective in bringing us together. Let's try to extend this, let's try doing it some other way. Let's trying getting some of our local artists to do things."

MO: Did that in fact happen?

WTW: That in fact did happen, specifically at 121st Street.

MO: In a hispanic community?

WTW: In a hispanic community. I think it happened all over the city. I think the wall mural program that really caught on was specifically spurred on because of that early involvement of Smokehouse and of City Walls.

MO: I guess you're getting into the development of your particular Smokehouse aesthetic. Before you do that, could you explain the analysis or the theoretical background out of which your desire to empower these people and to work with them came? You hadn't grown up among them?

Art historian Michel Oren (MO) conducted a series of interviews in 1988, excerpted here, for his eventual study on Smokehouse in *Black American Literature Forum* (Autumn 1990). Oren met with William T. Williams (WTW) to discuss the group's process, design decisions, community participation, abstraction, and art historical precedents, among other topics.

WTW: That's not true. It's just the opposite.

MO Excuse me.

WTW: It's just the opposite. I lived in the rural South. My parents moved to New York,
 I lived in Harlem, they moved from Harlem to South Jamaica, we lived in South
 Jamaica. I grew up specifically in a rural southern background and then an urban black
 community. Billy Rose grew up in Bedford-Stuyvesant, Guy grew up in Jersey City, and
 Mel grew up in Houston. I don't think it was our desire to empower them, because that
 would be implanting… giving us too much power and also would be a parental attitude
 on our part. What I see ourselves as being involved in was on one hand being visual
 artists, and the whole idea of a visual artist being interested in communication and
 humanity and the pursuit of aesthetics, all of those really wonderful things. But
 there was a pull specifically in my mind and in the other members that we came upon,
 that there was a time when art functioned in a public arena--during the Renaissance,
 specifically in African culture, in numerous cultures it had functioned in a public
 arena. When it became private, that transition to being a private activity had all
 kinds of things that had to do with economics, had to do with… (telephone call here)…
 very often when it was in the public domain it was used for propaganda, it was used
 for control, there was an element of power involved in it. There is that history
 to art in the public domain. My specific interest had to do with when you're in art
 school and you're being taught about art, you're taught in a classroom context.
 Very often a lot of that stuff is wonderful in a theoretical context in a classroom.
 If you can make a work of art that's only communicable to those persons who have gone
 through the same system, that same kind of educational system, then it seems to me
 there's a problem. You can't just speak to the committed. A work of art it seems to
 me has to have a life that can encompass a larger body of people. It's difficult for
 us because we're in a very diverse culture, cultures are no longer homogeneous, they
 no longer have homogeneous symbolic systems, sign systems, and it provides a very
 difficult problem for the artist, for the visual artist. And I think what we were
 attempting--in our meager little ways, four artists--were to begin to test those
 kind of ideas, test those issues in a public context. Can we make art if we move away
 from the galleries, away from the museum and deal with people who very often have
 never been in a museum… Yet there's an aesthetic system that they're functioning in,
 yet there are indigenous folk art forms that they function with (and) have grown up.
 Can we begin to stimulate them to begin to use those elements? That was my interest,
 still is my interest.

ME: We decided it would be better if the work were not figurative in order to emphasize the change rather than to put... let the message be the change rather than put information out which said why the world needed changing.

MO: What was the change, specifically?

ME: The change was simply... is that you make a place visually and aesthetically better and therefore more human. We could have chosen another mode but what we felt at that moment... certainly what I felt was that abstraction in that case offered a way of letting the message be the actual change. In other words we were interested in actually changing society--not preaching or converting people in the sense of missionarying or something. Although... changing people in a sense automatically means that, but what I mean is the work itself could literally be better. Look, our real concepts had to do with, we would like to start new cities... like the ideas at Brasilia or something implied, because even they weren't totally... actually that successful in terms of totally integrating human society and how people worked and lived. But it was attempts in the same direction, and it was by a group of young people here but who didn't have those resources. I mean at least when the people in Brazil who were interested in developing that part of the country did that and went to Niemeyer and those people, they had the resources in hand if they chose to do it. We did not have that kind of relationship to our societies... What I'm getting at is therefore abstraction... was a device. It could have been another device but we felt that what had happened in Mexico was one version of what could be, and that there was another side to the same kind of coin.

MO: Among the precedents for this kind of work would you include the Russian Constructivists. They had the idea that by changing the spaces in which people lived and worked that they would somehow begin to form "the new man"--that is, the new socialist man.

ME: I was aware of the Russians... and I wouldn't discount what they did, but it was not a particular influence on my thinking at the time. I grew up in Texas, went to school in California, I'm closer to the Mexican and Afro-American developments that way. All those people were aware of what happened in Russia, so I don't discount it, but if you're asking, was that impetus for me, not that much.

MO: What about geometric work in African art--kente cloth and...

ME: Oh yes, it was a part of it. See, the question of geometry wasn't a big question. We decided on it and went ahead. We didn't have any big argument therefore (?)

Michel Oren and Melvin Edwards (ME) discuss abstraction as a vehicle for change and Smokehouse's position in relation to muralism and figuration.

we were aware. By 1970 I was going to Africa, but before that I was already well aware of it... I was aware of African art by 1955, when I came right out of high school...

MO: What part of Houston?

ME: Fifth Ward, if you know Houston. I grew up in Fifth Ward; my family and me and my relatives are all over Houston but Fifth Ward is our area of history. Murals themselves, given that kind of information, were not new, and there was no reason to follow the Wall of Respect. What they were doing, they were doing. What we were doing, we were doing, that's all. It's like, again if you want to use the real African sense of things, abstraction and realism happen at the same time. I always tell my students there really is no difference, you'll never make art that's as... the only thing real you'll create is when you have a baby. Everything else is abstract, whether it's figurative or not. Those are academic classifications that we need in order to identify one piece of phenomena or another but they don't have anything to do with... If we can conceive and make them manifest that's... so it was a way of putting something else... another vista and way of doing it, because you could it was emphasizing what was being emphasized less, in other words more structural. So if you want to use the Constructivist notion that getting directly to... the direct handling of phenomena in a situation where things had not been handled that directly. You could say it might have been a similar kind of choice, but since we didn't have the resources and scale to extend it as far as we would have, or would now if it were possible. I still work abstractly and geometrically, and the response from our communities has always been positive to my work in that respect, and it was something I maintained all the time. It's just a question of whether you only look to the recent history of painting and sculpture as your basis, or whether you look beyond that.

MO: Yes, effective scale. That is to say, what would be the relation of your work to the people and the houses, the architecture that was already there? How could you be sure, given the vigor and energy of your designs, not to dwarf or overwhelm the people?

GC: We couldn't, we couldn't. The energy... we always got a chuckle out of this: The energy that came out of the neighbourhood was far more massive than anything we could put on the walls. We got the biggest kick out of that. Because no matter what we did, and it wasn't our intentions to overwhelm the neighborhood. Our intentions were to make pieces that fit into the neighborhood. Don't forget this was the era of civil rights, and metaphorically integration of all elements was on our minds, so it wasn't about putting... sticking a monument in the plaza, or as James Wines said, turds in the piazza. It wasn't about that, it was about taking the wall of the building and reflecting it in a painting. By getting a building to turn, to appear to turn in an unnatural way. It was street level interaction.

MO: Why did you want that building to turn?

GC: Well, we were artists, and the visual problems that we took on for ourselves... we were playing with space, it was a dialogue with the environment. If the building goes this way, "Well let's... If we put this here, this angle or this color here, it'll make that wall of the building disappear, or it will make it look like it's going to infinity, or something like that." We were really sharp, we were really on our toes every minute, every second that we were there.

MO: Why should the people who lived there particularily have appreciated these tricks?

GC: I think... you know, it was a black neighborhood, jazz and improvisation, and things that we like to think are indigenous to black culture... became evident in a matter of hours to the people, so they would come by and go, "Wow, look at that wall, look at that color," and then they would move on, and then they would come back, sometimes they would dance... Oh, that's right, boy, you brought back a memory--I remember we were sitting there watching, we were sitting there looking at a wall, I think it was a big orange section to the wall. And I think three kids, three little kids came walking down the street, and they stopped and looked at the wall, and they all just simultaneously broke into this nutty dance, and they did that for a few minutes. We were rolling. And then they just went on their way. So it was that kind of reaction. There's a whole psychology about color can affect people and I guess we exploited that. We never really discussed it... Well, if you paint everything black it will make you feel down, if you paint everything red it will make you feel up, or whatever it is. We never really discussed it but we found the results in the environment.

Michel Oren and Guy Ciarcia (GC) discuss Smokehouse's spatial dynamics and the inherent energy of Harlem. The group's street-level compositions directly engaged residents as they moved through the neighborhood.

GC: You're asking me if we thought we could make the neighborhood a better place for the art, right?

MO: That is, you're really distorting the spatial, the feeling of this neighourhood, you're changing it and did you think... Was that simply art, or did you think that it was actually going to change the way people were thinking about themselves and their environment, by their feeling that they were in a different space from the way they used to be in it?

GC: It was on our minds, we talked about it. We thought of the effect of on some guy walking out of his house, and suddenly being confronted by a wall, let's say, in front of it. Or walking down the street and coming across this angle that wasn't there before. It might jar that person into a different thought--even if it was momentarily, it would have been satisfying for us. I think Bill could probably go into that in greater detail and more articulately than I can. It was a street level art and by that I mean the paintings weren't meant to be looked at frontally. We felt that the effect was best achieved by the pedestrian in motion. In other words you walked past it, and had some kind of uplifting experience.

MO: Was it a kind of anamorphic art?

GC: You got me. I don't know what that word means.

MO: Oh, there are paintings that are made to be looked at sideways, or from a peculiar angle, not frontally—for example, there is a Holbein in which... you know that? the skull...?

GC: "The Two Ambassadors," right?

MO: That's right.

GC: That was part of it. It's funny, the way, the mode that we were working in worked that way automatically. We didn't plan it that way. We didn't... well actually I think we did. I think we did. We would look at something from an angle and, yeah, sure we did, because I remember changing masking tapes, changing the angles of the masking tape. So, yeah that did have a lot to do with it. Boy, I hadn't thought that about.

MO: That meant that your experience of the wall would change as you walked by it.

GC: As you walked by it, exactly.

Of the few existing scholarly references to the Smokehouse Associates, most have been contextualized within broadly anthologized histories of abstract art, the Black Arts Movement, or social histories of Central Harlem.[1] These references only suggest how the group's socially imbricated art visualized a deep and critical relationship between race and placemaking. The spatial character of the sites rejuvenated by Smokehouse, however, provides us with yet another intellectual context to consider: social activism in postwar architectural thought. Taking a strategic interest in the language and concepts of architectural modernism, Black artists often collaborated with architects and interior designers to critique urban renewal, calling out its negative effects on the spatial and economic development of Black neighborhoods.[2] Smokehouse's visual manipulation of modernist spaces should be understood within this context if we are to appreciate the architectural relevance of its approach. Architectural history offers us a unique lens of interpretation, expanding our notion of who ultimately served as authors of public life in the city. Through experimental references to modernist space, Black artists and residents realized the latent potential of many architecturally designed public spaces throughout Harlem. This essay outlines some of the conceptual parallels between Smokehouse's public mission and the socially progressive discourses found in traditional architectural histories, from federally funded public housing projects and architectural utopian schemes to grassroots design advocacy movements.

As the historian and critic Anthony Vidler has noted in his study of architectural utopia, modern architects transitioned from early speculative works that critiqued the function of the built environment to designing literal environments that could shape contemporary urban life.[3] Moving beyond the utopian architect's desire to unilaterally shape public

1. See, for example, Michel Oren's essay "The Smokehouse Painters, 1968–70," *Black American Literature Forum* 24, no. 3 (Autumn 1990): 509–31; and Mark Godfrey and Zoé Whitley, eds., *Soul of a Nation: Art in the Age of Black Power* (London: Tate Publishing; Los Angeles: The Broad, 2017), 56–60.

2. A few noteworthy examples from this period are the Architects' Renewal Committee in Harlem (ARCH), the Real Great Society, and the National Organization of Minority Architects (NOMA), all of which put people of color in conversation with architecture and planning professionals. These and other groups have been profiled in recent exhibitions, such as *Now What?!*, which was curated by Lori Brown, Nina Freedman, and other members of ArchiteXX. A full list can be found at nowwhat-architexx.org/articlesall.

3. See, for example, Anthony Vidler's discussion of Thomas More's "Utopia" in "Mercier as Urbanist: The Utopia of the Real," in *The Scenes of the Street and Other Essays* (New York: Monacelli Press, 2011), 170–74.

space, Smokehouse's formal principles echoed the new social politics of post-Minimalist art, which challenged the self-referentiality of Minimalism through a renewed engagement with the world. William T. Williams, who founded Smokehouse, describes the group's artistic ethos as a belief in the social power of site-based installations, consisting of painted surfaces and sculpted geometric forms, to bring new life to the derelict spaces of Central and Spanish Harlem. According to Williams, "The whole notion of the group is that we were going to make anonymous works of art that were collaborative...where the function of them was to put them up in a community and stimulate something."[4] Abandoned lots and trash-strewn backyards became abstract sculpture gardens and spaces of contemplation. These experiences were not cloistered in a museum, nor were they reflections of the artist's solipsistic gaze; they invited public interaction and interpretation. The temporality of a Smokehouse installation was constituted by a range of ephemeral strategies and techniques for activating urban spaces that resembled the logic of Archigram's Instant City.[Fig 1] Archigram—a name that combines the medium of "architecture" with the temporality of the "telegram"—was a collective of London-based artists founded in the early 1960s intent on redirecting consumerism and military technologies toward restructuring cities disrupted by the violence of war.[5] The Instant City scheme illustrated the radical transformations that might be effected by diverting monies and technologies from destroying the earth toward making it a more viable and interconnected place.

In contrast to Archigram's interest in channeling Space Age technologies to stimulate social life, Smokehouse's employment of painted surfaces and abstract sculptures to inspire on-the-ground social change was far more immediate and pragmatic. Neighborhood volunteers, from

4. William T. Williams and Michel Oren, Michel Oren interviews with artists, 1979–1991, Archives of American Art, Smithsonian Institution, 11.

5. "Its work was part of a larger shift in avant-garde concern in the 1950s and 1960s, from the creation of singular 'works of art' such as paintings and buildings to the exploration of art as a lived medium, as a way of structuring everyday life for all." Simon Sadler, *Architecture Without Architecture* (Cambridge, MA: MIT Press, 2005), 7.

Fig 1. Archigram, Instant City Airship, sequence of effect on an English town, 1969

young children to the elderly, served as on-site consultants and workers—a practice that ensured local buy-in and guaranteed a better alignment between Smokehouse's artistic principles and the social values embodied within everyday milieus. Painting the walls of a derelict space encouraged residents to devise other cooperative practices at the sites such as street fairs and musical performances. In this way, Smokehouse's interventions demonstrated to Harlem residents that even areas burdened by over-policing, chronic underemployment, and invasive urban-renewal projects possessed an inherent capacity for cultural life. Guy Ciarcia even recalls that leftover paint would often find its way into a resident's living room, nearby fire hydrants, or other elements of a site, extending the field condition of the group's interventions to other areas within the city.[6]

As a mural arts group, Smokehouse was innovative for combining its focus on the social with an abstraction often associated with postwar avant-gardes. This synthesis is apparent when one compares their approach to the work produced by peers such as City Walls, Inc. in New York City or the Organization of Black American Culture (OBAC) in Chicago. The figurative approach of the latter group's Wall of Respect was rejected by the members of Smokehouse for its overtly political message. Never ones to employ a didactic approach to art, they believed that abstract art would better amplify the social life of an existing space by extending whatever political impulses were already present locally. This meaning was often manifested through the ways that people in the community decided to incorporate Smokehouse's aesthetic energy into their lives. Similarly, the Smokehouse artists rejected the sublime application of abstraction for its own sake. Williams was critical of City Walls for what he considered the group's use of the city as a blank canvas for the artists' egos.[7]

6. Guy Ciarcia and Michel Oren, Michel Oren interviews with artists, 18.

7. Williams and Oren, Michel Oren interviews with artists, 11.

A monumental City Walls mural completed in 1970 by the artist Tania (Tatiana Lewin) on West Third Street near Mercer Street provides a dramatic contrast to Smokehouse's approach. Stretching nearly thirteen stories high, this project could be seen for miles around as it rose above a busy traffic intersection.[Fig 2] Yet, the mural's elevation above street level meant that no one could directly interact with it, effectively removing it from the pedestrian's experience.

The corridor of painted walls that Smokehouse completed at the corner of East 121st Street and Third Avenue is in distinct contrast to the singular focus of Tania's mural.[Fig 3] In the case of Smokehouse's work, the speed and perspective of the pedestrian governed nearly all major artistic decisions. Rising a mere fifteen feet from the ground, the walls extend the datum of public storefronts in the area, with the bright colors of each wall emulating those found in the shop windows, clothing, and furniture of Harlem residents. Each geometric pattern operates anamorphically, enabling abstract forms to unfold for the viewer as they move through space. Such an approach results in a more intimate placemaking strategy, creating a contained volume of space that compels people to pause, meander, and wonder. Ciarcia notes that derelict lots, often filled with trash or frequented by drug users, were almost immediately transformed by the efforts of the group.[8] Residents learned to reclaim these forgotten spaces, slowing down to take in their surroundings anew as they contemplated the latent potential of their neighborhood.

Superficially, City Walls and Smokehouse shared an ardent commitment to pursuing an abstract modern aesthetic, but a closer reading of the racial politics of public housing in 1960s New York reveals political undercurrents that might otherwise be elided. Public art had become an important element of urban renewal, even as

8. Ciarcia and Oren, Michel Oren interviews with artists, 4.

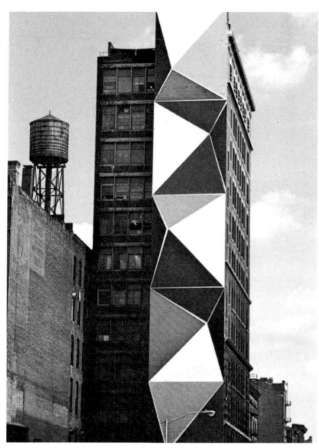

Fig 2. Tania, wall painting at Mercer and 3rd St., New York City, c. 1970.
A project of City Walls, Inc.

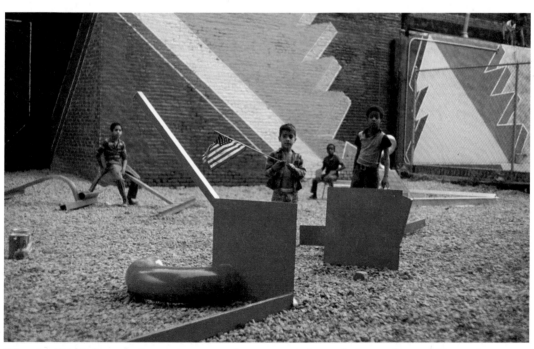

Fig 3. Children play among the completed murals and sculptures,
E. 121st St. between 2nd and 3rd Aves., c. 1969. Artwork created by
Smokehouse Associates

decision makers debated what character such art must have in order to revitalize urban space. During the New Deal years in the 1930s, the New York City Housing Authority (NYCHA) institutionalized the social value of public art by earmarking funds specifically for installing art in federally funded public housing projects.[9] This Progressive Era initiative was meant to reeducate the working class by elevating the level of public taste. An early example of this approach was the Williamsburg Houses, one of the first federally subsidized public housing projects designed and built for the city from the ground up in the late 1930s.[10] The modernist architect William Lescaze campaigned for the installation of abstract murals in the rooms reserved for social functions because he believed they would uplift the spirits of manual laborers, enabling them to think beyond their day jobs. The nonrepresentational aesthetic of modern art—in both the surrounding murals and the architecture—presented abstract imagery to open the mind to new possibilities. Burgoyne Diller, the head of NYCHA's Mural Division, recruited Ilya Bolotowsky and other abstract painters to create murals for these spaces.[Fig 4] The residents of the Williamsburg Houses even participated in a short-lived art-lending program with the Metropolitan Museum of Art that was intended to expose working-class residents to middle-class notions of art collecting and appreciation.[11]

The history of art in public housing as a mechanism for social uplift provides an important backdrop to the racial politics of mural art projects throughout the 1960s and 70s. The public housing murals of the 1930s evolved from the paternalistic ideals of Progressive Era politics, which employed art and architecture as tools for reforming the social mores of the working class. Counter to the prevailing expectation that the uneducated needed to have their aesthetic taste reformed, Smokehouse's murals of the 1960s

9. For a history of the Federal Art Project, see official government tracts such as *Federal Arts Project: A Summary of Activities and Accomplishments* (New York: Works Progress Administration, 1939) and secondary studies, such as Jonathan Harris, *Federal Art and National Culture: The Politics of Identity in New Deal America* (Cambridge, UK: Cambridge University Press, 1995) and Victoria Grieve, *The Federal Art Project and the Creation of Middlebrow Culture* (Urbana: University of Illinois Press, 2009).

10. Nicholas Dagen Bloom, *Public Housing That Worked: New York in the Twentieth Century* (Philadelphia: University of Pennsylvania Press, 2008), 45–76.

11. A report of this practice is indicated in a photocopy of *Projector*, a newsletter created for the Williamsburg Houses, which survives in the LaGuardia and Wagner Archives. Its status is well documented in state reports, such as Williamsburg Houses, Landmarks Preservation Commission, June 24, 2003, Designation List 48, LP-2135, 7.

Fig 4. Ilya Bolotowsky, *Untitled, From the Williamsburg Housing Project Murals*, 1936. Oil on canvas, 85 × 211 in. Brooklyn Museum, on loan from the New York City Housing Authority, L1990.1.1

directly engaged with working-class communities to author works that incorporated elements from their social environments. Smokehouse's approach implicitly critiqued that of City Walls, which supported the unbounded expansion of capital investment in the city, a form of expansion that often undermined the role of local residents in placemaking strategies. It was the unequal access to art, first cloistered in the museum and then propagating in the wealthiest spaces of the city, that inspired the Smokehouse artists to commit themselves to amplifying and elevating life in Harlem, an often overlooked neighborhood. Here, art could be used to inspire all.

Each Smokehouse project began with a meeting between the Associates and a community representative, whether a member of a local block club or an elected or appointed representative of Harlem. Williams's description of their artistic practice echoes a participant-led process, now commonly taught in architecture schools, that engages in community design. Generally termed public-interest design, these approaches use community charrettes to crystallize the needs and wants of an entity as diverse as a neighborhood.[12] After hosting preliminary meetings with constituents to determine the existing agendas of each institution, the Smokehouse Associates would then prepare a series of visualizations consisting of site photographs, which the artists overlaid with painted designs. Once a commission was officially established and a preliminary budget was set, the group would descend on the site to produce "blueprints" for the work.[13] Created individually, these blueprints were combined on-site as the work progressed. What is so astonishing about this process, already more collaborative than many architectural utopian schemes of the period, was that Smokehouse found a principled way of collaborating with the broader public outside of the official channels cited above.

12. A good example is Rural Studio. See Andrea Oppenheimer Dean and Timothy Hursley, *Rural Studio: Samuel Mockbee and an Architecture of Decency* (New York: Princeton Architectural Press, 2002), 154–62.

13. Williams and Oren, Michel Oren interviews with artists, 18.

The public spirit of Smokehouse lies in the expand-able nature of its design process—from consulting directly with architects, musicians, and graphic designers to inviting local residents to paint the patterns laid out on the blueprints. This communal involvement corresponds to the collective nature of the contemporaneous civil rights movement: it took an entire community to create, embrace, and expand the aesthetic vision of a Smokehouse installation. Each project operated as a series of prompts that solicited further collective action.

The fact that Smokehouse pioneered a participant-led community design practice in the 1960s positions the group as a historical parallel to Paul Davidoff's theory of advocacy planning of the same period.[14] Davidoff, a planner by trade, first began to address the challenges of commu-nity representation with his professional work at Columbia University in the 1940s and 50s. He advo-cated for the creation of publicly oriented planning organizations that would operate as professional advocates on behalf of community members who lacked social ties to decision makers in the city. In the organizations that followed this model, such as the Architects' Renewal Committee in Harlem (ARCH), advocacy planning groups would often go so far as to create alternative design proposals to combat the potentially negative impact of an impending urban-renewal plan.[15] These socially conscious design groups combined the expertise of innovative planners and architects, such as the planner C. Richard Hatch and the African American architect J. Max Bond Jr., who were consecutive leaders of ARCH. The field of advocacy planning established a precedent of the artist as an agent of social change, subverting the traditional expectations of technocratic expertise. No longer segregated in official institutional spaces and lobbied by private market interests, artists were free to build bridges between the multiple con-stituents of an urban community.

14. Paul Davidoff, "Advocacy and Pluralism in Planning," *Journal of the American Institute of Planners* 31, no. 4 (1965): 331–38. This process was new because it sent the architect to work in the field with low-income clients, sometimes opening offices in neighborhoods for more direct access. During the 1960s and early 1970s, this contributed to a long-term relationship between architect and client, with multiple jobs instead of a one-time interaction.

15. For a brief history of the group, see Brian D. Goldstein, *The Roots of Urban Renaissance: Gentrification and the Struggle over Harlem* (Cambridge, MA: Harvard University Press, 2017), 16–19.

A more complete historiography of postwar urbanism will require architectural historians to mine the work of artists of color who employed the conceptual tools of architectural modernism to reform the built environment. Disciplinary histories of Eurocentric avant-gardes restrict our gaze to the work of architects alone. Yet, this can be overturned by looking to other modernist approaches to urban space, including Smokehouse's socially activated installations, the architextual writings and poetry of June Jordan,[16] and Amiri Baraka's architectural plans for Kawaida Towers in Newark, New Jersey.[17] Such an interdisciplinary history would better outline the social life of abstraction that is sorely missing from our current surveys of the architectural past. Instead of isolating the disciplinary histories of art, architecture, and urban planning from one another, combining them under the rubric of social projects undertaken by Black people would clarify the extent to which they are unified by social activism. It would also recover contributions often dismissed because they lack discipline-specific credentials that have little bearing on the work itself.[18] Documenting the critical importance of the Smokehouse Associates in shaping urban space not only reforms our understanding of history but may provide useful models for future spatial practices driven by residents themselves.

16. June Jordan's collaboration with the utopian architect Buckminster Fuller is detailed in Cheryl Fish's essay "Place, Emotion, and Environmental Justice in Harlem, June Jordan and Buckminster Fuller's 1965 'Architextual' Collaboration," *Discourse* 29, no. 2/3 (Spring and Fall 2007): 330–45.

17. For Kawaida Towers, a modernist housing complex meant to visualize the racial politics of Black Power, see Komozi Woodard's *A Nation within a Nation: Amiri Baraka (LeRoi Jones) and Black Power Politics* (Chapel Hill: University of North Carolina Press, 1999), 216–54.

18. See Alexis Pauline Gumbs, "June Jordan and a Black Feminist Poetics of Architecture," *Neo-Griot*, March 21, 2012, kalamu.com/neogriot/2013/09/22/culture-june-jordan-and-a-black-feminist-poetics-of-architecture/.

"Don't wait for approval from your neighbor;
 because your neighbor might be waiting for you."

—Sly Stone, Harlem Cultural Festival, 1969

Many a kid who came of age in New York City between the late 1960s through the 1970s knows them. The outdoor paintings—eye-popping abstract murals featuring hard-edged or optically oscillating geometries—spoke not through words, but through color, shape, line, and repetition. They seemed to have always been baked into the textures of the city's walls and surfaces. For grown-ups, they spelled out the expanding vocabulary of a new age, a spectrum of visual and spatial shifts in the metropolis including the mind-bending supergraphics of new subway stations, boutique windows, and corporate lobbies, and the playful countercultural signage and street furniture that was turning New York from postindustrial sepia to Information Age Technicolor.

Exposed by demolished and burnt-out structures sheared off by new expedient avenues and cut-and-cover subway lines, party walls awaited new infill construction that never happened. The gap-toothed topography of New York's building stock and its patchwork of walls was suddenly not consigned to a quotidian invisibility. A new generation was taking notice of these surfaces. They were artists first and foremost. But they were aided and abetted by a growing creative and activist insurgency of designers, architects, urban planners, social reformers, and visionary cultural organizations intent on reimagining a democratized urban landscape.

Smoke Rising

On August 13, 1968, the activities of the Smokehouse Associates officially entered the public record. A press release and dedication ceremony via the Parks Department declared that the collective (identified as only William T. Williams at the time, who had mentored youth from the Inner-City Workshop Program) had been spending the summer painting abstract geometric murals

in sites around Harlem, and the two murals at Sylvan Place on 120th Street were cited (see p. 48). The announcement also described the collective's transformation of a "number of walls" within the preexisting but relatively new vest-pocket park on nearby 123rd Street between Lexington and Third Avenues. August Heckscher, then Parks Commissioner under the reformist mayor John V. Lindsay, was quoted as saying, "The creation of neighborhood landmarks by contemporary New York artists who use the images and materials of our time opens up exciting opportunities for transforming our city." Ironically, the press release, titled "First Outdoor Mural by Contemporary New York Artist to Be Presented," centered not the Smokehouse murals completed months earlier, but a gigantic mural (measuring seventy-five by eighty-six feet) by the artist Robert Wiegand from the group City Walls, Inc. at Astor Place.[1]

The smaller Smokehouse murals, tucked away in urban corners and making bold insertions into the Harlem neighborhood, were arguably the first supported by the City. But unlike Wiegand's work, they received no dedication plaque or official ceremony attended by the press and city leaders. Smokehouse's walls were already in use, a part of the environment for kids playing games and elderly residents relaxing in the pocket parks transformed by the collective. Aesthetically, if not in scale, Smokehouse's imagery was not dissimilar to Wiegand's. Both featured hard-edged abstractions with colorful zigzag forms that activated previously drab environments. Yet the two groups were foundationally distinct. While City Walls was concerned with altering the visual fabric of the urban environment on a grand scale to improve the quality of urban life, Smokehouse was intently focused on fostering community involvement and collective creation. However, as with most things in New York, location—and real estate, funding, and who was in the limelight—was everything.

1. "First Outdoor Mural by Contemporary New York Artist to Be Presented," press release, Department of Parks, City of New York, August 13, 1968. Wiegand was closely associated with a group of like-minded downtown artists (among them Allan D'Arcangelo, Jason Crum, Tania [Tatiana Lewin], Forrest Myers, Mel Pekarsky, Nassos Daphnis, and Todd Williams), who were eager to expand their work into the city's physical environment. Through their individual and collective actions starting in 1967, they would soon come to be known as the public art collective City Walls, Inc., which incorporated as a nonprofit in 1969.

The Museum of Modern Art, quick to take the cultural pulse of the city, in April 1969 mounted *Paintings for City Walls*, a small exhibition featuring illuminated transparencies and photographs of nine completed projects by the group. The show, by choice or happenstance, was a purely City Walls affair, making no mention of the contemporaneous activities of Smokehouse. One year later, in May 1970, the Jewish Museum corrected this omission with the exhibition *Using Walls (Outdoors)*, which broadened the perspectival scope and multicultural understanding of large-scale, abstract mural making in the city. In the exhibition catalogue, the art critic Dore Ashton identified the Smokehouse Associates and City Walls as the key players in the new public art movement. A photograph showing Smokehouse's designs for three rectangular forms mirroring three shattered tenement windows above was given pride of place on the catalogue's cover (see p. 49).

Super (Berg's) Market

In the summer of 1969 on a commercial stretch of East 121st Street in Harlem, the owner of the local grocery store Super Berg's Market stopped Williams on the street. The Smokehouse artists had become recognizable fixtures in the neighborhood. In just one year since their first murals had appeared, local residents had embraced the collective's colorful, energetic presence. By Williams's account, the owner was eager not only to boost business and draw attention to his storefront, but to participate in what was taking place around him.[2] Just a few streets away at Mount Morris Park (also known as Marcus Garvey Park), the sounds coming from the Harlem Cultural Festival vibrated and echoed down adjacent blocks. Musicians including Sly and the Family Stone, Nina Simone, Stevie Wonder, and Mahalia Jackson were bringing Harlemites out and together—not simply to be

2. This and other accounts in this essay are based on the author's conversations with William T. Williams on September 27, 2019, and July 21, 2021.

entertained, but to see themselves and to experience the possibility of true joy in less than joyful times. The phrases "Black Power" and "Black Is Beautiful" were finding a new creative flowering that summer. Smokehouse was a part of this kaleidoscopic energy, a newfound agency animated by a positive and resourceful spirit.

The glass storefront at Berg's did not have enough surface area for Smokehouse to contemplate a full-scale mural, but the collective was not deterred. The artists painted a mural beginning at the top of the store's facade, running perpendicular above the one-story shop. A triangular hard-edged form became part of the architecture as it receded over the tar roof, subtly visible to passersby attuned to the growing vibrancy of the street.[Fig 1] The collective also painted a bright orange, blue, and fuchsia mural next door to Berg's at street level, amplifying the optical effects they created above and below, and leading the eye from one to the other.

So it was that 121st Street became the de facto Smokehouse main street. Several other murals populated the area nearby and as far north as 135th Street, but 121st could be thought of as Smokehouse's incubator.[3] There the artists completed at least ten distinct walls, including a minipark filled with brightly painted steel sculptures in the style of Melvin Edwards's own abstractions, arranged like heavy board-game pieces over a field of gravel. Neighborhood kids fell in love with the space, occupying and laying claim to it as they played among the sculptures, visibly delighting in its pure sensory joy.

Playing the City

Of course, the practice of wall painting was not new to New York City. For well over a century, its mercantile class had seen the commercial potential of the city's ever-changing inventory

3. In 1968 Williams was also commissioned by the landscape architect M. Paul Friedberg to create a series of large, square, enameled-steel panels for a new, ambitious playground and recreation space at Gottesman Plaza on West 94th Street between Columbus and Amsterdam Avenues. Installed and integrated into rectilinear, gridded climbing structures, the panels shared Smokehouse's colorful abstract vocabulary.

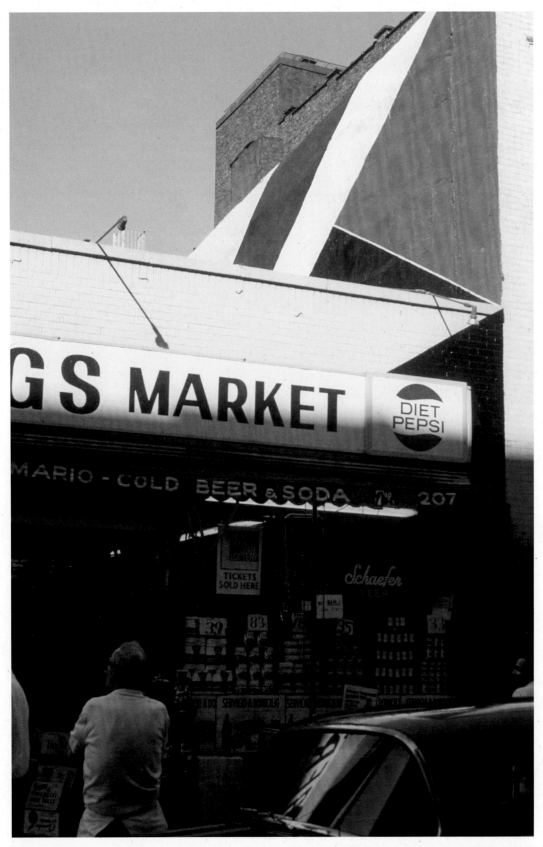

Fig 1. A mural cascades down the front of Super Berg's Market, E. 121st St. between 2nd and 3rd Aves., c. 1969. Artwork created by Smokehouse Associates

of vacant wall space as prime real estate for advertising its abundant wares. Ads for everything from sewing machines to eyeglasses called out to passersby from high above the streets. These were not billboards or paintings executed on canvas affixed to buildings. They were produced on the buildings themselves, painted images and words intended to be instantly read and internalized from afar and below, created by a confraternity of gifted artisans who knew how to capture the distracted urban eye. It was an art form perfected in the unique verticality and constant reshuffling of available surfaces of the built environment.

By the 1960s, the muscular city of commerce and manufacturing was dying. A different city with unknown futures remained. Staggering out of the Industrial Age, the city experienced the loss of working-class jobs and the phenomenon of white flight to the suburbs. In battle-hardened, neglected neighborhoods populated overwhelmingly by people of color, striving communities struggled as the fabric of social networks and family life frayed amid falling tax revenues and declining city services.

As the City's first Director of Cultural Affairs during the Lindsay administration, Doris Freedman was a fierce early advocate for public art in New York. A champion of emergent contemporary art practices in the 1960s, she integrated experimental art into the public realm, organizing the exhibition *Sculpture in the Environment* in October 1967. This groundbreaking, citywide show brought modernist and Minimalist sculpture, kinetic art, Happenings, and conceptual performances by twenty-four artists onto the city's streets, where citizens could interact with and respond to art in their daily lives. Such a thing had never been attempted, let alone under the auspices of a City agency. It upended forever the idea of what art could do when removed from the "restrictive walls of museums and galleries," in the words

of the Smokehouse artists a few years later.[4] Freedman, who went on to head City Walls and later the Public Art Fund, was a strong supporter of Smokehouse from the start, connecting the group to potential funders and advising on New York City affairs.

Freedman credited the efforts and vision of the pioneering urban landscape architect and radical playground designer M. Paul Friedberg with bringing contemporary art and artists into the urban design process.[5] As early as 1965, a young, idealistic Friedberg envisioned modern public spaces in the city as multiuse and multigenerational democratic spaces where art, play, and relaxation could coexist. He first demonstrated this concept when he transformed two vacant lots in Bedford-Stuyvesant into vibrant vest-pocket playgrounds in 1965 and 1966. Friedberg insisted that artists be a part of the overall process. His colleague, the urban planner Ronald Shiffman from the Pratt Institute's new Center for Community and Environmental Development, suggested engaging fine art and graphic design students to design and execute murals, and to work with local kids to paint them on the surrounding walls.[6] The resulting abstract murals—a crucial component of the shared public spaces that formed a Gesamtkunstwerk along Quincy Street—incubated a visual landscape that would sweep over the city in the coming years.Fig 2, 3 Abstract geometries had become a dominant component in the nonverbal, pictorial universe of modern play. Now artists and designers were finding ways to extend that language beyond functional rules and boundaries to the visual expression of freedom itself.

Williams was in his final undergraduate year at Pratt during this time. Inspired by the pivotal work of the Abstract Expressionist Hans Hofmann and the geometrically patterned quilts produced by the women in his family from rural North Carolina, he committed himself to the language of abstraction,

4. "Smokehouse Associates," in *Using Walls (Outdoors)* (New York: Jewish Museum, 1970), unpag.

5. Doris Freedman, "Notes for Book," 1967, *Public Art Fund Archive*, Series IV, Subseries A, Box 22, Folder 14, Fales Library, New York University.

6. Residents of neglected neighborhoods such as Harlem, Central Brooklyn, and the Lower East Side were fed up with economic disinvestment, bleak streets, and declining social services. In 1965 Bed-Stuy leaders and activists including Shirley Chisholm and Elsie Richardson, together with members of the Central Brooklyn Coordinating Council, were agitating for the creation of parks and playgrounds in what was then commonly termed the "largest Black ghetto in the United States." Soon Richardson and others were working closely with Shiffman, who saw new urban design as an extension of the struggle for social and racial equality, and sought to form results-oriented alliances between the creative design expertise of Pratt and the grassroots political activism of the surrounding local community. It was Shiffman who enlisted Friedberg, then teaching at Pratt's School of Architecture, in these pilot projects.

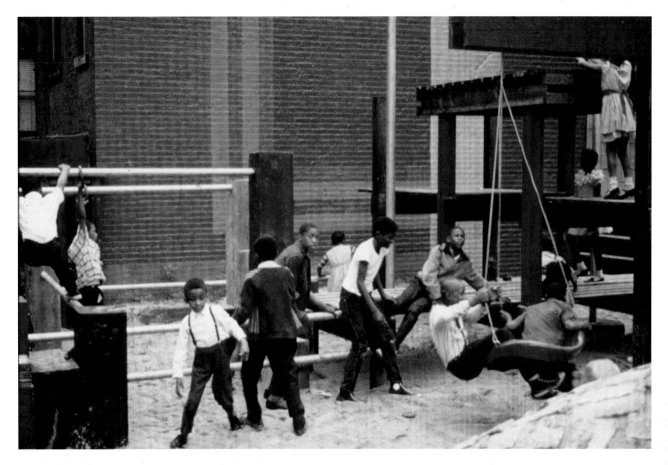

Fig 2, 3. Bedford-Stuyvesant vest-pocket park, Leffert's Place, between Franklin and Classon Aves., Brooklyn. Murals by students from Pratt Institute visual art and graphic design programs together with neighborhood youth, c. 1966

a freeing, fluid form of expression that could function in the environment. The Bed-Stuy pocket parks and their murals fed the confluence of grassroots public engagement and open-air abstract placemaking in ways that would resonate with Williams's practice in the years immediately following. The possibilities of early experiments such as the Quincy Street murals exploded in Smokehouse's Harlem projects. What had been initially tentative initiatives involving the local community at Pratt became robust on-the-job workshops and lessons in collaborative art making in the hands of the Smokehouse artists, who consulted with local residents, block associations, business owners, and youth groups on every project.

The Eye of the Beholder

In a blistering piece in the *New York Times* on September 16, 1972, the conservative art critic John Canaday complained that City Walls should change its name to "City Eyesores."[7] Just a year earlier, the critic had taken potshots at the urban public art movement for its "blatantly obstreperous violations of the elementary principles of mural design, scaled and patterned to overpower or obliterate their surroundings rather than to pull them into some kind of harmony."[8] He mocked outdoor works as no better than the faded advertisements of the early twentieth century that they were replacing. Many in the art world establishment, and even some among the avant-garde, broadly dismissed what City Walls, Smokehouse, and their ilk were creating as misguided "do-gooderism" at best, and populist, decorative, and naive at worst. Emily Genauer, the art-beat reporter for *Newsday*, declared that "any more diagonal bars in red, blue, yellow, green, and white running high as a building's roof" should be banned.[9] Deeply skeptical that positive, real-world changes could

7. John Canaday, "'Dutch Genre Drawings' at the Morgan," *New York Times*, September 16, 1972.

8. John Canaday, "A Mighty Big Hair of the Dog," *New York Times*, September 12, 1971.

9. Emily Genauer, "On the Arts: Lithography Lives in Hard-Edge Era," *Newsday*, May 3, 1969.

ever result from such projects, Genauer, writing about City Walls, rhetorically asked: "Will alienated ghetto kids now identify with their communities because they can play basketball in a vest-pocket park against a background of chevron stripes by a young hard-edge painter?"[10]

Genauer's throwaway line about the meaninglessness of "ghetto kids" playing basketball against an optically dynamic background of chevron stripes actually referred to a work by Smokehouse, not City Walls. It was from the suite of works, executed with modest support from the City, that was noted in the above-mentioned Parks Department press release of August 1968: the 123rd Street vest-pocket park, a through-block series of outdoor "rooms" for play and repose set off by the prismatic swoosh of a gravity-defying angular rainbow. Genauer probably got her information by scanning *Street Art/N.Y.: A Photo Essay*, a booklet published in 1968 by the Parks Department (see p. 47). With photographs by street photographers such as Katrina Thomas, the booklet documented a summer in the city aimed at empowering local communities by decentralizing culture and bringing art onto the streets.

In a spring–summer that had begun with the assassinations of Martin Luther King Jr. and Robert F. Kennedy, and ended with the brutal police riots at the Chicago Democratic Convention in late August, the fruits of Smokehouse's initiatives were anything but superficial palliatives. The city's progressive cultural street programs were attempting to hand power, responsibility, and autonomy over to local cultural producers and artists in residence across the city. Genauer's reading of the spread in *Street Art/N.Y.* showing kids playing in a space activated by Smokehouse's jump-shot geometries ignored the large epigraph on the page quoting Williams: "The community is the core that we start with, for they will be living with our works when we leave."[11]

10. Emily Genauer, "On the Arts: Planning Culture in the Parks." *Newsday*, September 7, 1968.

11. William T. Williams, quoted in *Street Art/N.Y.: A Photo Essay* (New York: Parks, Recreation and Cultural Affairs Administration, 1968), unpag (see p. 47).

Elsewhere in the booklet, the East Harlem street theater and performing arts director Enrique Vargas is quoted as saying: "The people around you are a chorus. You must perform with them rather than at them." The same could have been said for Smokehouse's core philosophy. The group's color choices and geometries, the art itself, was transitory. Paint on bricks was not an end; it was the start of an exchange. It was about people's everyday lives and the spaces they inhabited. It was art rooted in their spirits. As with the eclectic and magical celebration happening among the throngs at the Harlem Cultural Festival, it was about human bodies in motion and in relation to one another passing through city space, ennobled, uplifted, and part of a larger family. The Smokehouse Associates gave the community something beautiful: the rare opportunity to see themselves in all their fullness and grace.

Photographic Documentation

83–89 E. 123rd St. and Lexington Ave.
90–99 Sylvan Place (E. 120th St. between Lexington and 3rd Aves.)
100–101 E. 121st St. between 2nd and 3rd Aves.
102–08 NE corner of E. 121st St. and 3rd Ave.
109–13 Super Berg's Market (E. 121st St. between 2nd and 3rd Aves.)
114–17 E. 135th St. and Lenox Ave.
118–20 NW corner of E. 121st St. and 3rd Ave.
121–76 Minipark off E. 121st St. (between 2nd and 3rd Aves.)

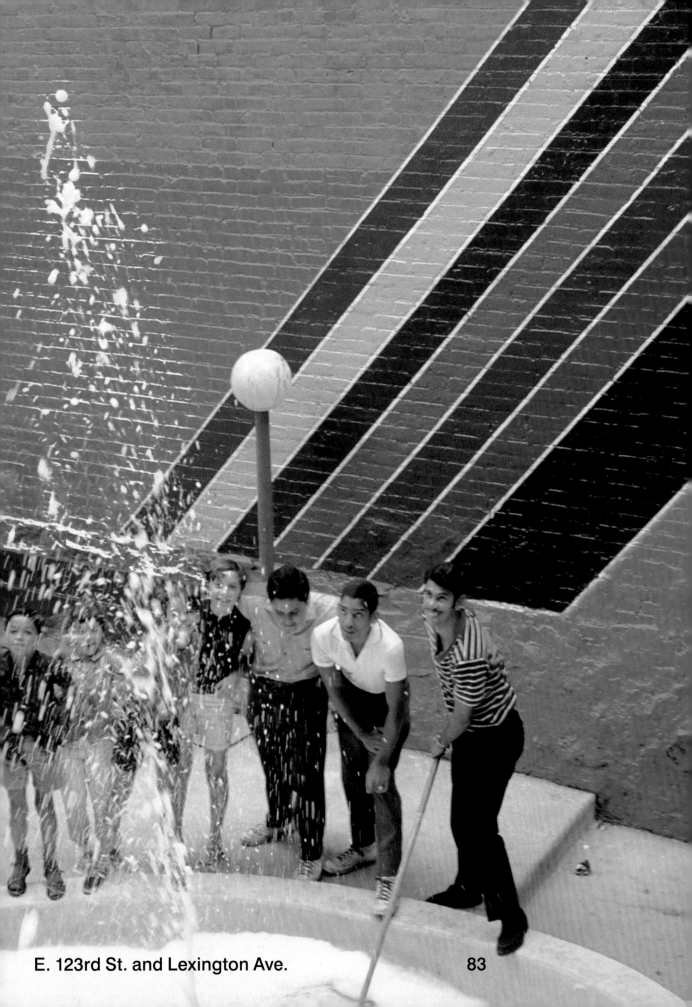

E. 123rd St. and Lexington Ave. 83

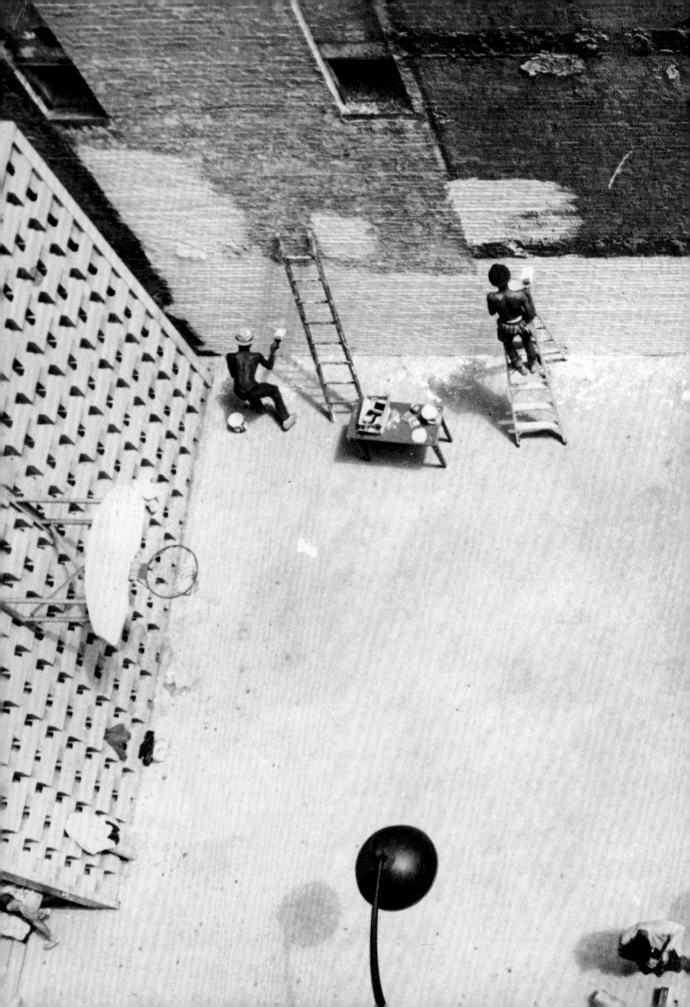

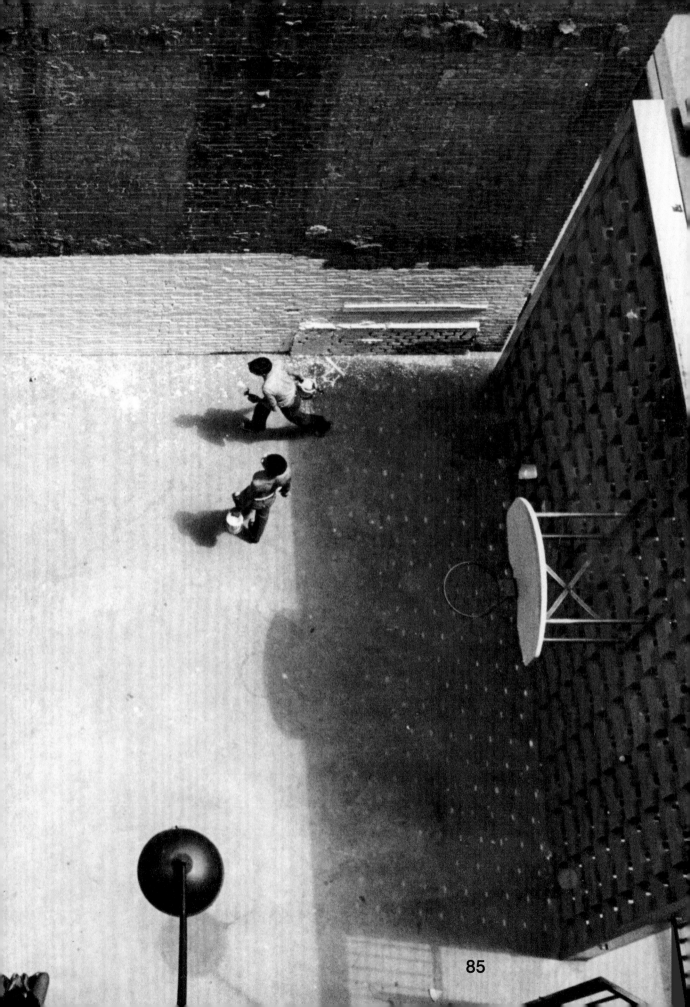

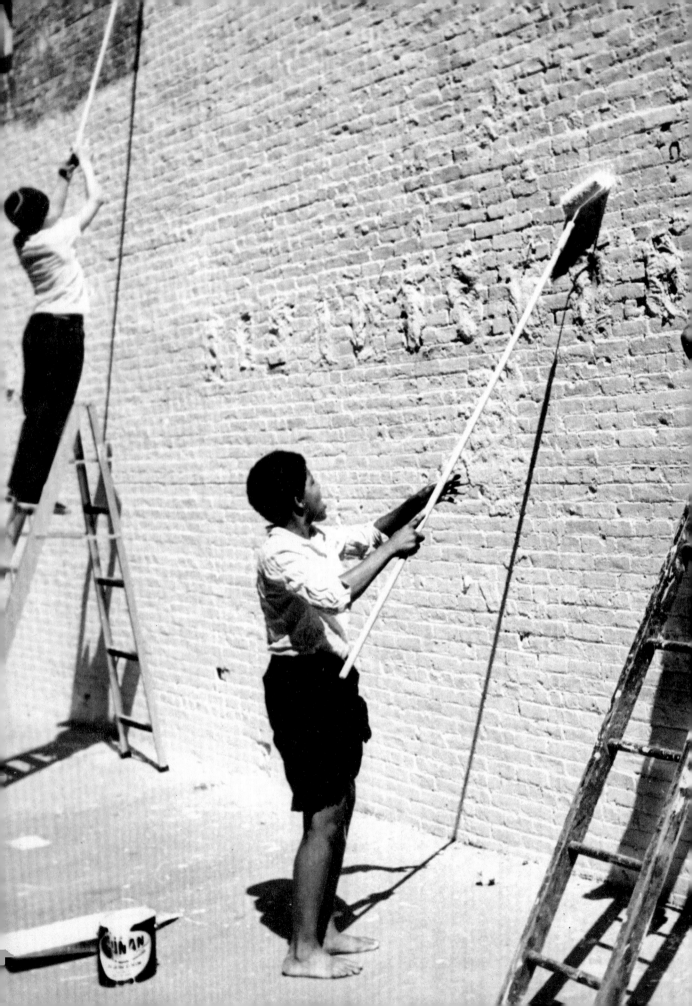

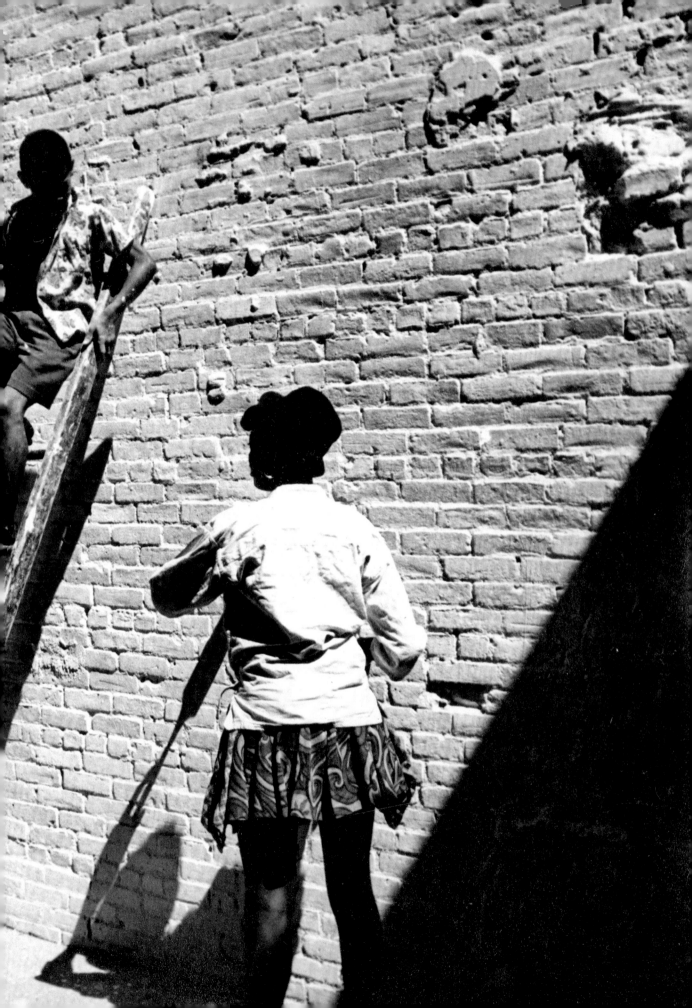

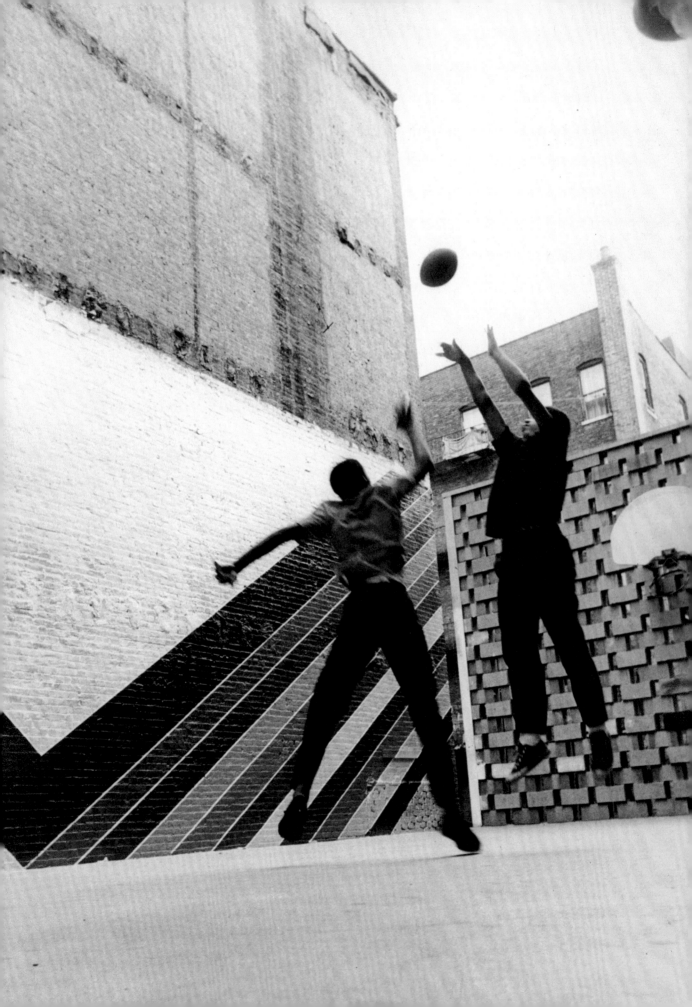

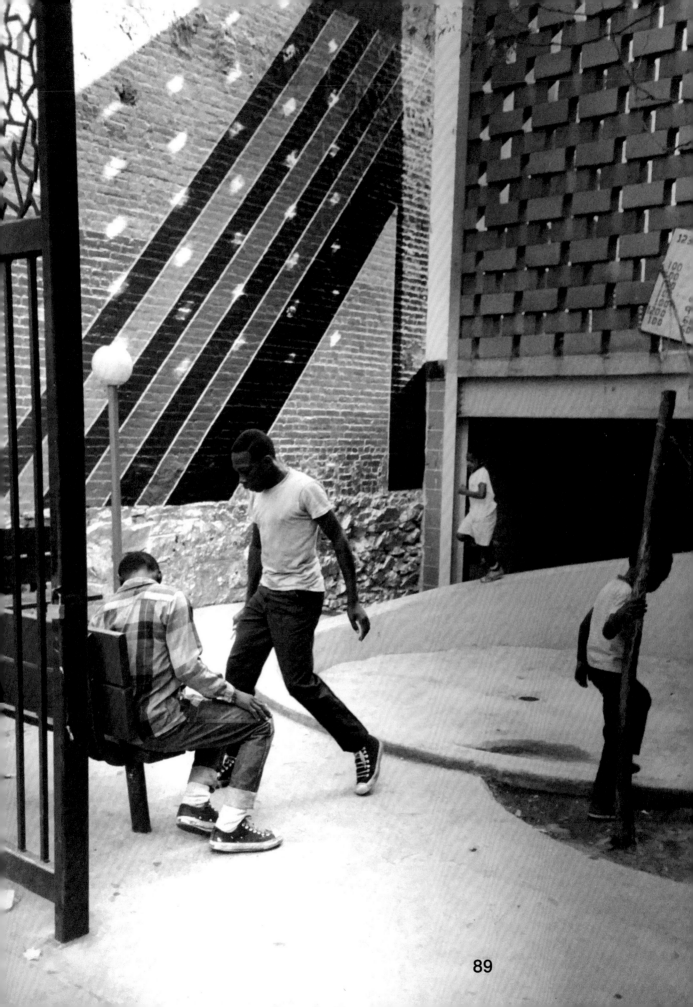

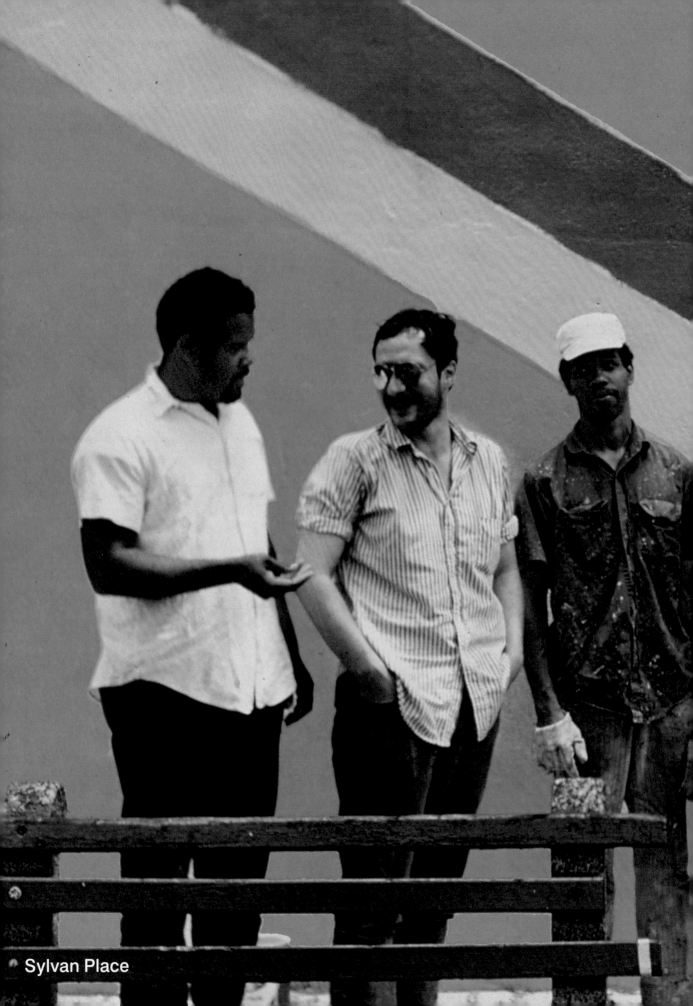

Sylvan Place

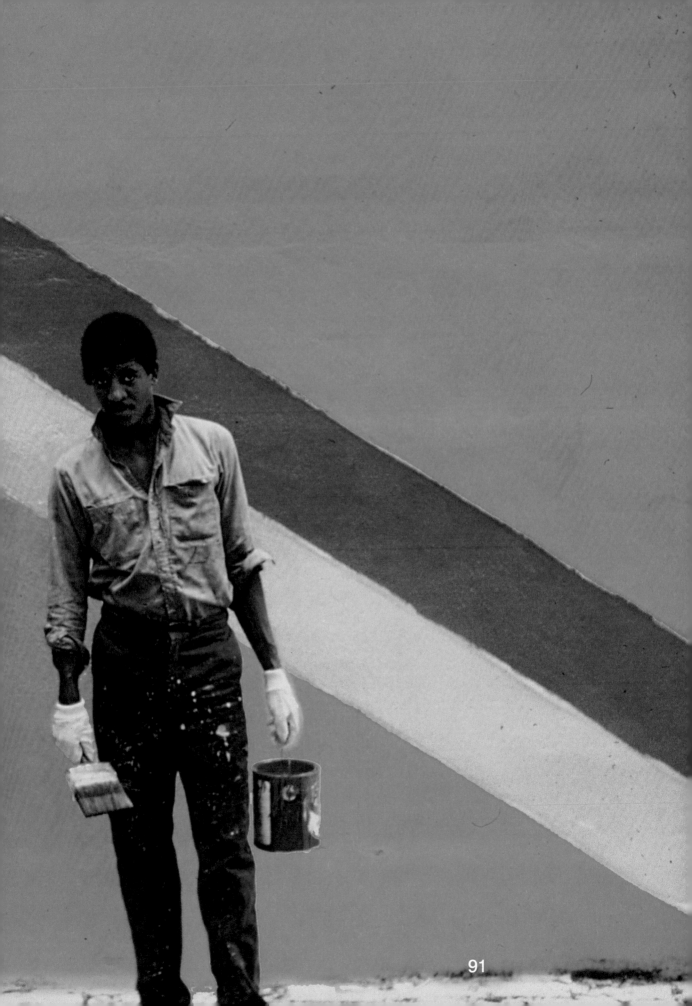

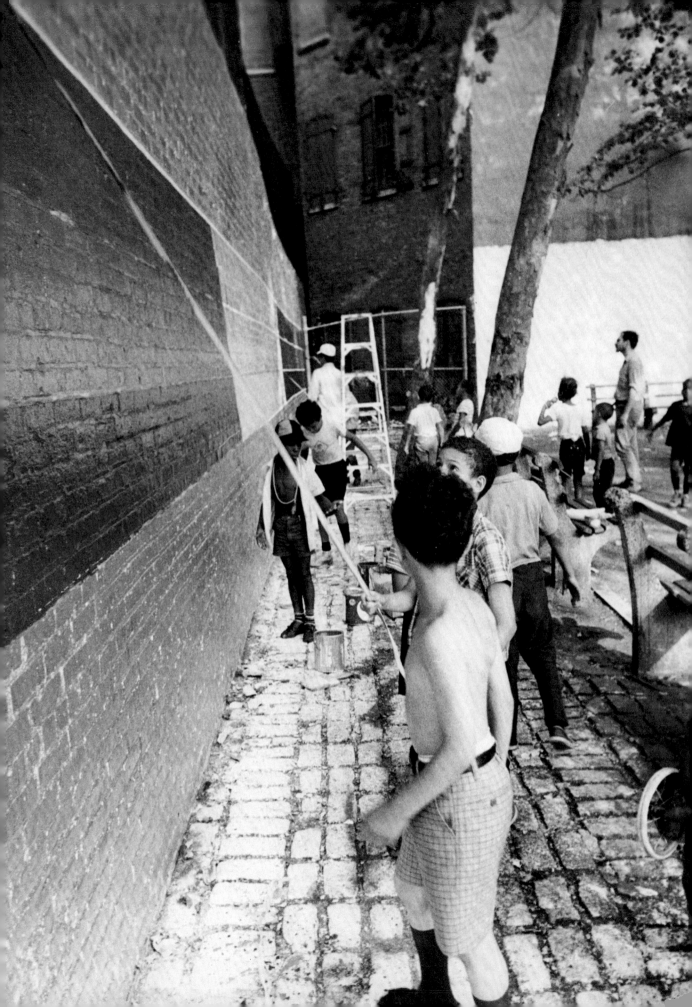

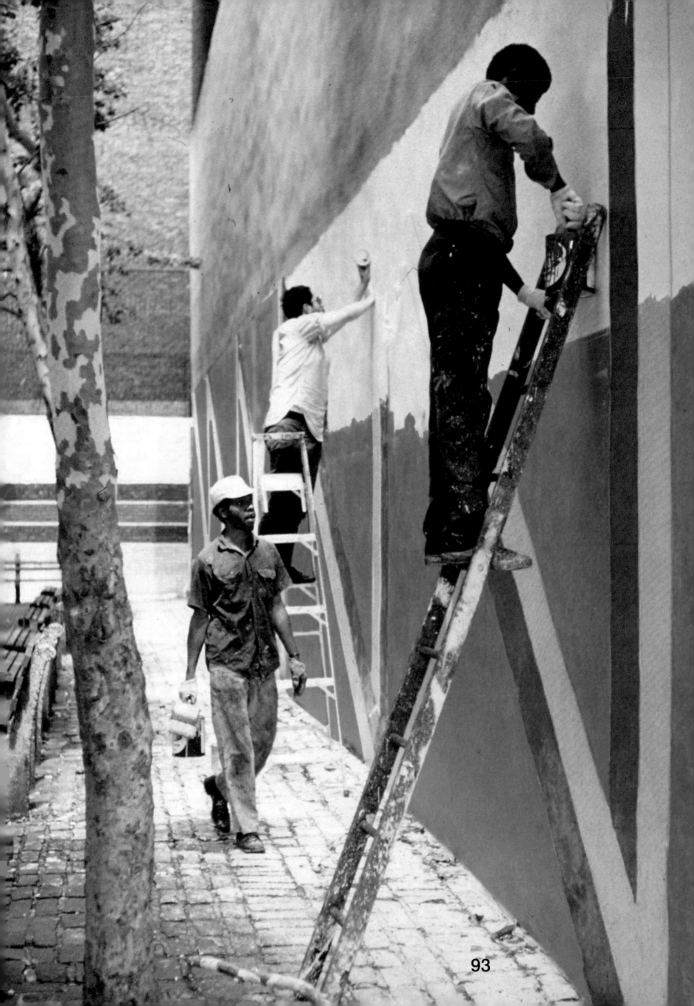

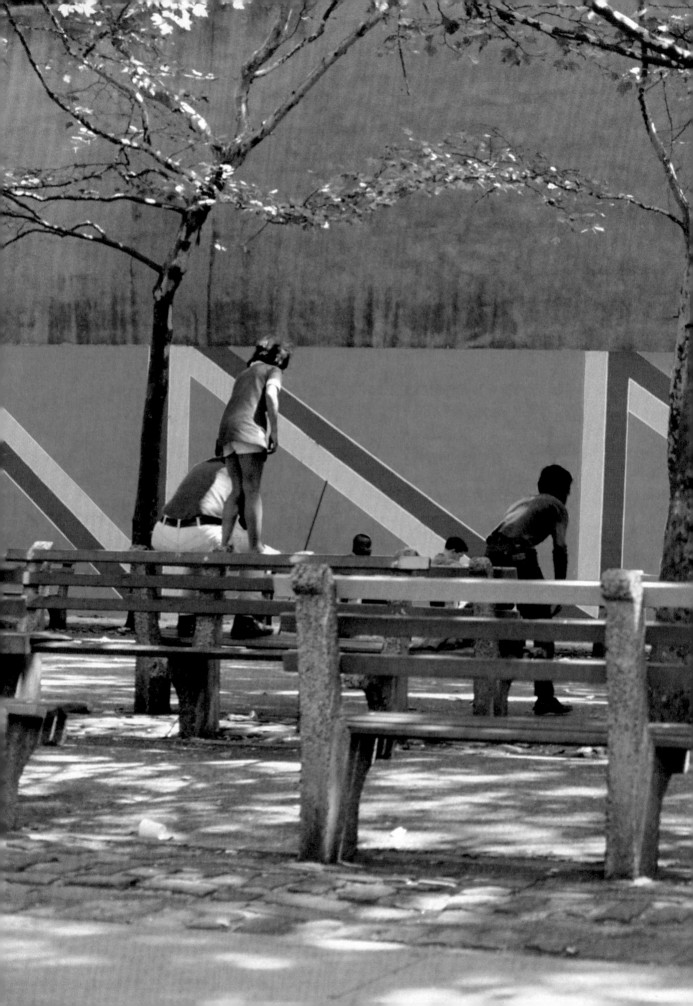

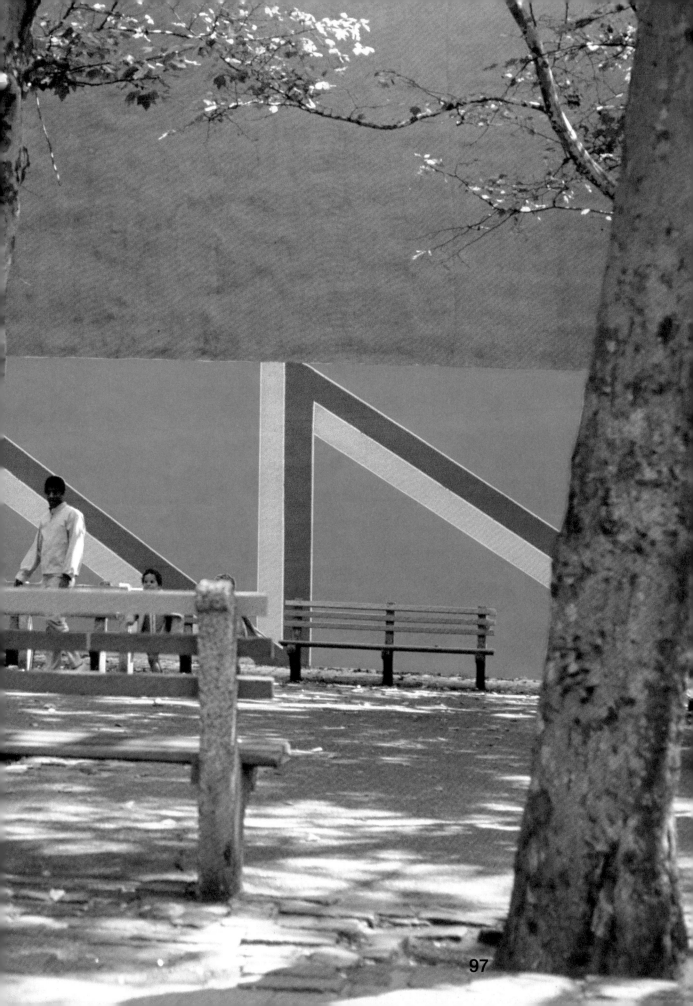

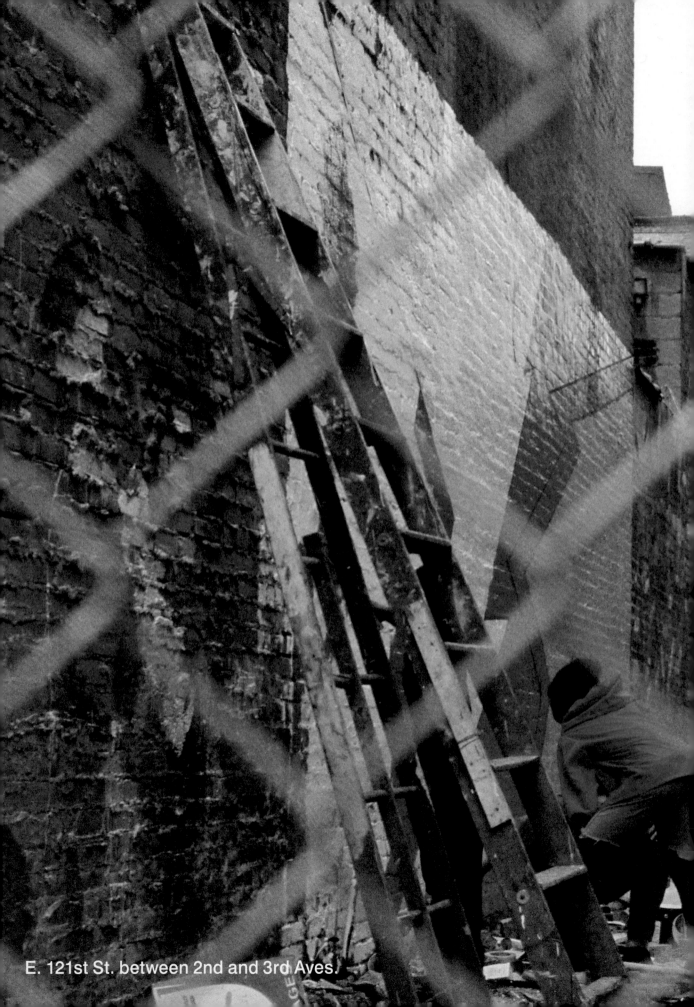

E. 121st St. between 2nd and 3rd Aves.

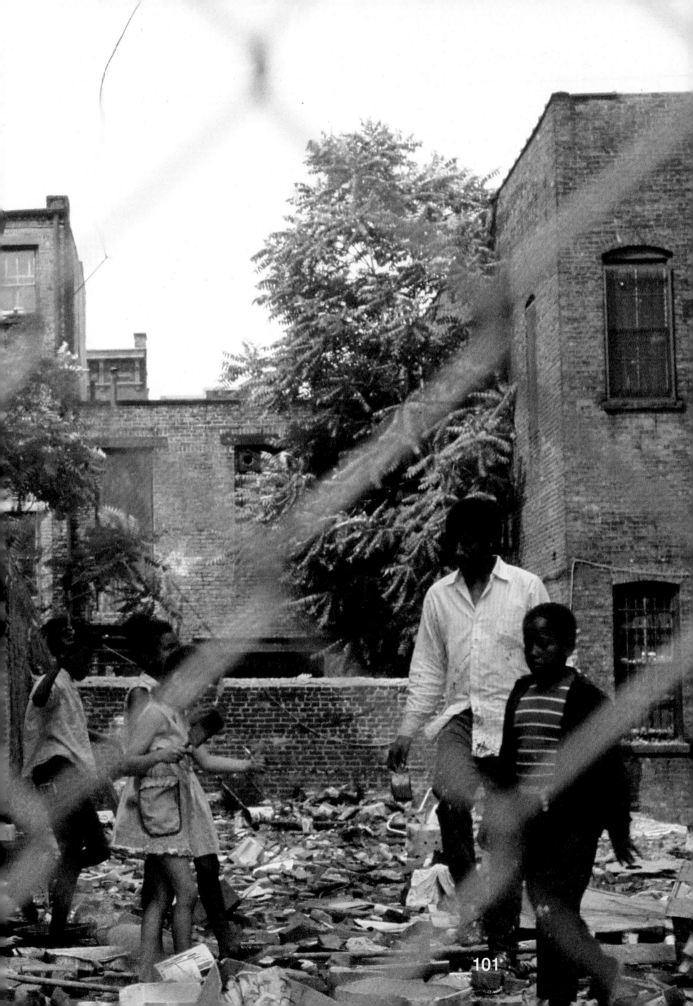

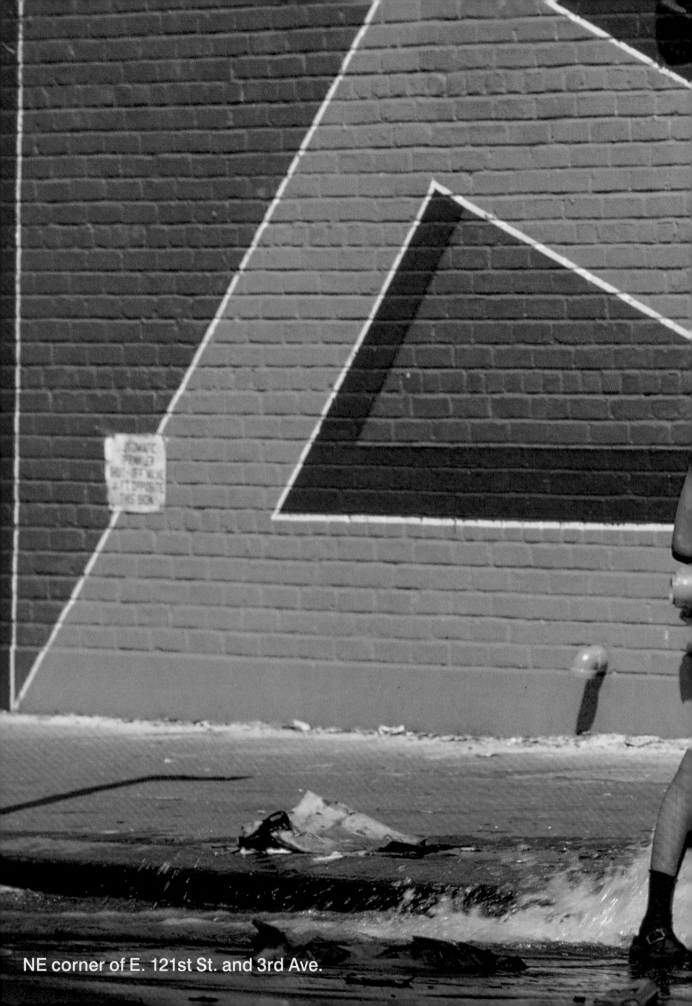

NE corner of E. 121st St. and 3rd Ave.

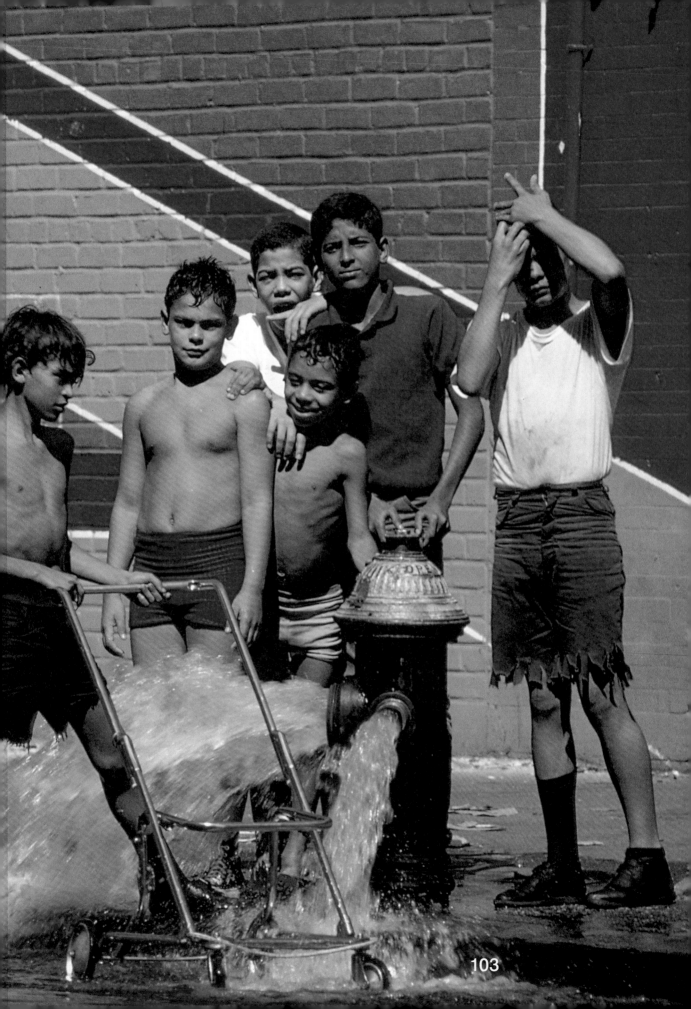

103

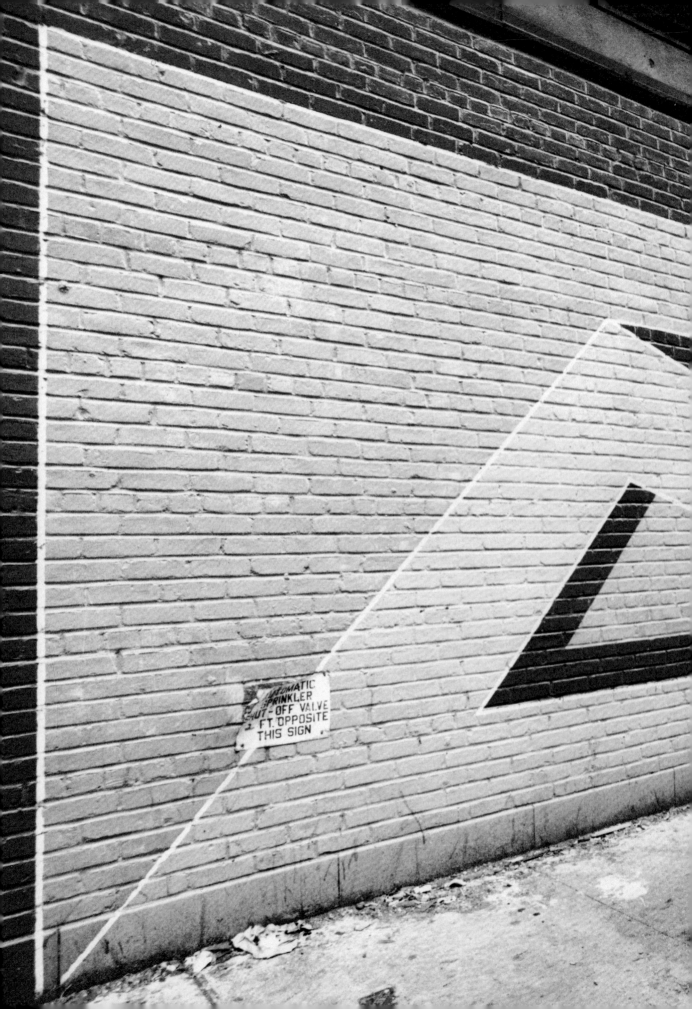

AUTOMATIC
SPRINKLER
SHUT-OFF VALVE
FT. OPPOSITE
THIS SIGN

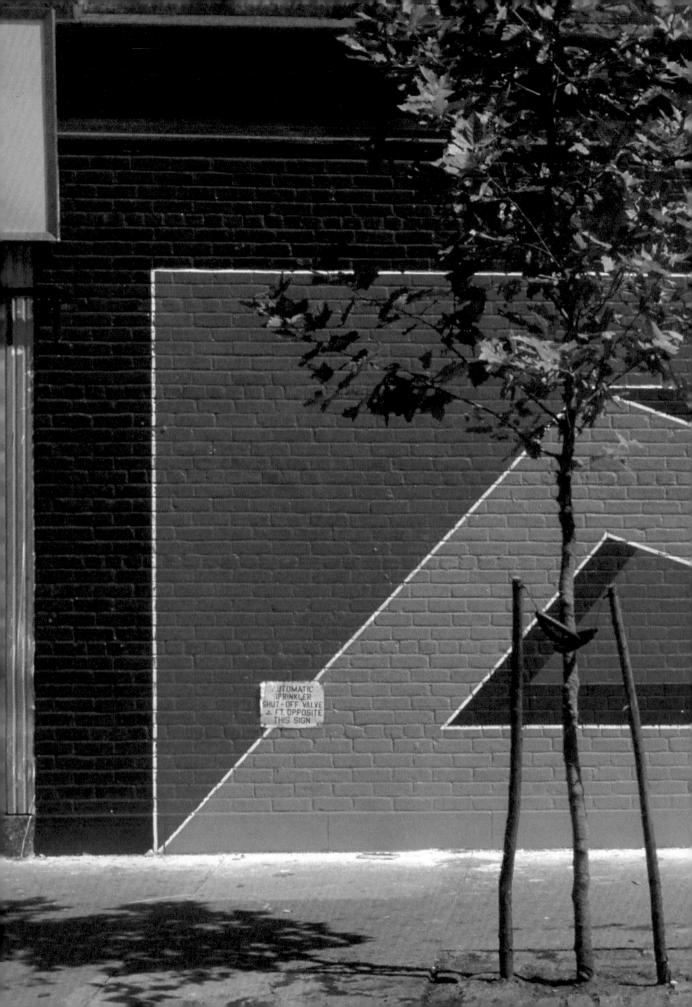

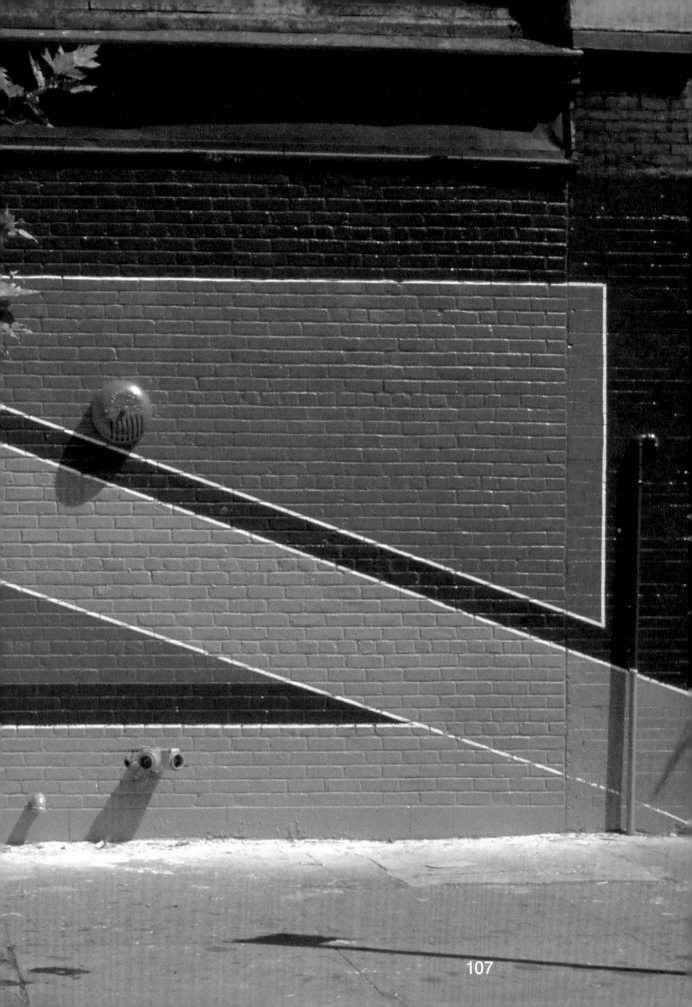

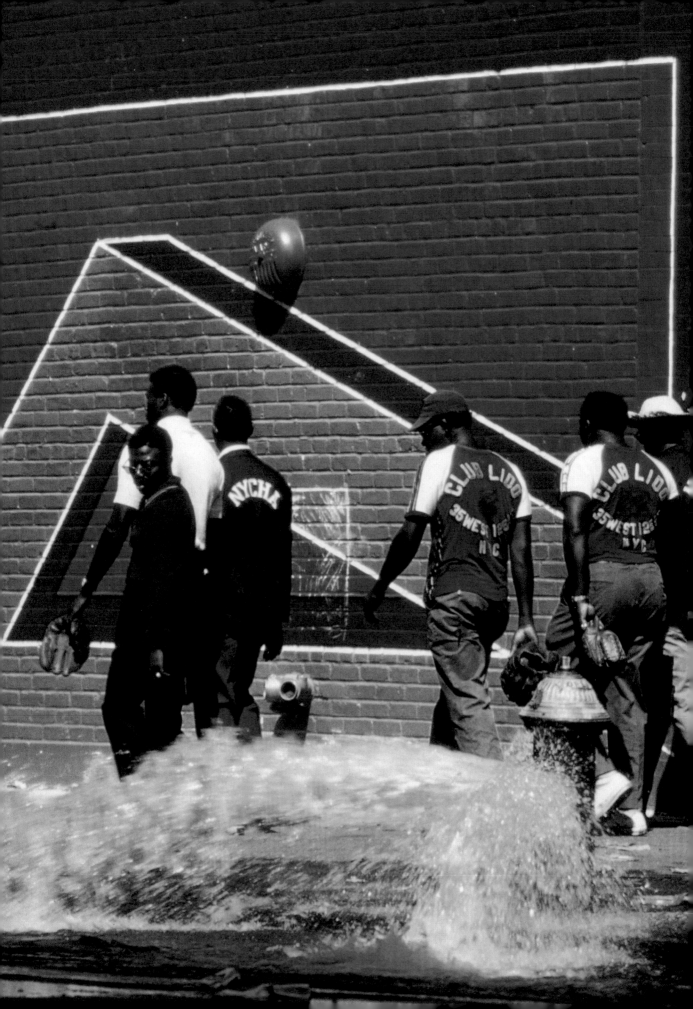

GS MARKET

DIET
PEPSI

ARIO - COLD BEER & SODA 7ᵗʰ 207

TICKETS
SOLD HERE

Schaefer
BEER

Super Berg's Market 109

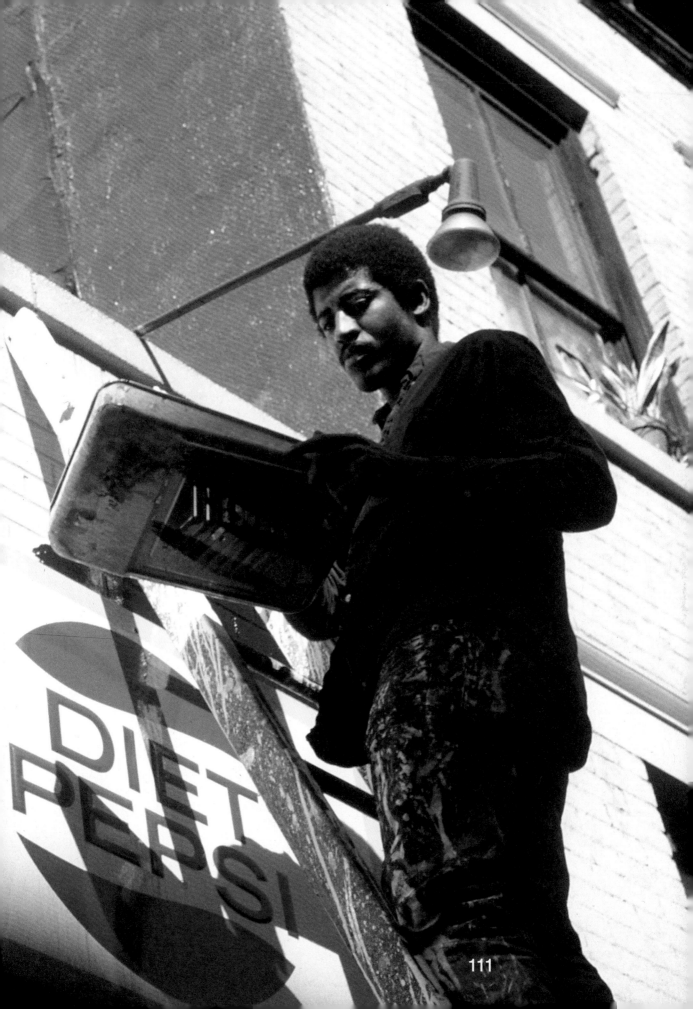

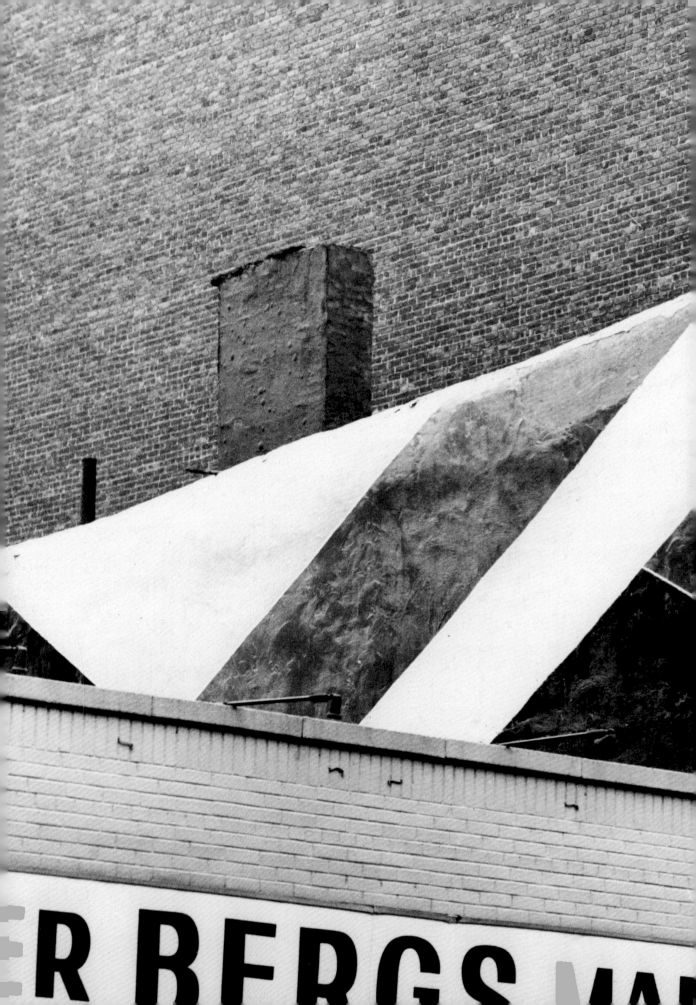

113

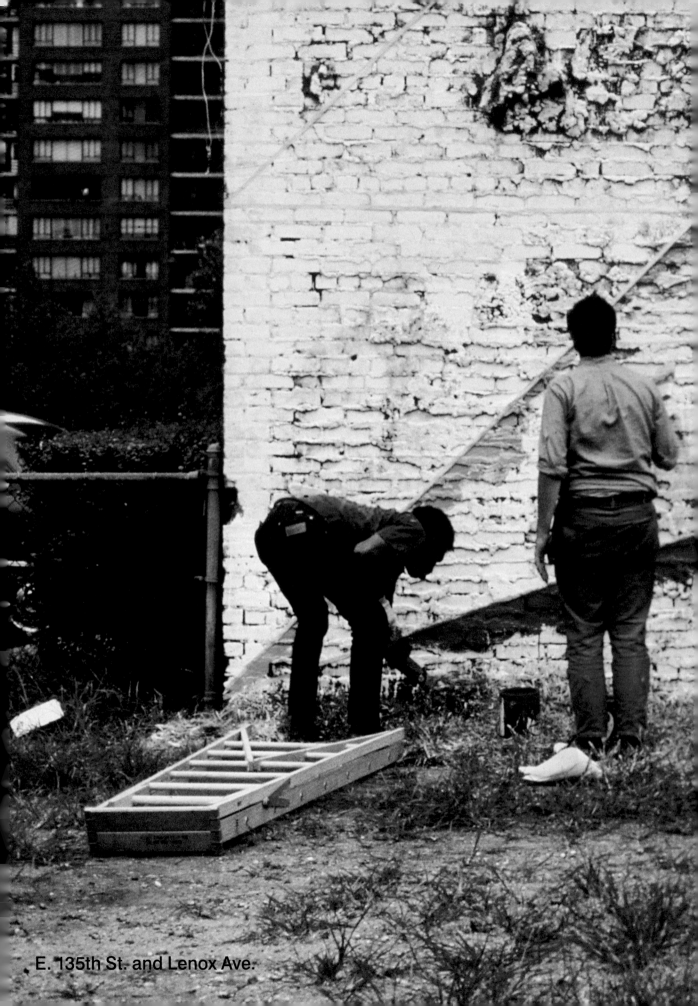

E. 135th St. and Lenox Ave.

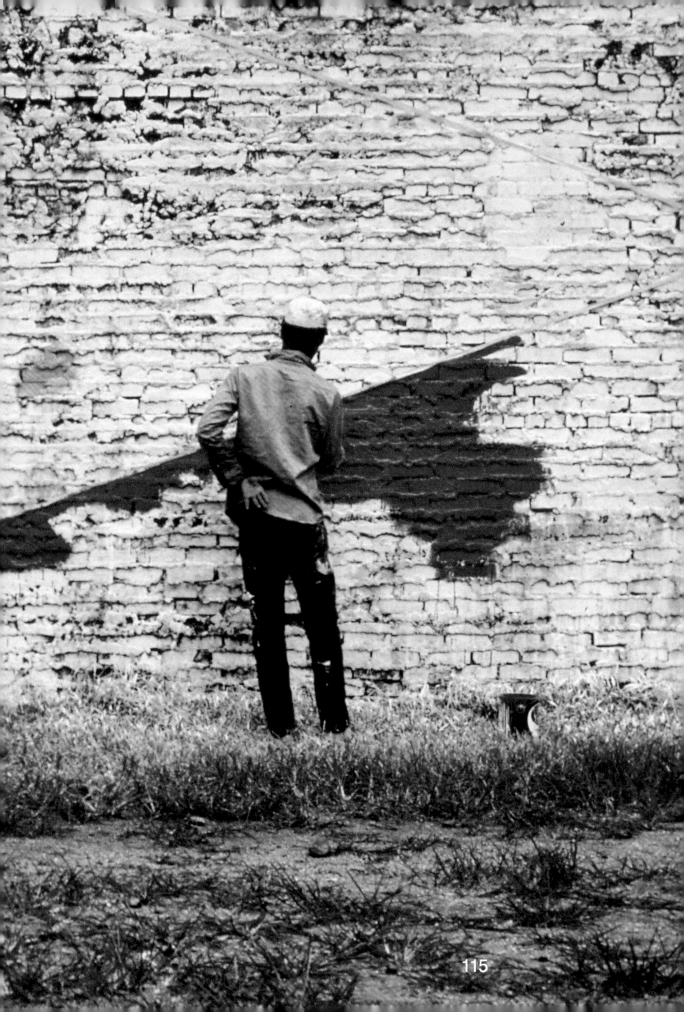

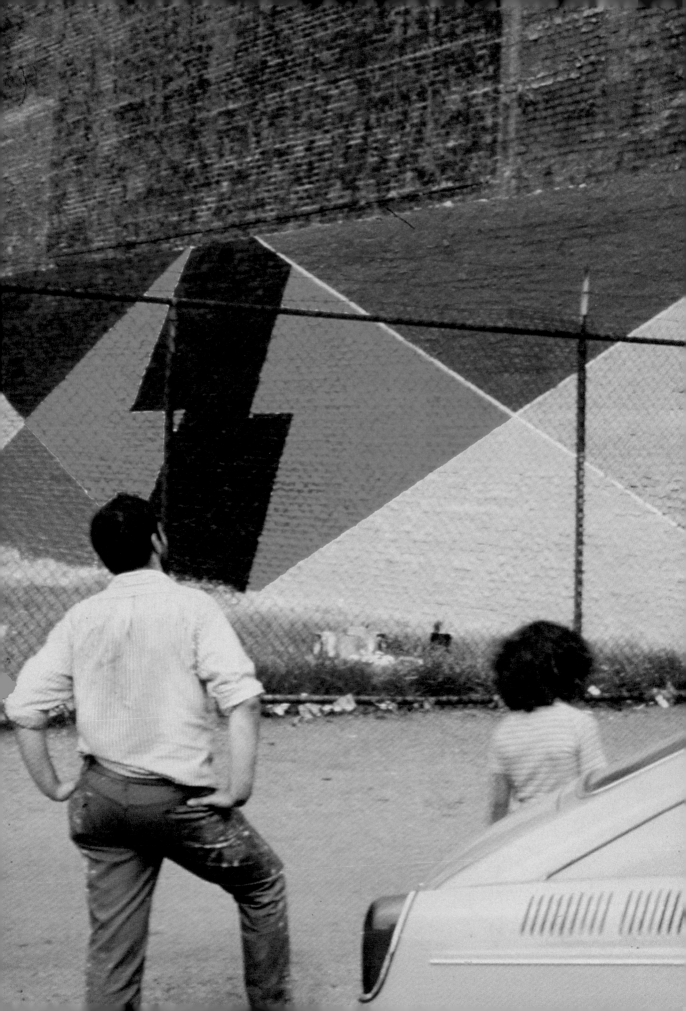

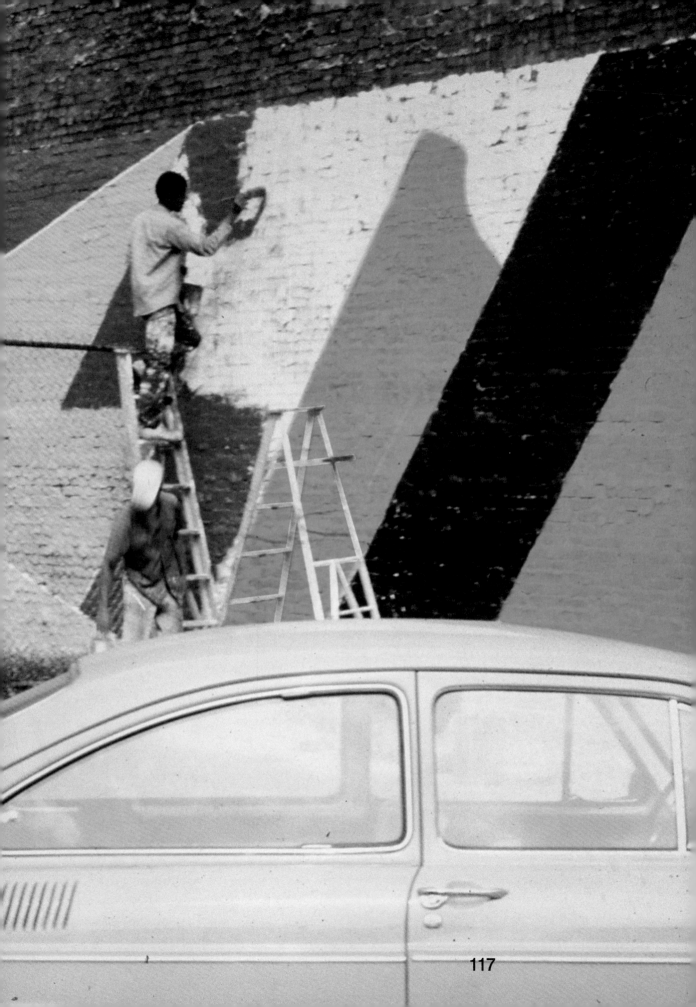

117

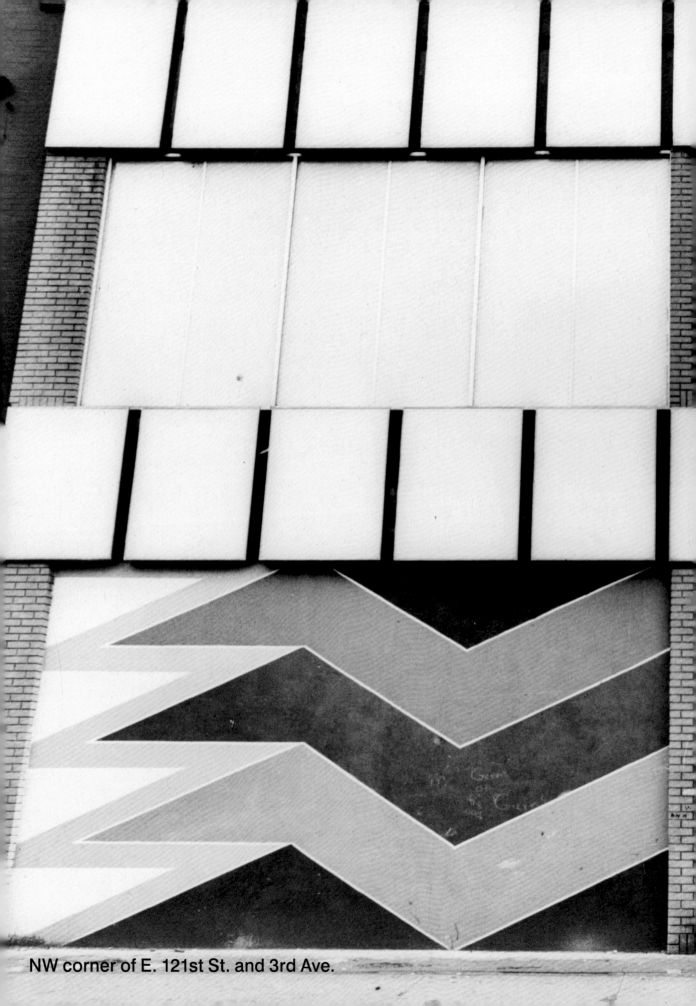

NW corner of E. 121st St. and 3rd Ave.

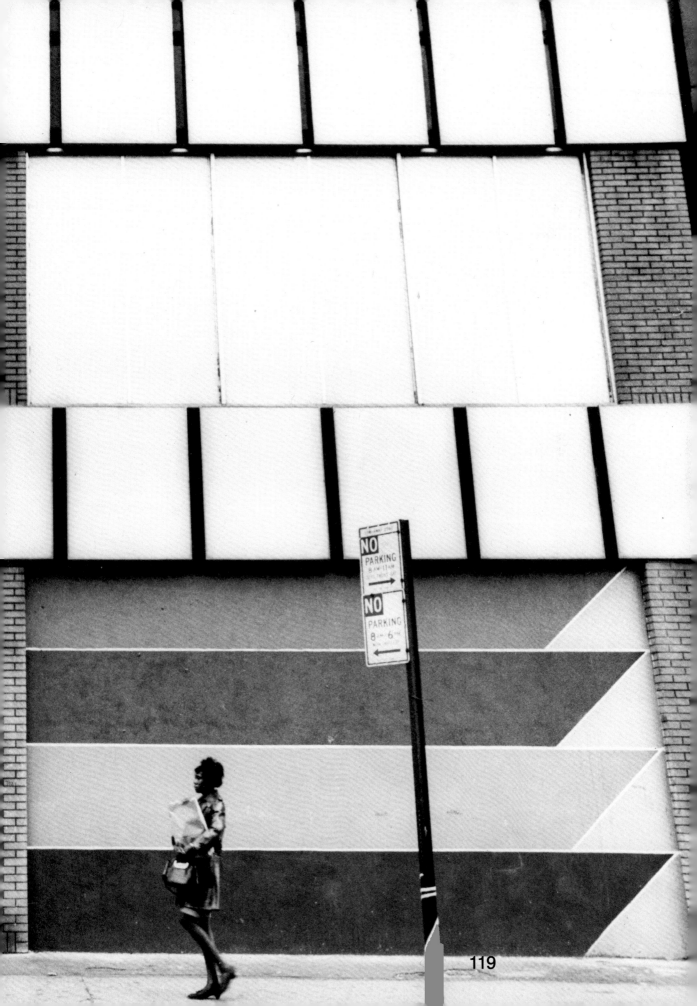

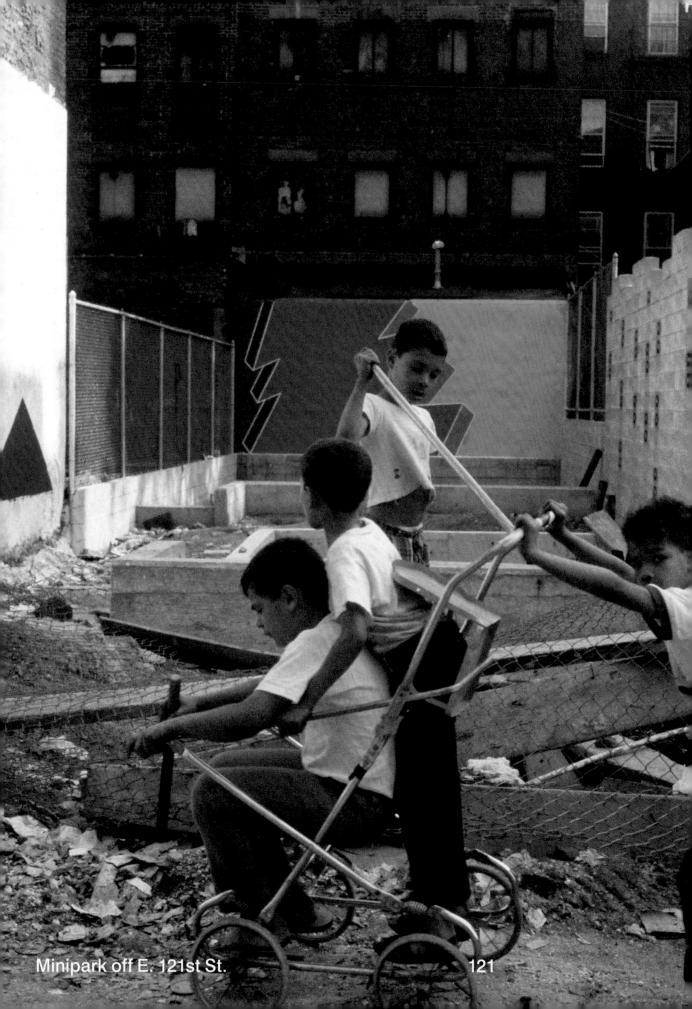

Minipark off E. 121st St. 121

123

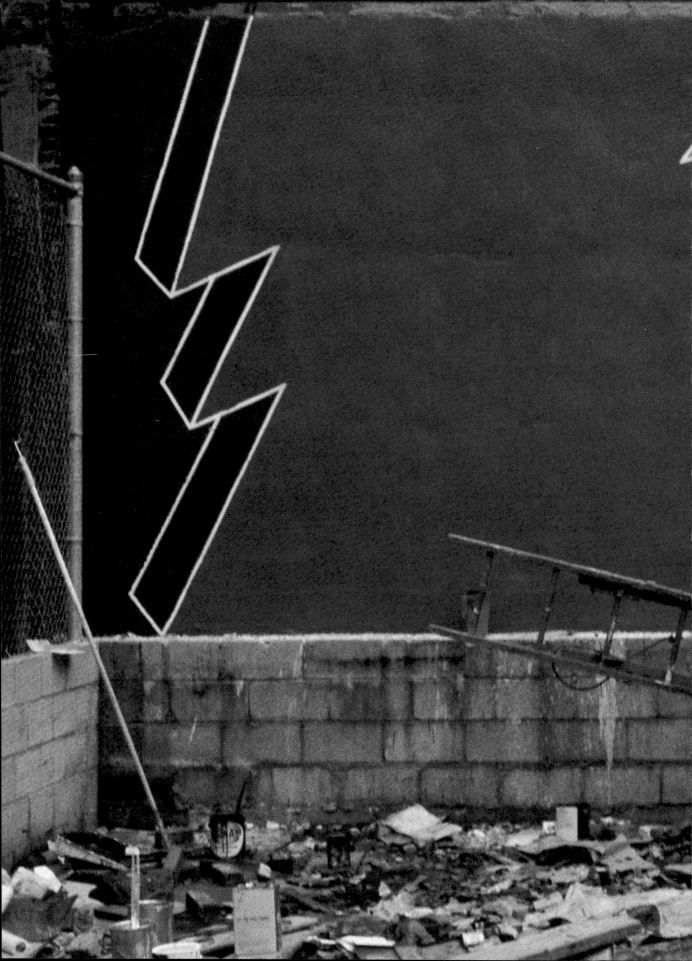

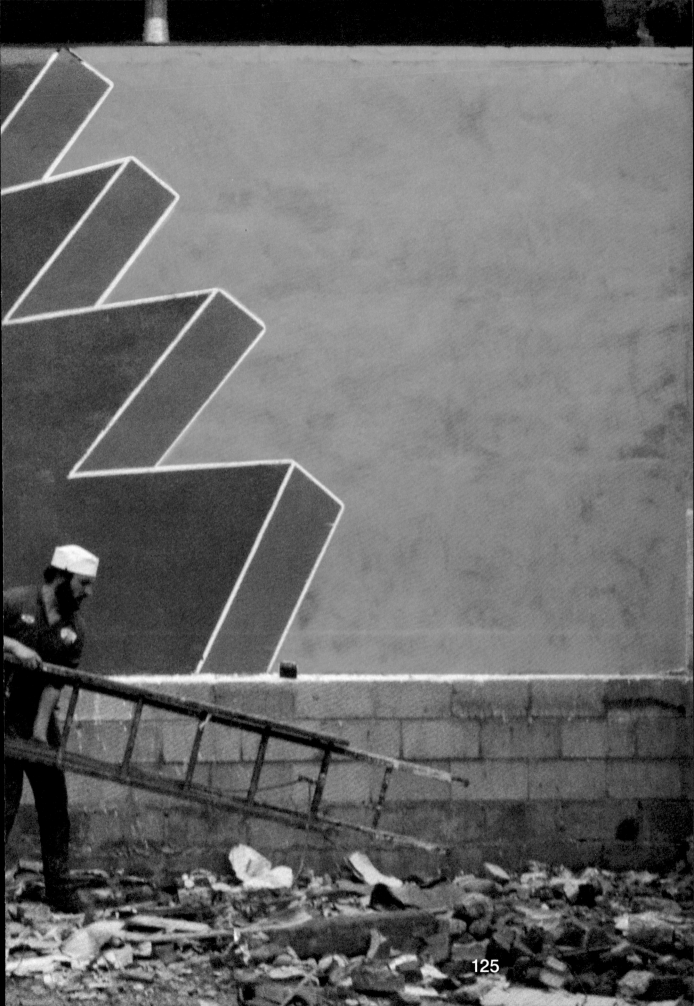

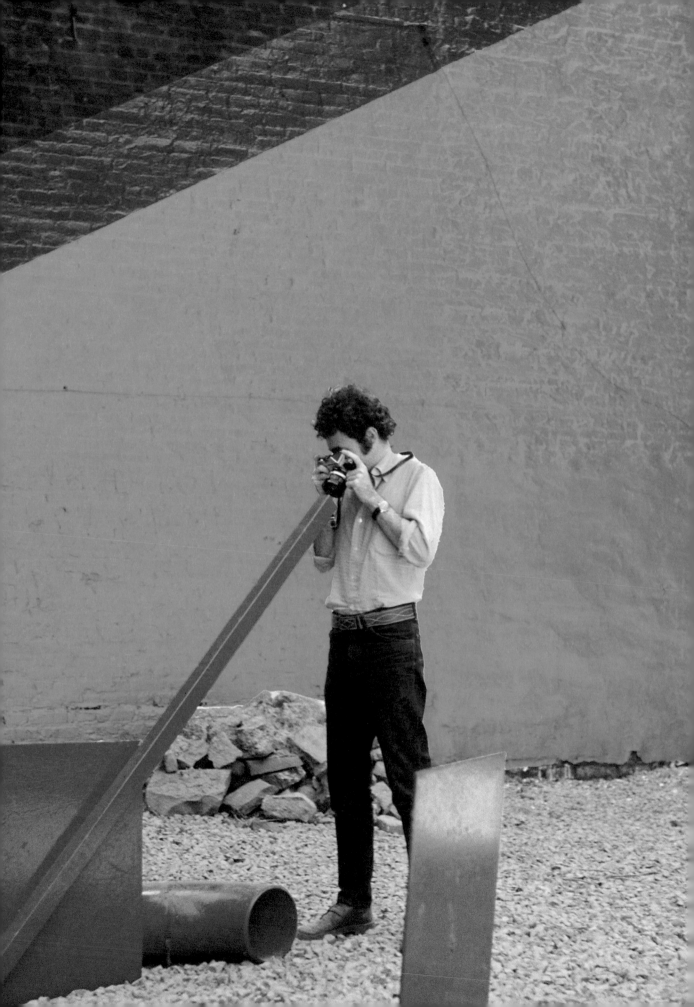

129

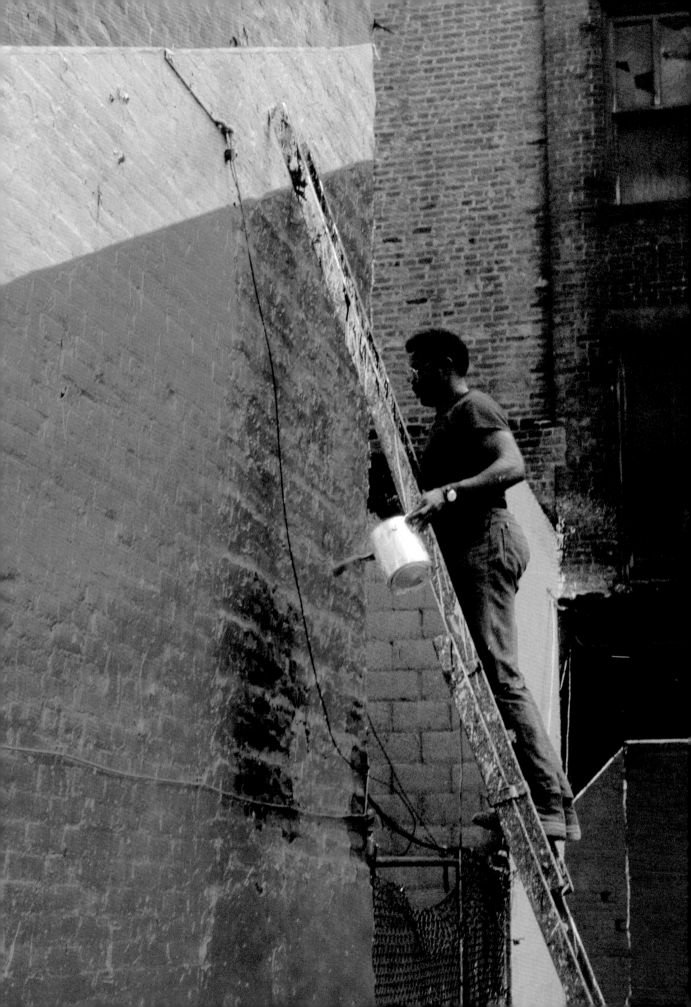

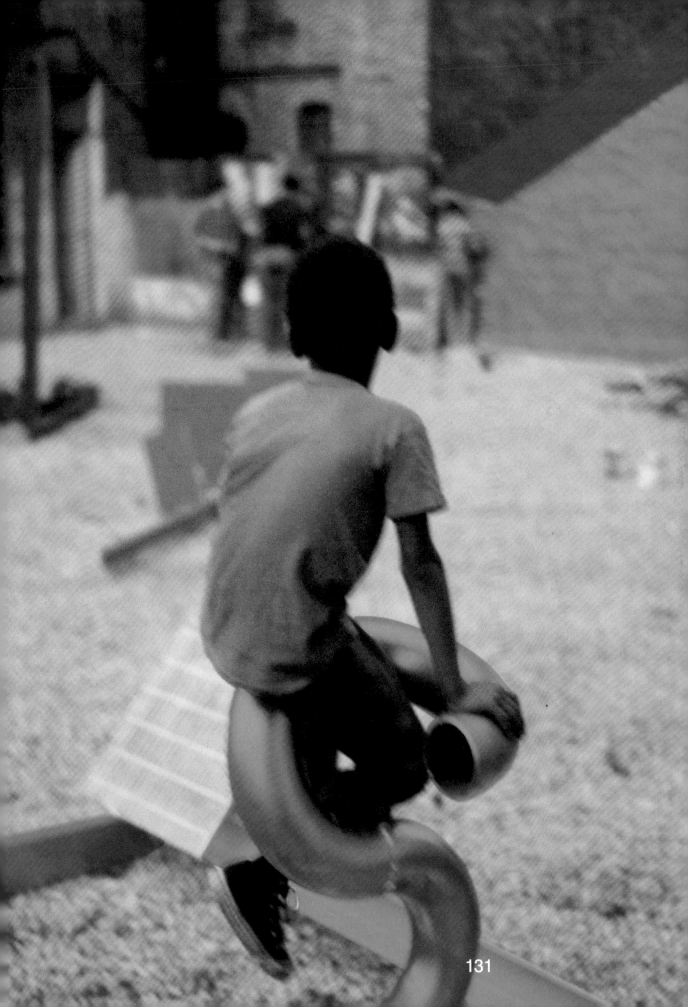

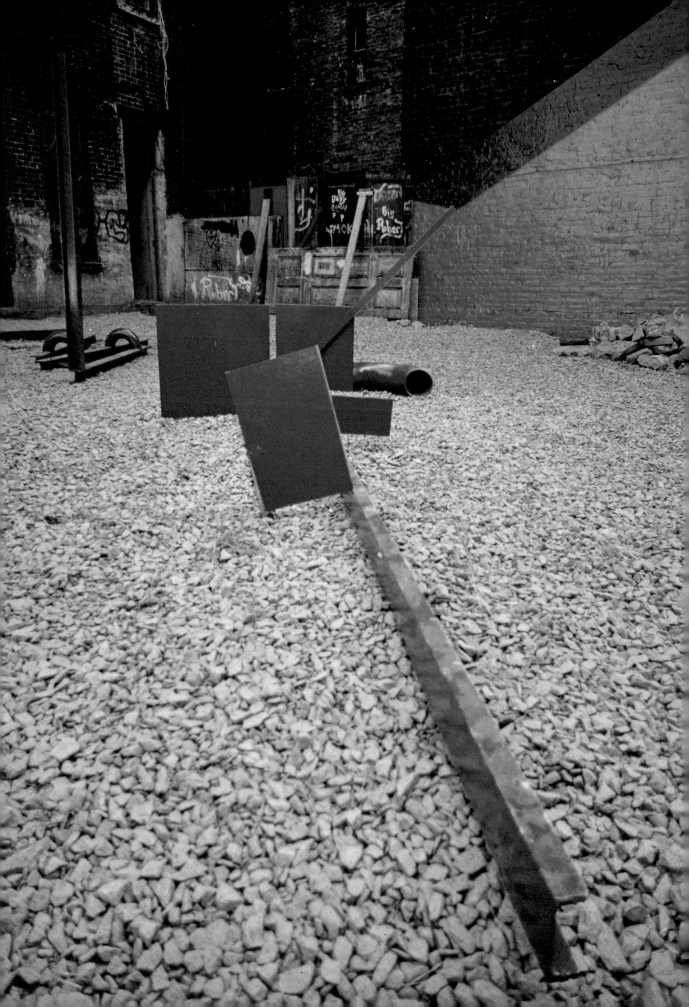

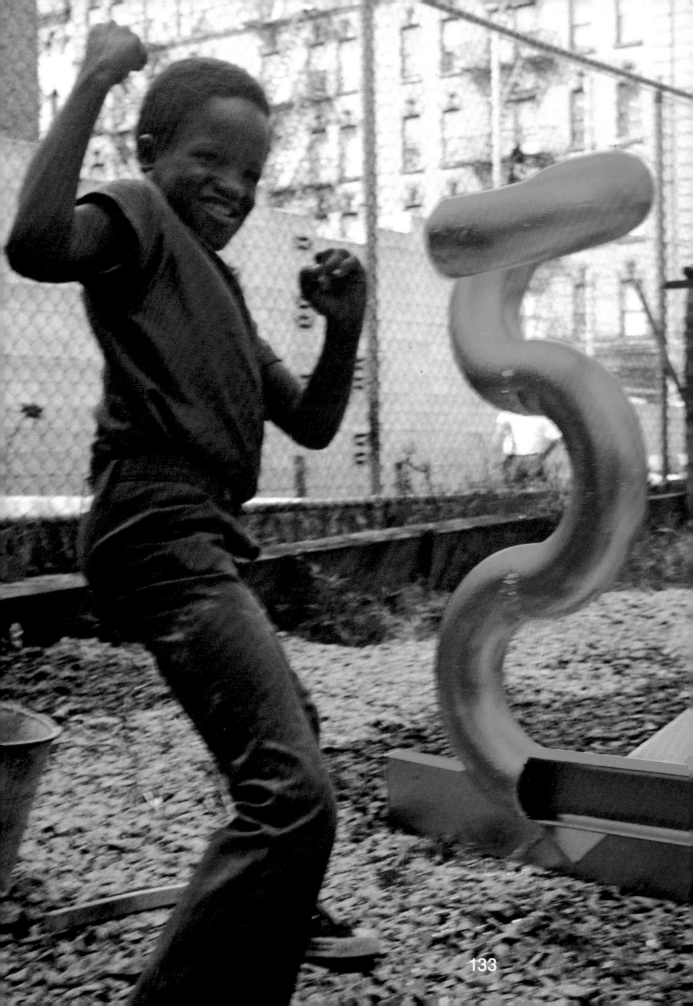

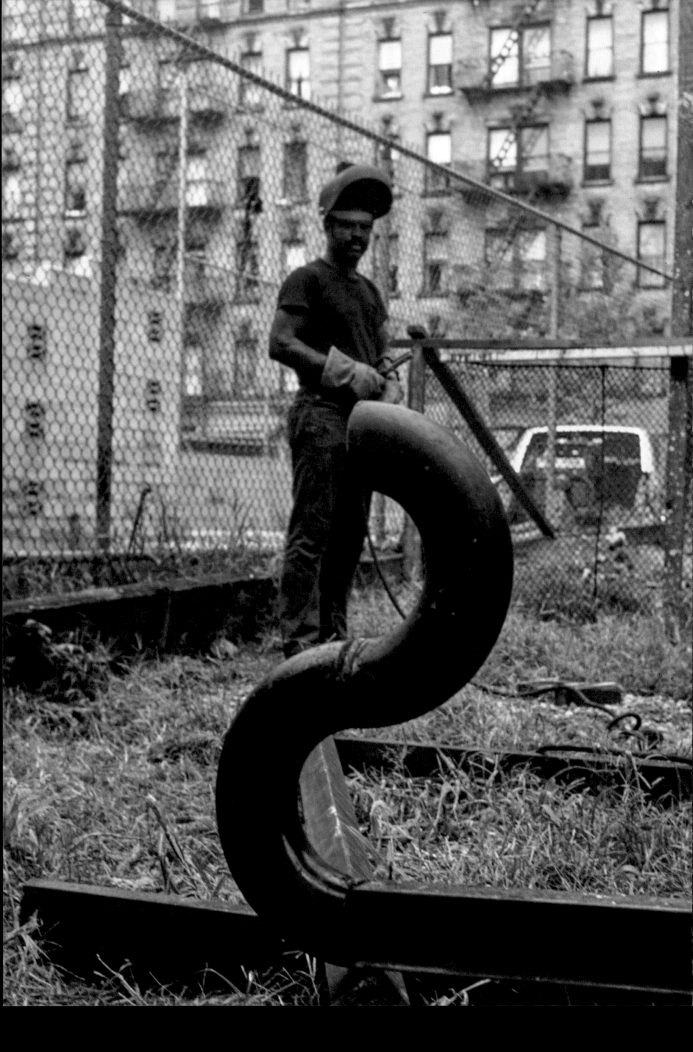

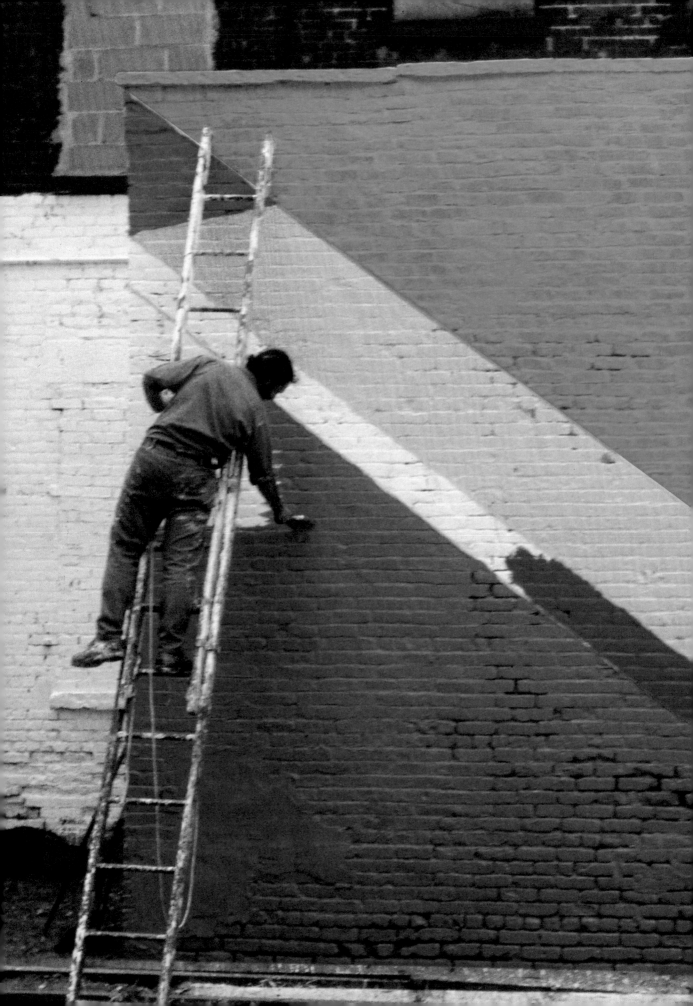

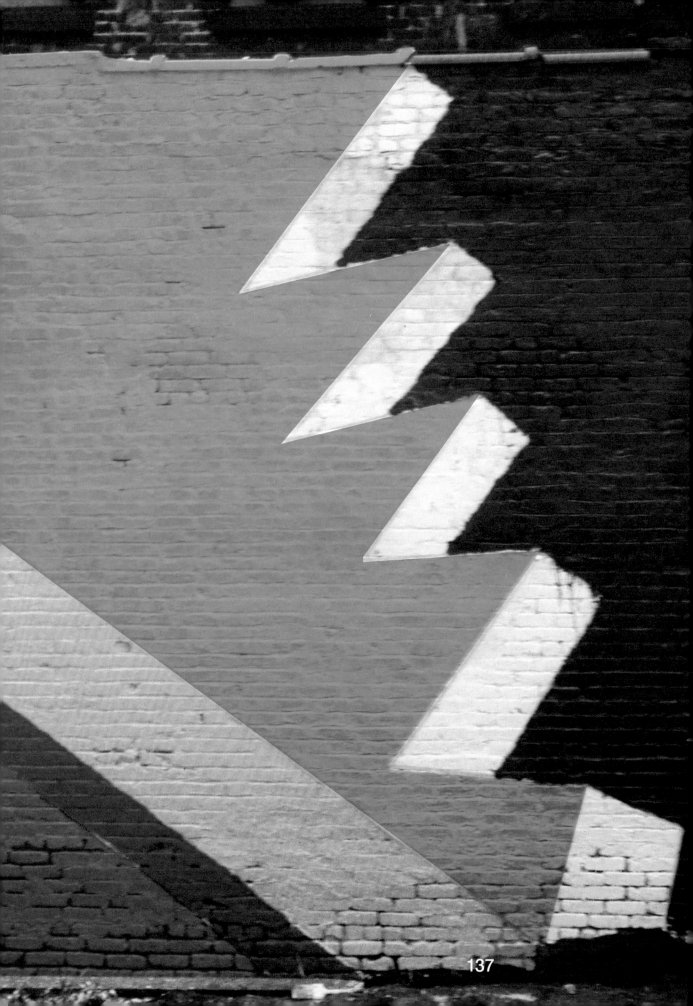

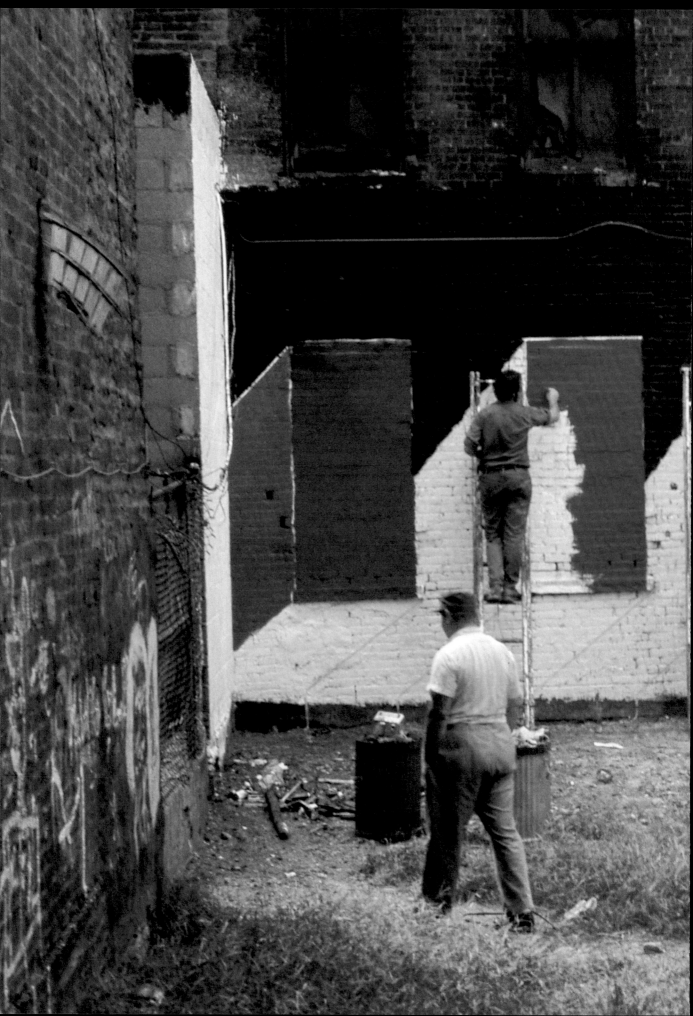

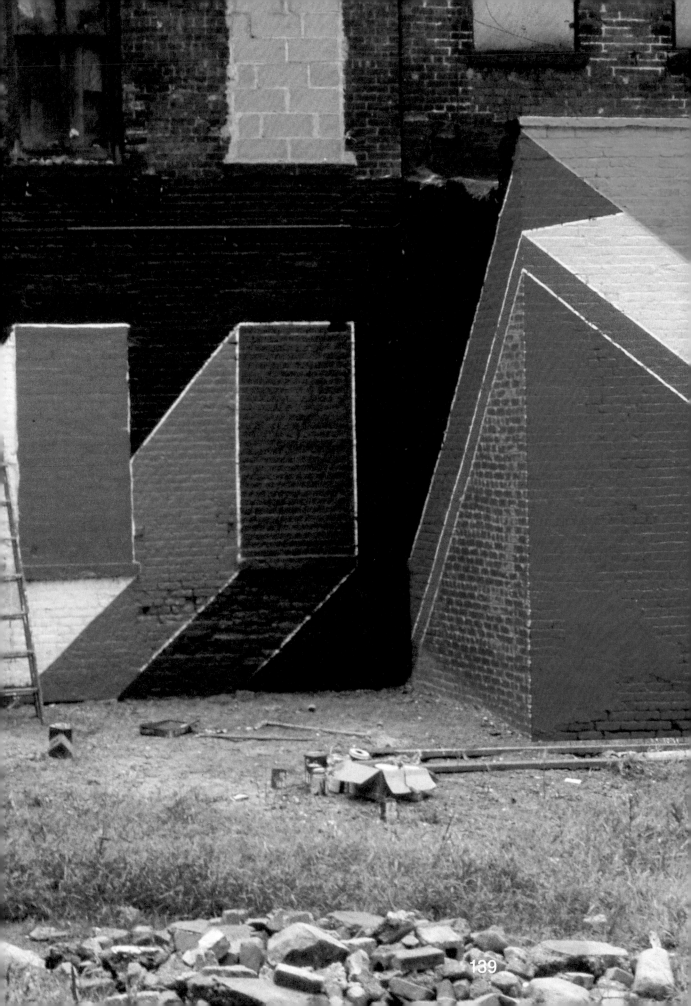

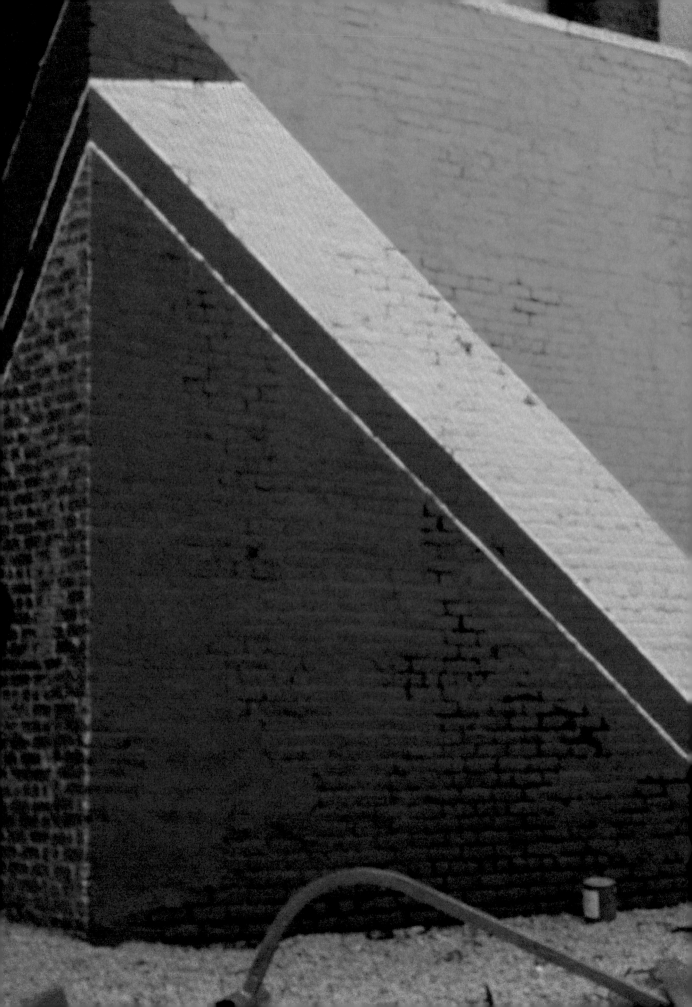

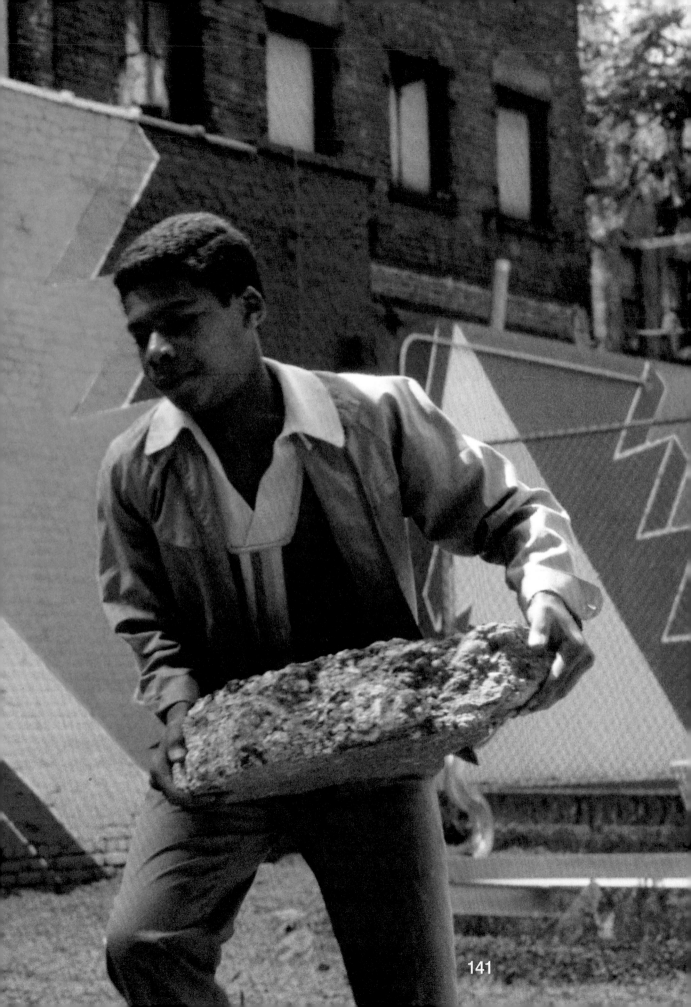

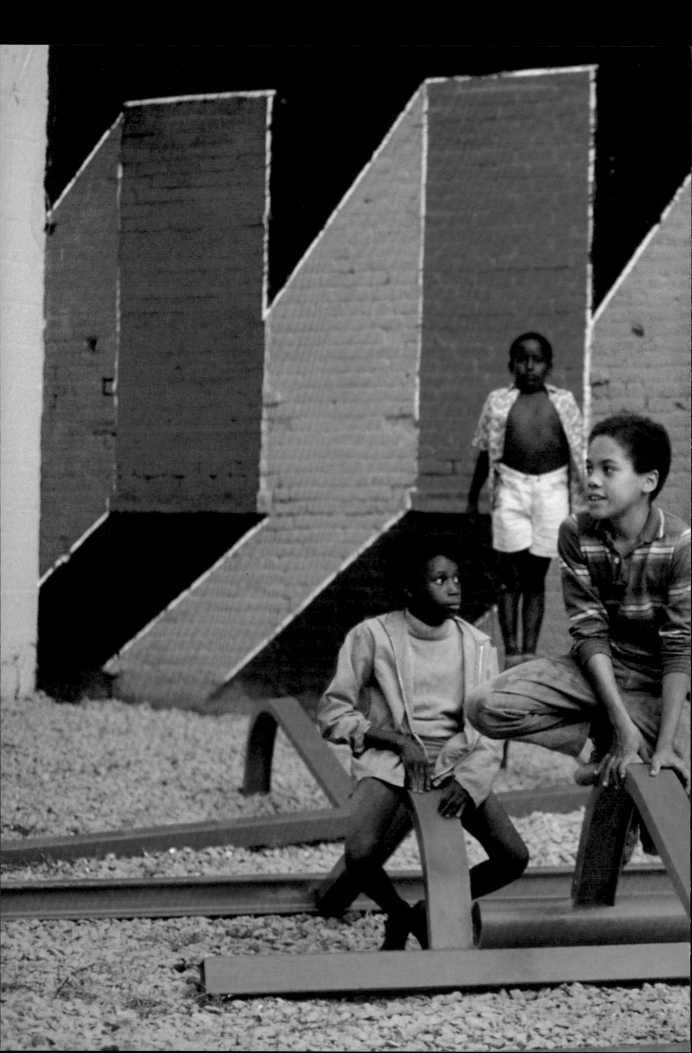

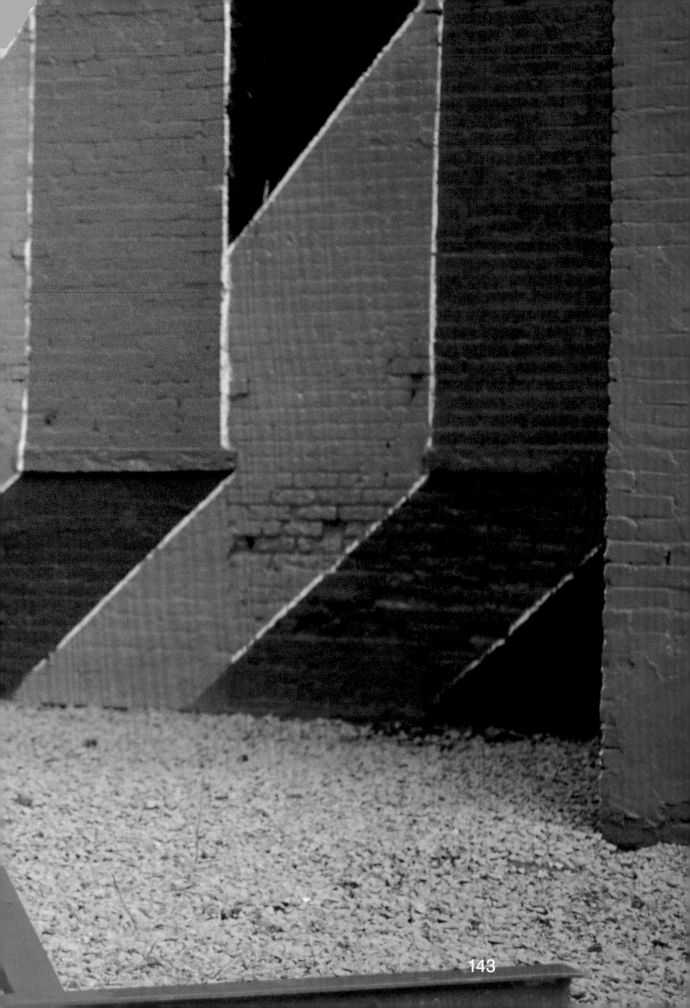

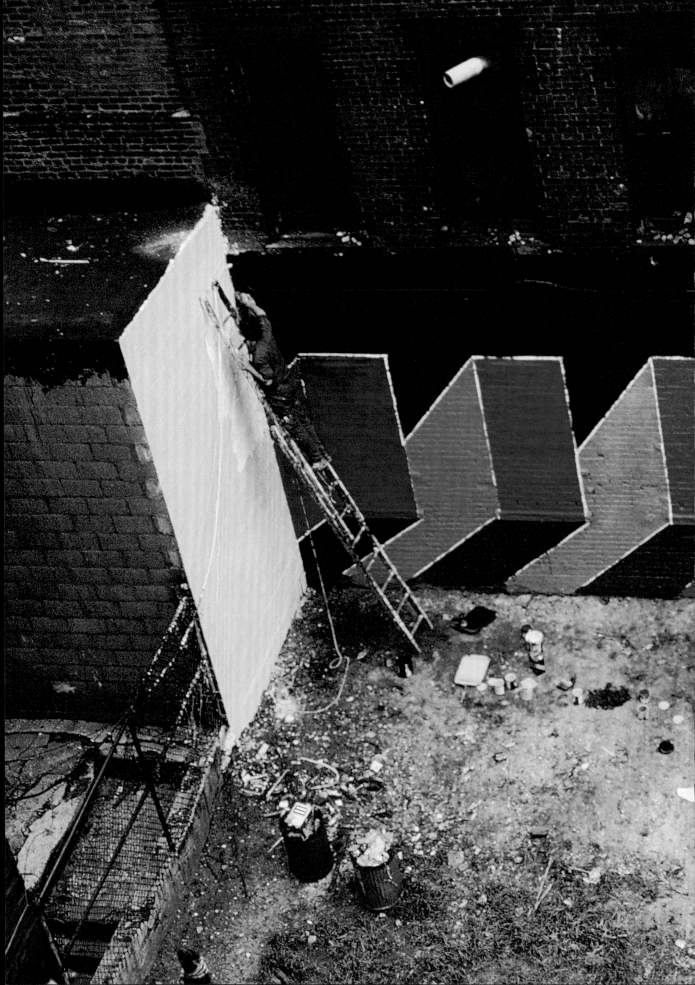

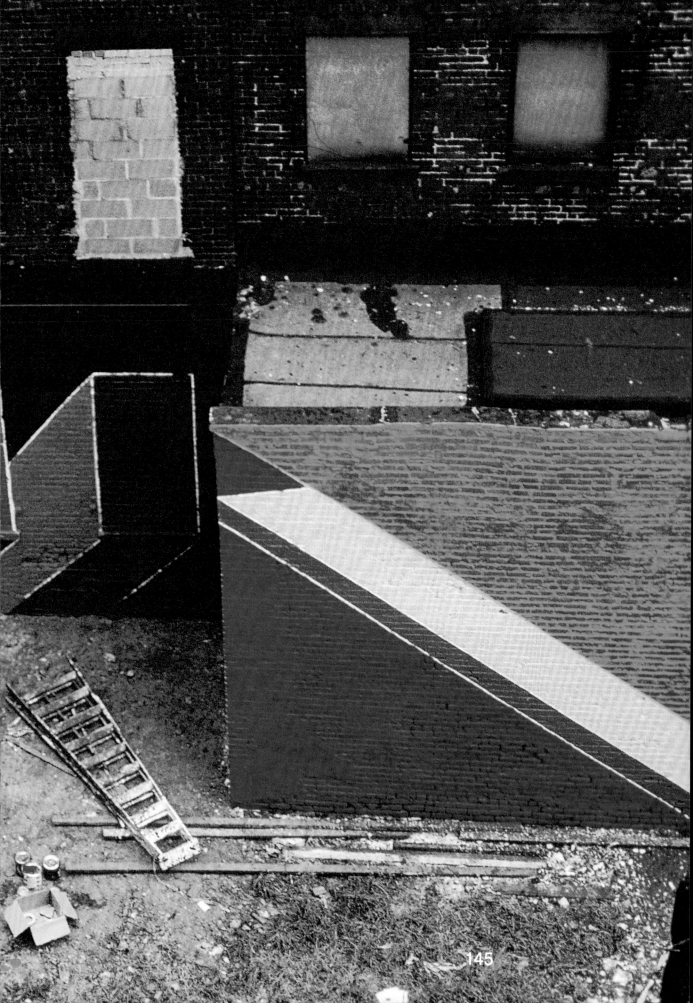

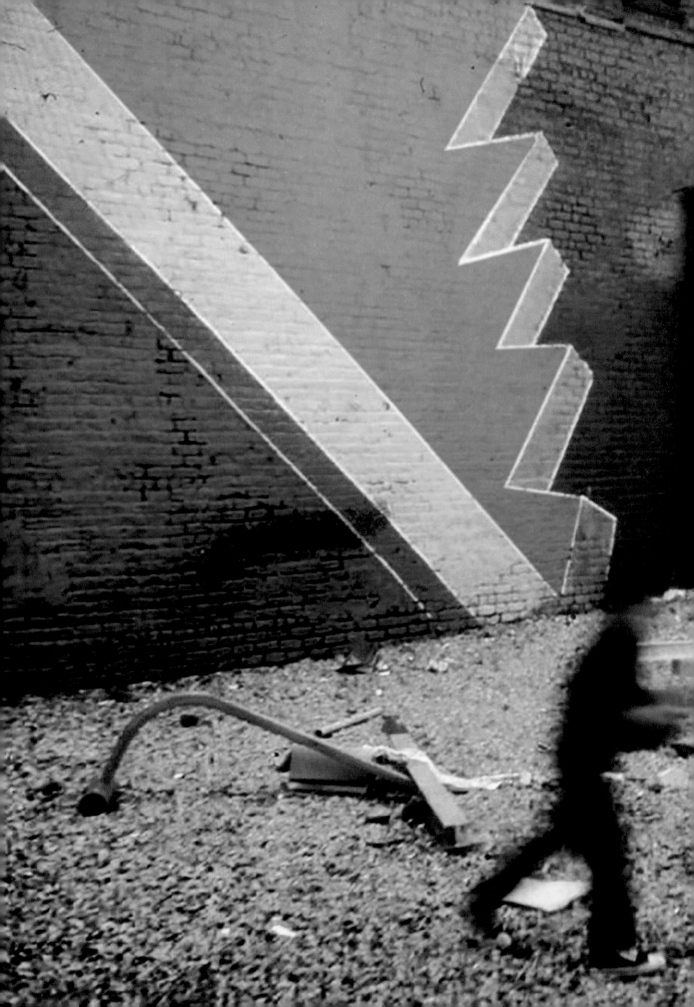

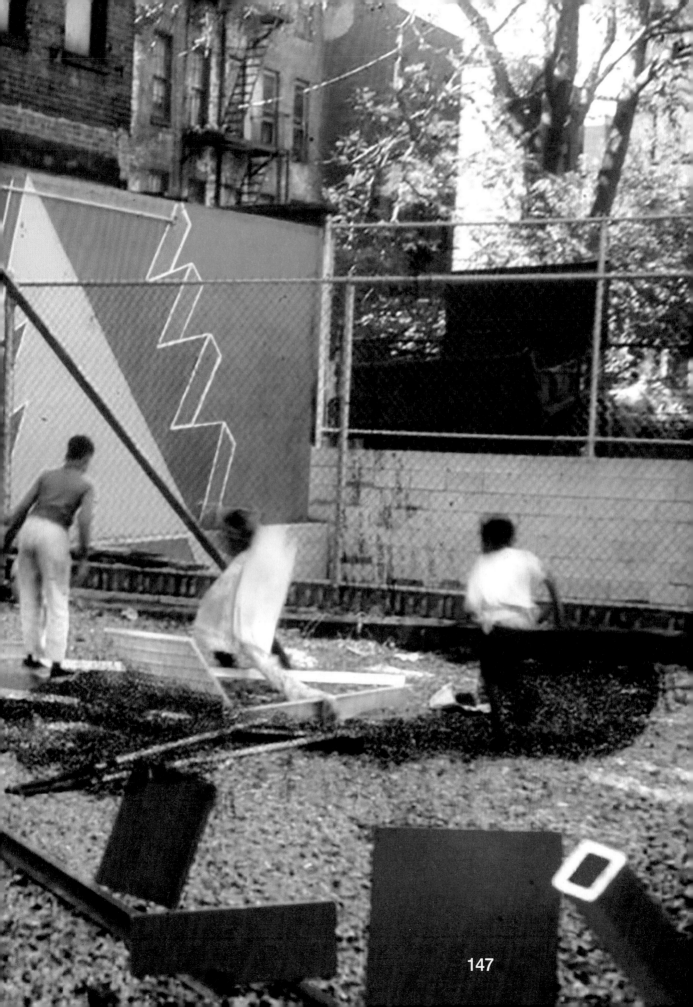

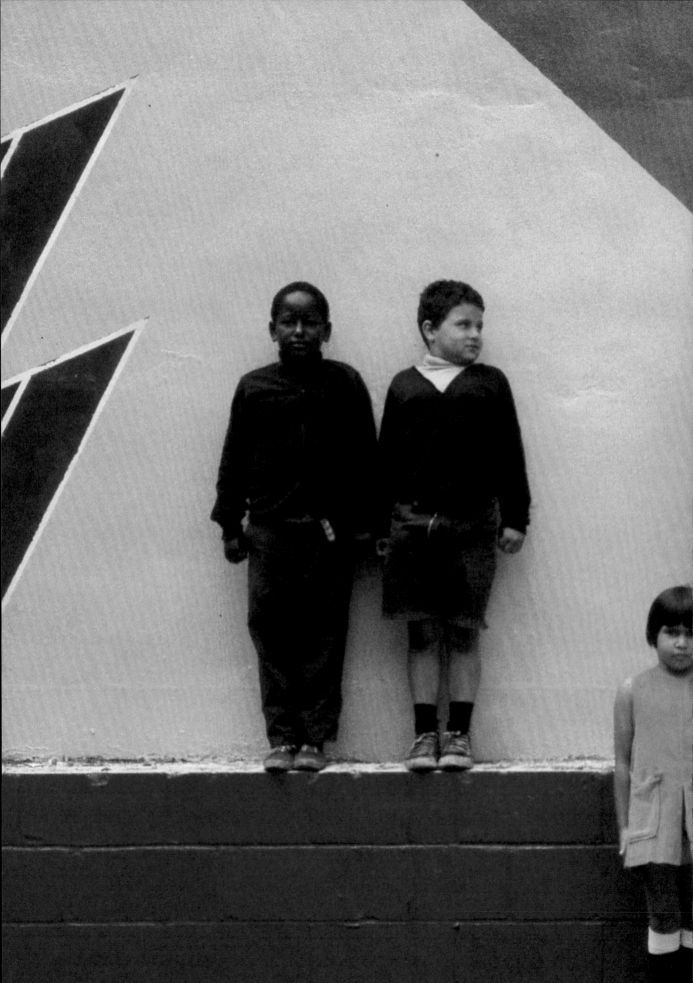

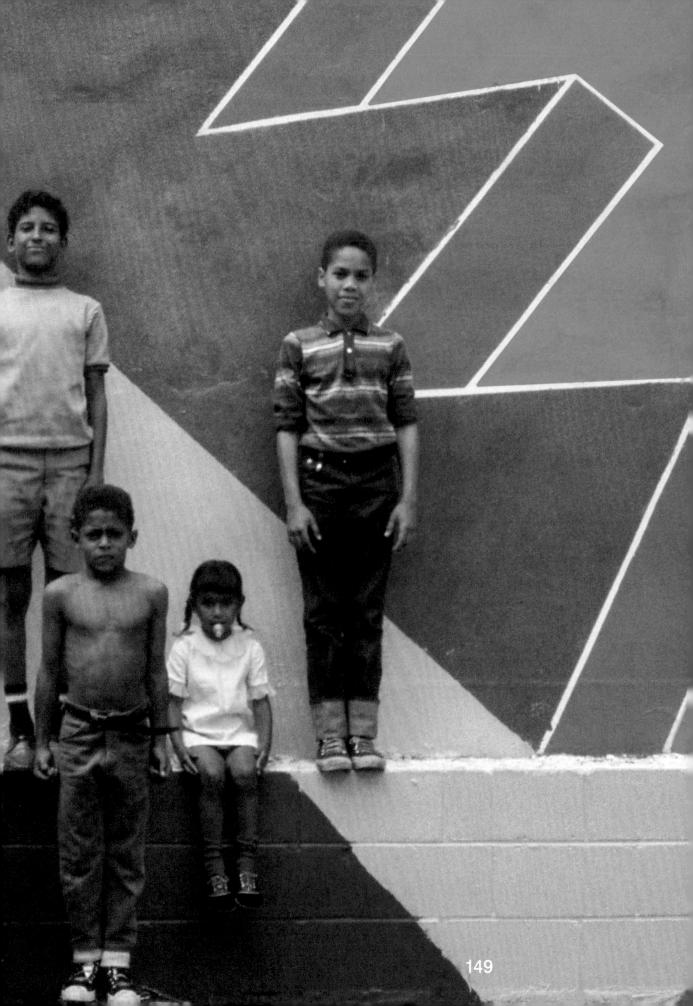

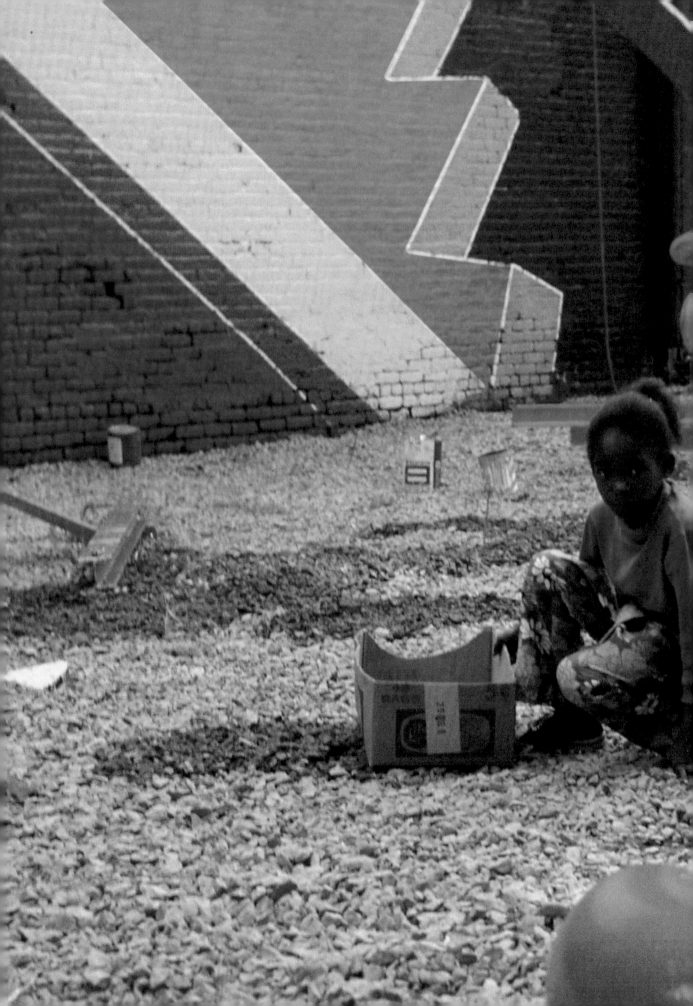

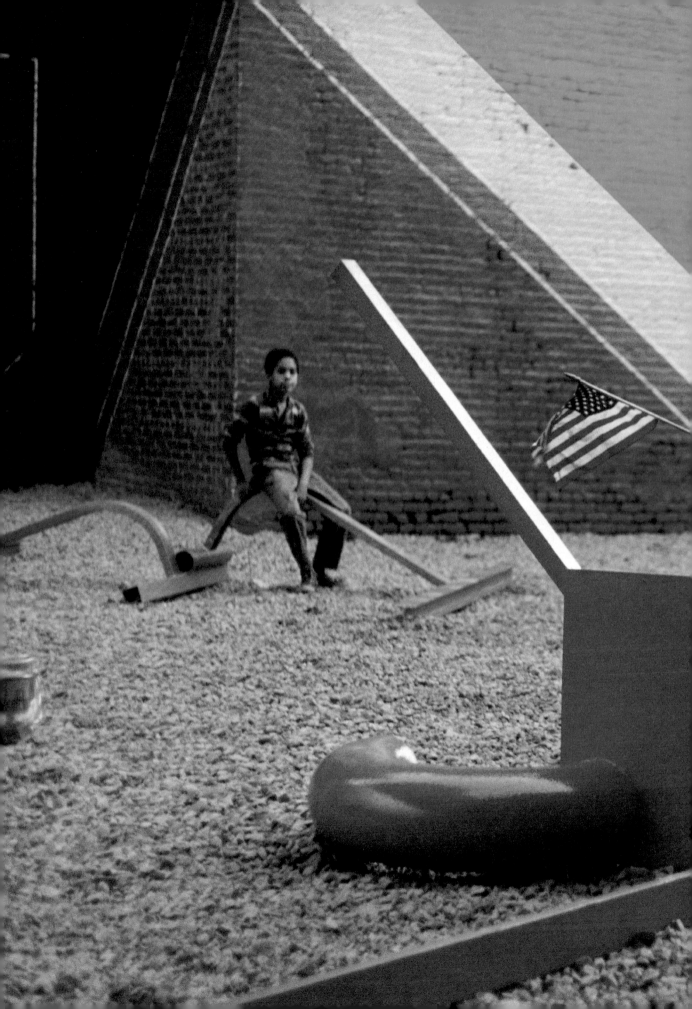

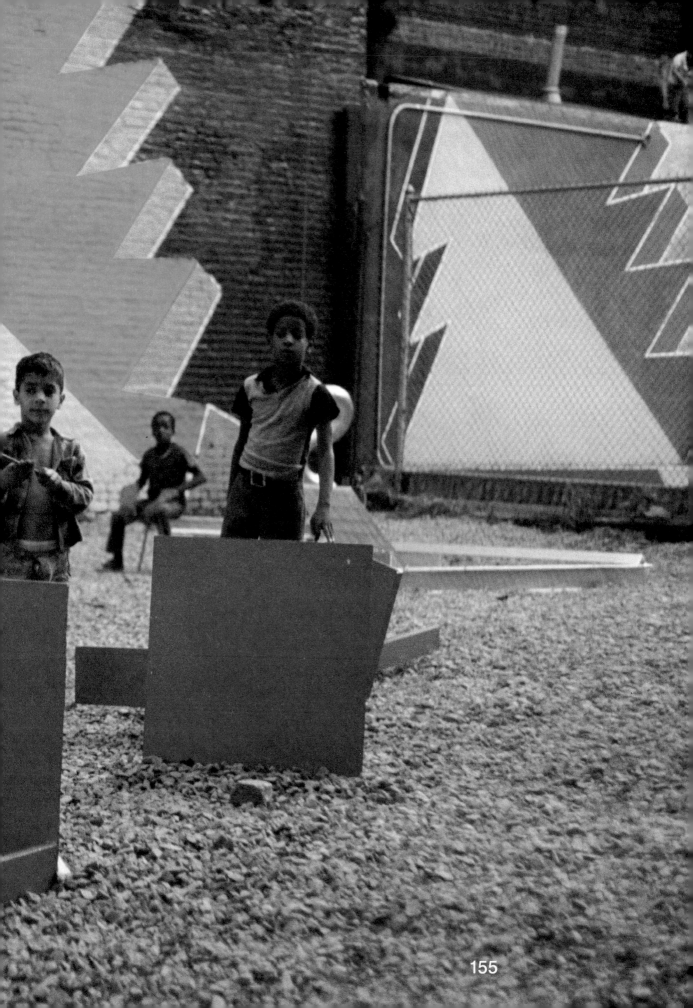

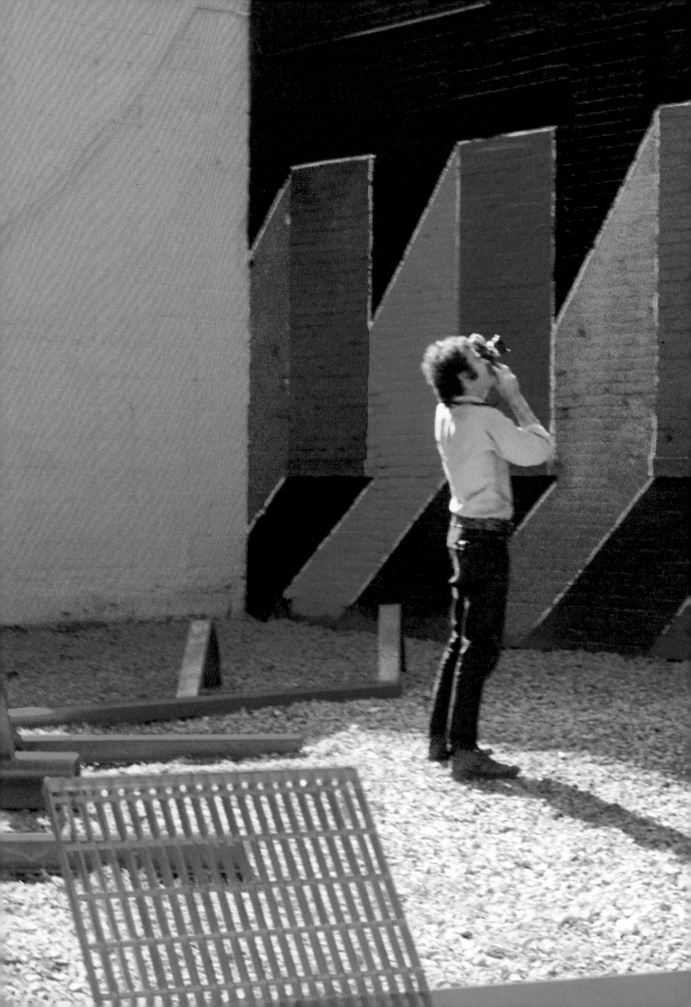

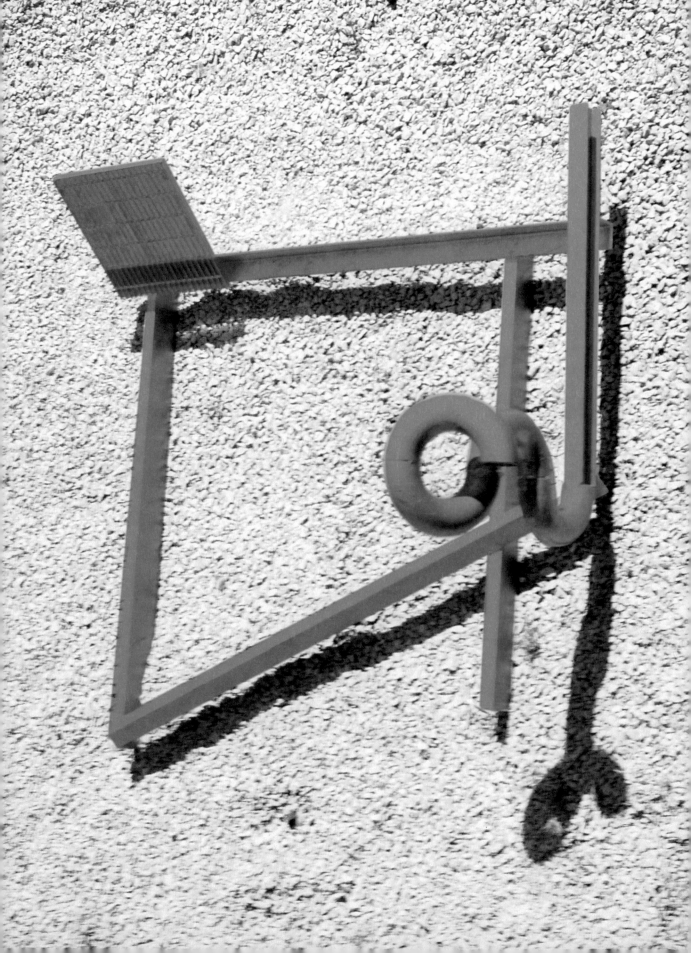

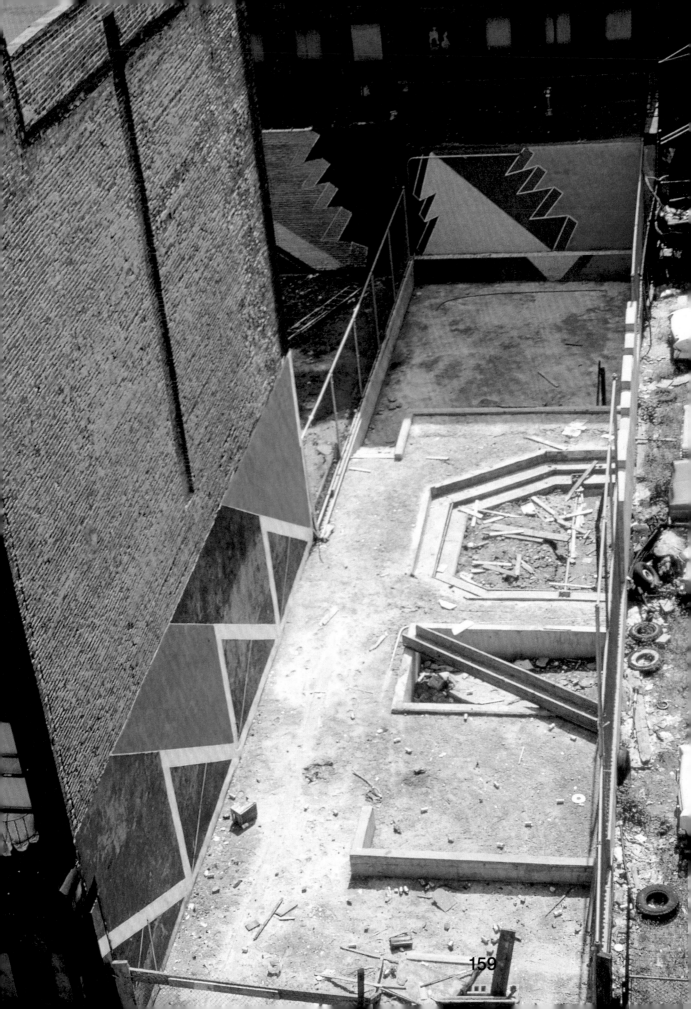

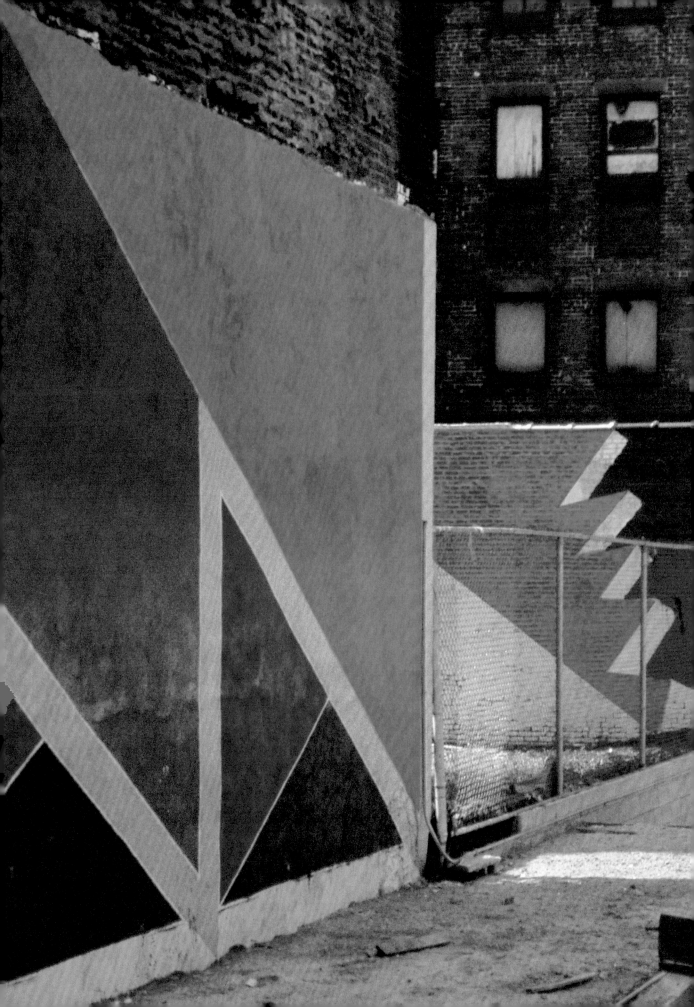

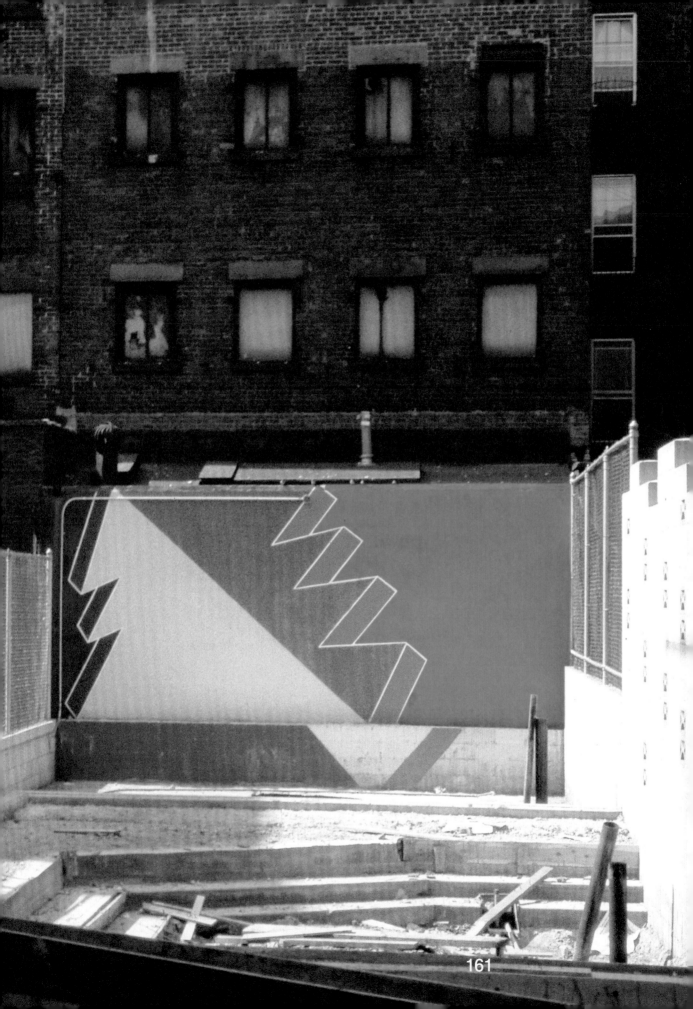

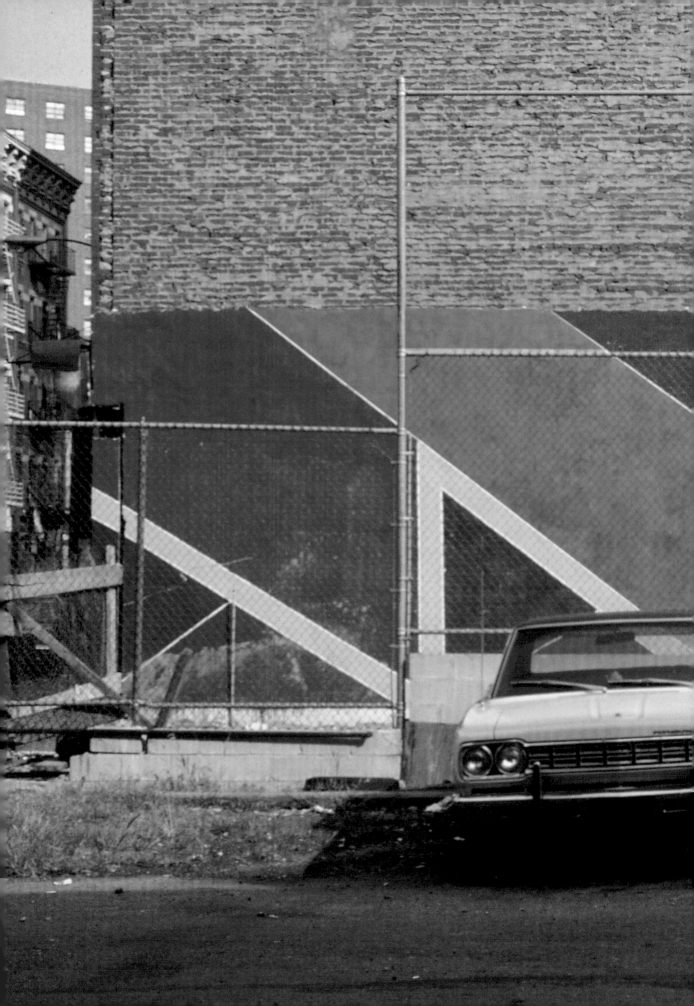

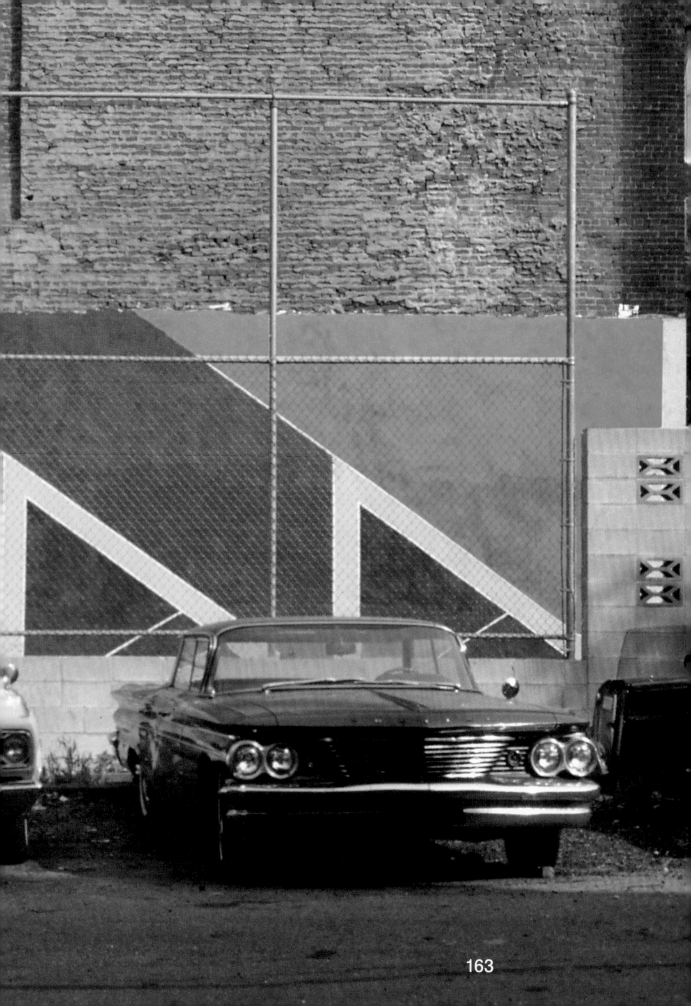

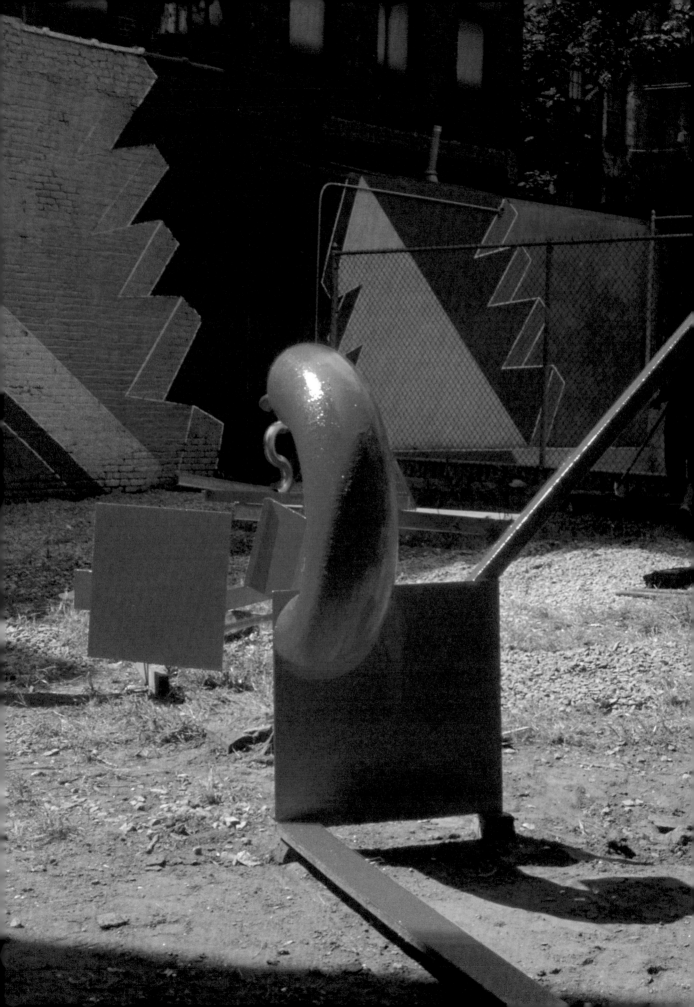

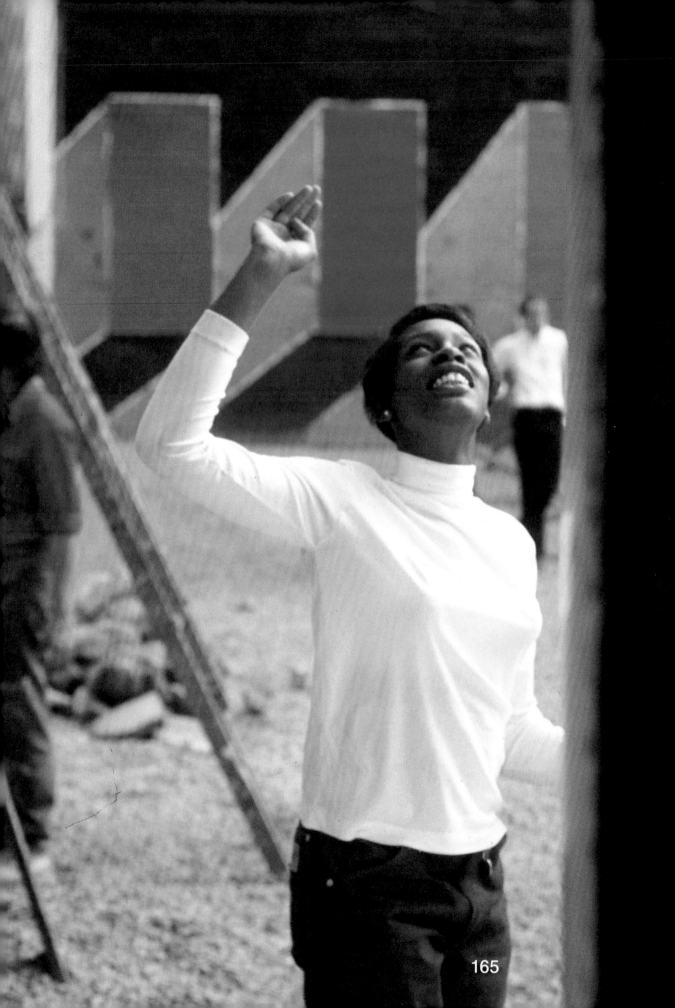

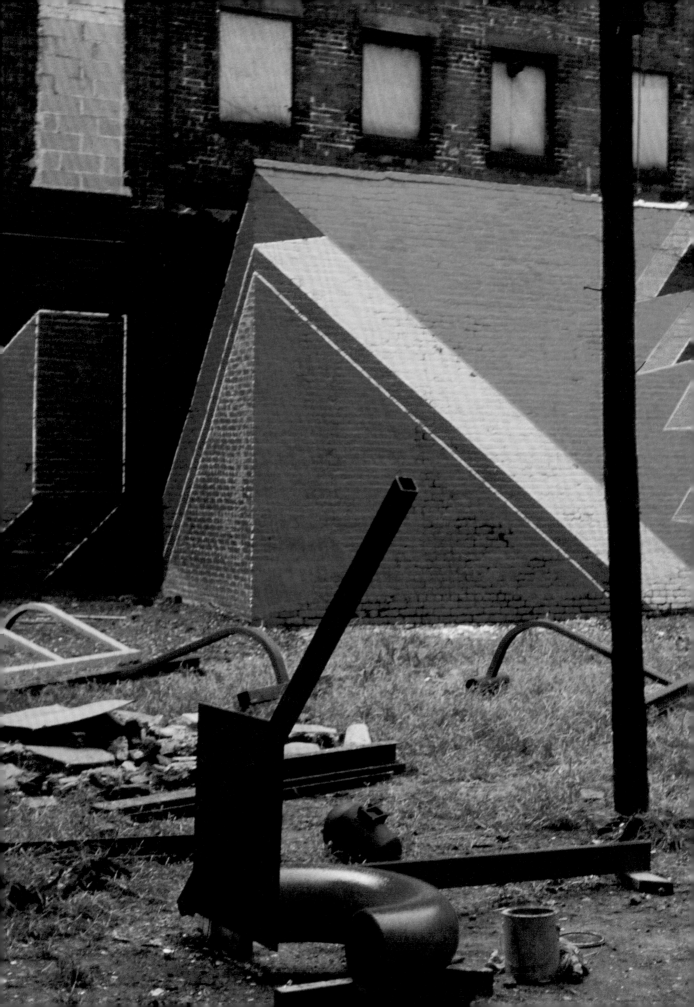

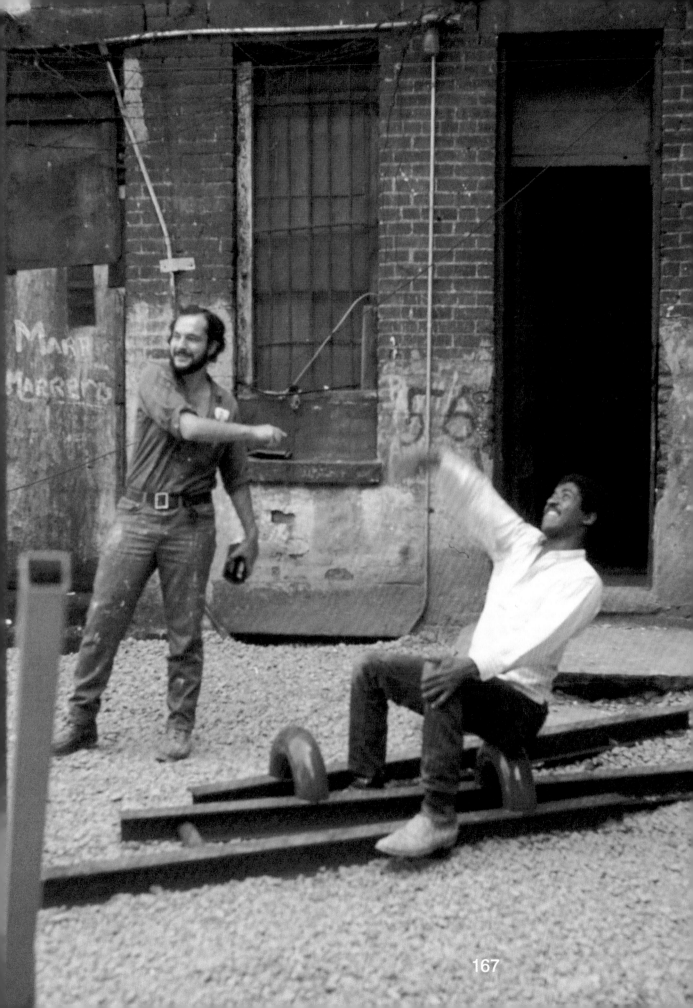

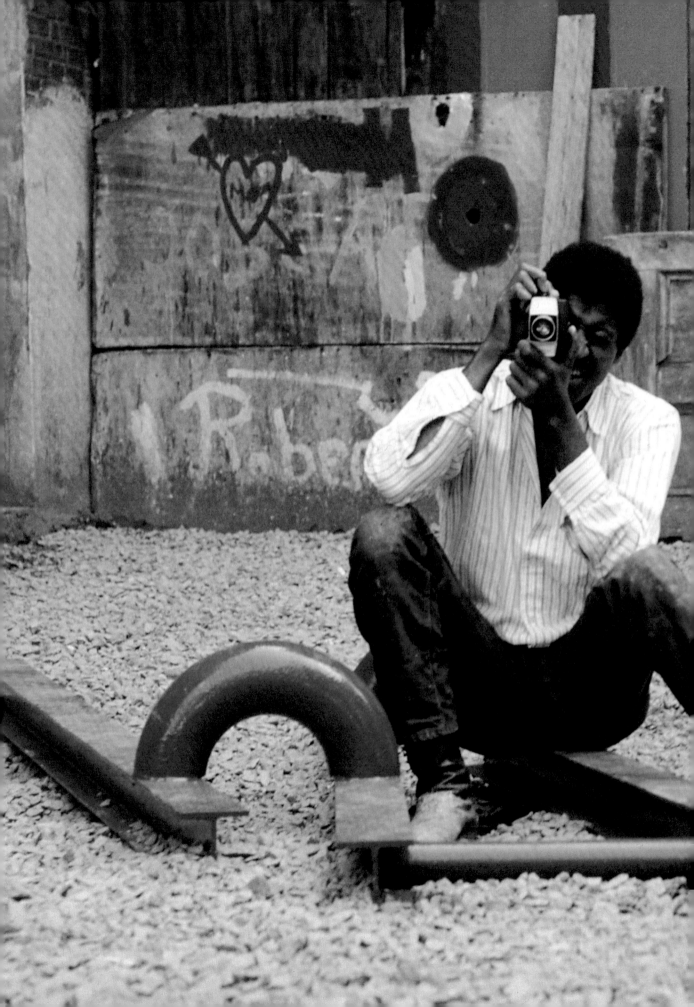

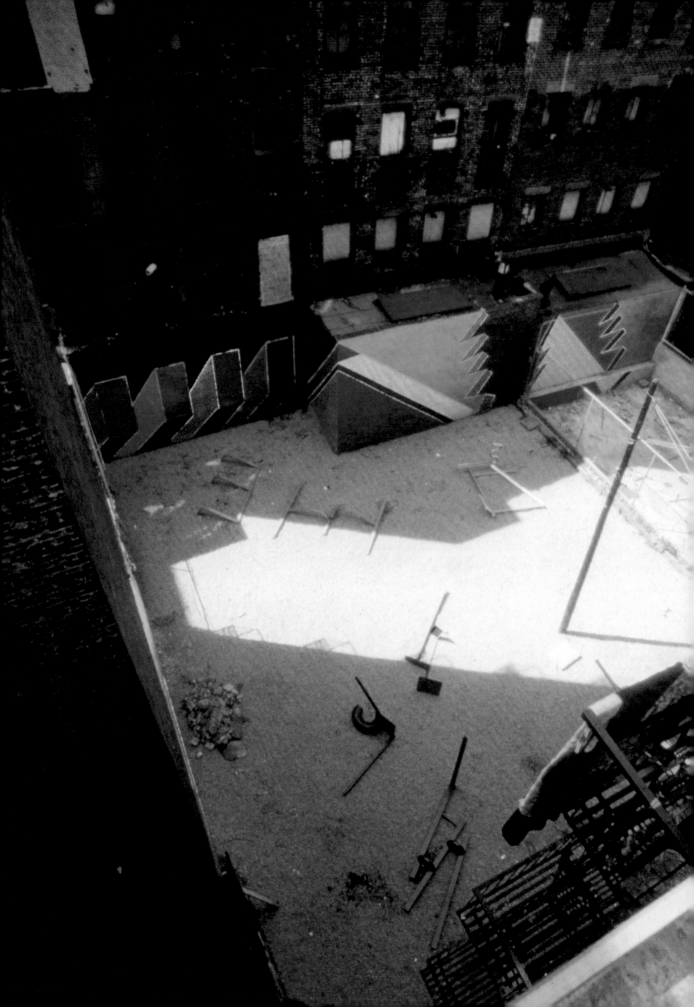

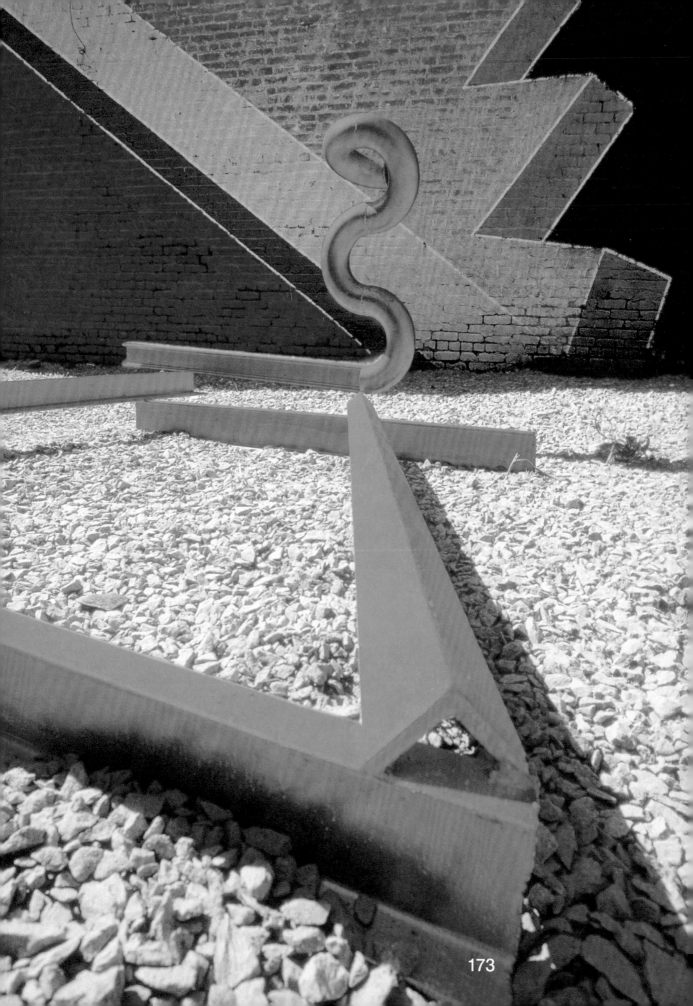

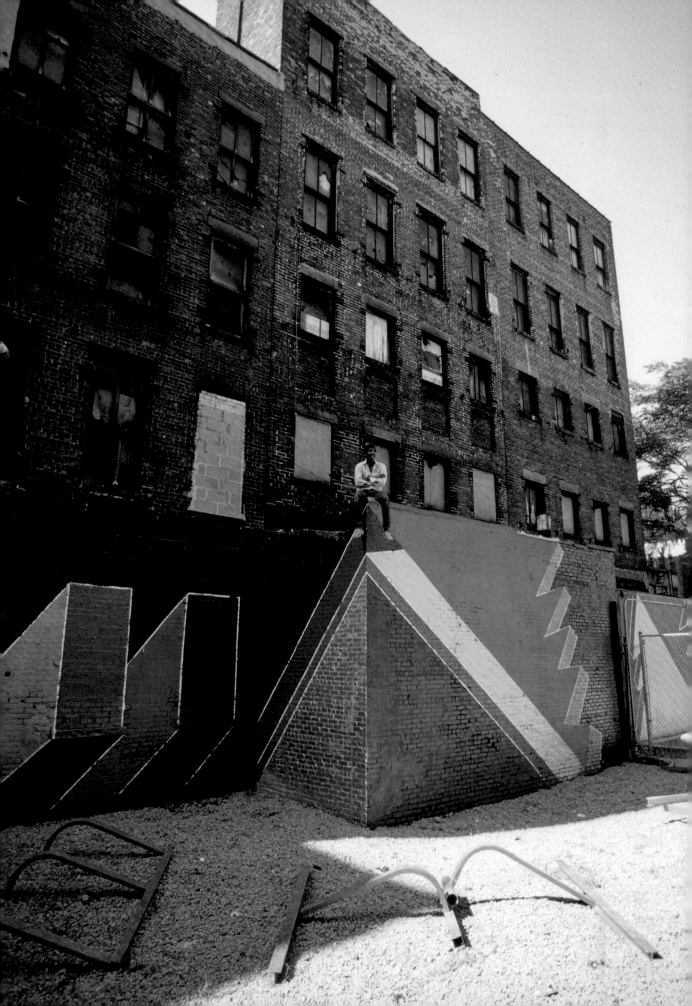

In Conversation: William T. Williams, Melvin Edwards, and Guy Ciarcia

Ashley James

In the photograph, six children stand, and one sits, in a loose formation along a wall of green, yellow, coral, and purple geometries (see p. 148). Most stand erect, with their arms closely locked to their sides, in positions by turns denoting compliance, confidence, or glee. Two smile; one child glowers; another holds his fists tight with pride. This snapshot is part of a small, though potent, cache of images that constitute the Smokehouse Associates archives, chronicles of the late 1960s collective. Through it, the beauty of this public art project is readily apparent: young city children among radiant color almost as vibrant as they are.

Yet there is a paradox to the photograph's documentary potential. With the physical works themselves long gone, these images are the few extant glimpses we have into a project that is now more than fifty years past. In this sense, they are exceptionally precious, balm against the erasure that follows the passage of time. At the same time, however, these images ultimately do not, and cannot, capture what it meant to have actually experienced these walls firsthand—a reflection of the limits of photography in its communication of the past.

Such limits apply to any and all kinds of documentation, but for the Smokehouse project they do so distinctly, directly impacting, and potentially contorting, our conception of its meaning, purpose, and function. In the space of the photographic image, the walls are themselves images, backdrops, stable and stagnant, as still as the children who stand before them. But key to an understanding of the Smokehouse project is seeing these walls as the near opposite—as movement, unfixed and flowing. Smokehouse walls were meant to be not merely seen, but inhabited, felt, and experienced over time.

In the discussion that follows, three of the Smokehouse artists, William T. Williams, Melvin Edwards, and Guy Ciarcia, make clear the experiential conceptual underpinnings of their project. Their works were not conceived as stagnant images, but more actively, as facilitators of experiences. A word they use here—conduit—seems an appropriate descriptor of this goal, suggesting public art as a conveyer or channel for a new experience of urban life. Throughout this conversation, conduit seems to approximate the elastic potential of the painted wall as a platform for multidimensional and multisensorial engagements, experienced in different ways by different people.

It is in keeping with this idea of the conduit that the artists avoid the term mural, opting instead for the phrase "painted wall(s)." To the collective, mural

denotes representation and singularity. "Painted wall" instead offers room for porosity and fracture. A straightforward description free from historical meanings, it denotes no more than the fact that painting has occurred, leaving open the ways that a visitor ultimately sees or feels it.

The Smokehouse language of the experiential, active, and open-ended is one that rhymes with concurrent theories of Conceptual art, Minimalism, and performance art. Defined by the disintegration of the boundaries between art and life, these late 1960s art movements were similarly concerned with destabilizing the bounds of the art object and placing emphasis on audience engagement. While this rhetorical overlap is apparent, the Smokehouse Associates are keen to point out that these (mostly downtown New York) movements were not the intellectual or cultural source of their outlook. Rather, their approach was an extension of their individual and collective conceptions of how art can operate in public space, an approach informed in part by an African diasporic understanding of the work of art as always and necessarily holding the capacity for use and interaction.

Through their theorizations of public art as "conduit," the Smokehouse artists remind us of the varied contours of Black artistic practice during the Black Power period and the many ways we can understand Black artistic radicality during that time. Moreover, for art historians and cultural theorists, study of the collective may very well force a revision of how we understand and write postmodern art history, revealing new origin points and aims for experimental practices in the late 1960s.

Retracing these practices is difficult work indeed. As with investigations surrounding historical performance art, the limits of the archive make reconstructing not only space but time a more complicated endeavor. Recovering these historical scenes of engagement in part requires looking beyond the visual through written reflection and/or oral histories, including key interviews undertaken by art historian Michel Oren in the late 1980s.

But perhaps the photograph can yet contain flashes of more expansive meaning. A second image in the archive depicts a painted wall of orange, blue, and coral quasi-triangular forms (see p. 103). In front of it, six children crowd an uncapped fire hydrant, whose cool water gushes out and along the street. One child covers his eyes from an insistent, beating sun. Their shoulders and arms are a jumble of limbs, indicating that the photograph was taken spontaneously, during a pause in the long summer day of play. After its flash, one presumes a swift return to the revelry.

William T. Williams, Melvin Edwards,
and Guy Ciarcia

Moderated by Ashley James

August 9, 2021

James
My first question goes back to the beginning. Smokehouse is a significant name in that it relates to the overall goals of the group. Could you talk about how this name was chosen and the ideas behind it?

Williams
The name was suggested by Walter Jones, the writer, playwright, and actor. The underpinning of the idea was the smokehouse as a repository for lean times through the winter. Smokehouses are common in the South and certainly common in this country. Thus, the name Smokehouse.

Edwards
The name came later, through Walter, after we formed the group. We all had similar backgrounds—we came from mostly working-class families and were the first generation to be educated. We had a lot of rural roots in common, even though we grew up in large cities. I grew up in Houston, William in New York.

Ciarcia
And I grew up in Union City across the river. I was five minutes from New York. By the time I joined, I was living in rural Hopewell, New Jersey.

Williams
What was interesting was the different backgrounds of the four

people involved and how we were coming to the idea of working in a public space through a collaborative process. Part of the magic of the group was the diversity of opinions, ideas about what a mural, fresco, or a work of art was, and what the involvement of an audience could be. I think that kind of interaction was very much a part of the process.

Edwards
It was realistic and intellectual and provocative in terms of what was going on in urban development, not just in the United States and in Harlem, but throughout the world. I was aware of Brasília—this idea of planning societies—and at the same time, I was aware of New York's evolution from a farm in the Bronx and a port in Lower Manhattan. There was a time when east of what is now Macy's was called Little Africa. Those things are lost, and yet they're not lost, because they're the underpinnings of how people inhabit those spaces today. For me, coming from Texas, Harlem was as emblematic a destination as one could have. I first went west in order to go north to leave the South, and then a little more than ten years later, I came to New York, where I encountered William. We had all been developing our own ideas about art in a multiplicity of ways, and that really informed what we were doing.

James
When you think about migration patterns, the name Smokehouse returns to a Southern origin, even if by that time you all had crisscrossed the nation. I'm curious about what those first discussions were like and what ideas were fermenting among you all?

Williams
That's a difficult question. I think we were thinking about wanting an engagement with a place, with people, trying to think about what art's function is—what is art, what's art to an audience, as opposed to what's art to the artist? Our studio concerns were clear. A lot of the conversations had to do with perceptions: how are people perceiving and experiencing something? We were more interested in the experience for the viewer, as opposed to a didactic idea about what we were making. I think the two things are drastically different.
 I remember having endless conversations about the physical environment we were working in, the implications of scale, and the proportions of buildings and how that impacted how one perceived a work of art within that space. At that particular time, Harlem was going through a blight. There were endless empty lots, endless abandoned buildings. I was concerned with what was going to happen to the Harlem I had known all my life and that I had ties to. But more,

what was going to happen to the people living there? What were they experiencing, and how were they feeling about their homes? In some cases, it was the only home they had known, while other, younger people were moving in from across the country. So it was a changing place; it was dynamic and symbolic of what was happening in Detroit, Chicago, the Fifth Ward, all across the country. I think that type of engagement had to do with the humanity of Guy, Mel, and Billy Rose. They had no practical reasons, in terms of their careers, to be involved in Smokehouse other than a human concern—the idea that art has the possibility of changing people, places, and things.

Ciarcia
I came on board, I believe, in late July or early August of 1968. You guys had already painted several murals. Your experiences are a little different from mine. I remember the first piece I was involved with was in Sylvan Place. I had this hundred-foot-long wall and I was dealing mostly with formal problems—how to solve this, that, and the other thing. The sociological aspect was deeper for you than it was for me.

Edwards
No, you were very good at bringing up things that were pertinent and you humanized the technical challenges that were apparent, and that's important.

Ciarcia
I don't remember who decided to paint the background on that wall silver, but I do remember that a woman in the park came up to us after the wall was done, and she was just beside herself with joy. We changed the environment for her in a positive way. If I remember right, the drug addicts who had been there before left because they couldn't take the light. That silver background reflected all kinds of light into that park. That was significant for me. I never forgot that.

Edwards
Several people said, "You gave us our park back." In the city at that time, all of the wooden slats of the benches were gone. That was the city's way of preventing people from hanging out. But it meant older people and families couldn't sit in the park either. The city saw what was happening through our work, and they put the slats back on the seats, and families started to recongregate in the park. It became a positive part of the community's life.

The word "mural" was used, and I always said, "We're not doing murals." My own background and knowledge came from the Mexican muralists, who emphasized public art, mural scale, and social development, and really analyzed art's purpose in the twentieth century. People know the names Gabriel Orozco, Diego Rivera, David Alfaro Siqueiros, and others. The principles

in their work were moralistic, in that they intended the work itself to give messages, along with being spatially dynamic. Our work did not give messages. Our message, if you want to call it that, would have been that we changed the place, and because we changed the place, we were changing the situation. I think we were all in agreement with that idea.

This was in contrast to some other public art projects. People talk about the Wall of Respect in Chicago, and of course that dealt with imagery and protests and things like that. We stepped beyond protest to construct something new. Our ideas also extended to evaluating what happened after we did our work. I think this group could have planned and developed cities. We already knew how, and we eventually worked with people who did that in various places throughout the world. Guy had been in the schools in New Jersey, William was teaching at Brooklyn College, and I taught at Rutgers University later on. We also went to other places in the world at various points and saw what people were doing. We weren't limited, if you will, to the limitations of American art education in universities, where they're still often asking the wrong questions.

Williams
One of the things that came from this was the idea of having people stop and experience something. Our politics or message, if you will, really had to do with those people and their experiences, as opposed to having a didactic political message.

We made a practical decision about how high up we were going to paint on a building. This was paramount in terms of wanting people to have a relationship to the objects. It was also practical in the sense that none of us wanted to go up on scaffolding. They were old buildings, and there were all kinds of issues about insurance, safety, etc., that we would have had to confront. A more horizontal format also led to a longer-lasting experience for the viewer, and I think that participatory nature of their involvement was very important for what we were doing.

Edwards
There's a picture of Bill up on a ladder. (Laughs)

Williams
Yes. A very small ladder.

Edwards
That was about as high as any of us got. (Laughs)

Ciarcia
You forget, we lashed two of those ladders together and yours truly got to go up! (Laughter)

James
Picking up on that thread about the participatory nature of the work, horizontality, and the proportions of space, Smokehouse was happening concurrently with certain

ideas percolating in New York City during this time. I'm thinking particularly about the movement around Minimalism and performance art, which shares this language of an unfolding individual engagement with an artwork rather than the artwork as a concrete image. I'm curious if Minimalism and these parallel art historical discourses were something you were thinking about while making these participatory works? Or is it something you think about in hindsight?

Edwards
Minimalism was a label. At the time, there was already a good two thousand years of simple and complex compositions in human history—take the pyramids for example. We didn't work off of the labels. I taught for forty years, and I saw the growth and classification of things become more real than the realities. All of those aspects were already there.

Ciarcia
Of course, Minimalism was in the air in 1968. Those artists were having shows and everything. I can't say that for myself. I'm not surprised we were working like that.

Edwards
I hesitate with the label for us, that's all. You're quite right, the presence was there. My first painted sculpture with a geometric emphasis was earlier that year in the summer of 1968. I made a body of work while

in residence at the Sabathani Community Center in Minneapolis. The Walker Art Center saw the work, and they staged the first exhibition of sculpture outdoors in collaboration with the City of Minneapolis. All I'm saying is that these ideas and this potential were already there within us. They made sense, without bringing in, shall we say, pertinent local art history at the time. We were just trying to do something.

James
Perhaps it's the art historian's task to bring clarity to the historical categorizations of the moment.

Williams
Sometimes you refer to Minimalism as a style as opposed to a method of construction. What Mel is very much speaking to is that through our involvement and experiences of other cultures, you can see that tendency to simplify things. Certainly you can see that with any walk through the Metropolitan Museum of Art. The way of constructing something or thinking about things, as Mel said, precedes the idea of a style. Very often, we think of Minimalism as having started in the 1960s. I think that references a prevalent style occurring in that moment. It would do us a disservice to link us with Minimalism.

My thoughts about the Minimalist movement is that it was art about art, and art about art historical ideas. I don't think we were involved in

making art about art as Smokehouse. We weren't making art. There was no intent to make art. There was an intent to engage people in dialogue—dialogue not with words, but dialogue through an experience. And hopefully those people would then begin to forge other kinds of ideas and experiences. It's about empowering them as a community to take charge of their lives. What Smokehouse did was call attention to a specific space, and that then called attention to how and where the community was living. But their aesthetic experience with the wall was personal. It had nothing to do with urban blight. It had to do with a moment of humanity, an experience they were having with a specific place.

Edwards
In that period there were block associations already formed with concerns about the community. I remember one in particular responded beautifully with a sense of participation. It wasn't like we imposed something from our art world experience on the community. The things that happened in the years to come reflected that. There was a sculpture of mine, *Double Circles*, at the Bethune Towers at 143rd Street and Lenox Avenue. Within the year, it got graffitied up. I took photographs when it was fresh, and I took photographs of youngsters posing with the work with graffiti all over it. A part of what was going on in that period was

the early aspects of what became known as graffiti in the art world. But people have been writing on and marking walls since the days of the pyramids. We were part of a very long history of public art, and we weren't naive about that. I met the architect Demas Nwoko in Nigeria in 1970. He was challenging the European modernism that was being imposed at the end of colonialism. Nwoko said he could do something that was at once African, modern, functional, and original. Something that came from the cultures, plural, of Africa, and I think we're an extension of that. Harlem is a point, but it references the worlds we all come from and are still participating in. Smokehouse hasn't ended. If you go inside it, there are ideas that sustain. I'm happy this interview is happening because there's more to it. We won't have time to cover it all, but what can I say?

James
I want to ask about the way you all worked, an approach constructed with the intention of a viewer relationship, to change the environment, and to change an individual in a time-based negotiation. I'm curious how, in the making of these...

Edwards
You can say "painted walls."

James
So, in these painted walls, how did you ensure it didn't seep into mural making? How did you keep

the design process open-ended and in circulation, rather than codified into a specific image?

Ciarcia
I remember the four of us sitting around on a curb looking at a configuration of buildings and walls around us and talking about a diagonal here or a line there. Putting it together in our heads and knocking it around among the three of us. When we finally made a decision, we started laying it out. Sometimes it took off. We extrapolated on that; we'd make changes as we went along. I remember spending more time talking about it than painting it. Maybe I'm exaggerating. But I remember spending a lot of time in Bill's studio talking about the dynamics of the project. It seems like it almost took no time at all to paint the walls, especially when I introduced the rollers. We were doing it with brushes in the beginning, and that was taking forever. I'll take credit for the rollers.

Edwards
Well, keep on rolling, because it worked well! I had been living in upstate New York because I was teaching in Middletown. Then I moved into William's studio for a few months to get myself together. I saw the processes he used. Everybody we knew in that period was busy with their own experiments. It wasn't like the labels came first and then we applied our ideas to the labels. The ideas were evolving out of us

very directly, in terms of what we were learning from our own personal experiments. William's exhibition at Reese Palley Gallery in 1971 was a dynamic wall-to-wall installation of paintings. It was a knockout in the New York art world. So the quality of the people involved—Guy, Billy Rose, myself—we all had something to contribute. It wasn't argumentative. There might have been a variety of points of view.

One discussion I remember was between William and me. We were sitting in a room at the original location of The Studio Museum in Harlem looking out on Fifth Avenue. We were commenting to each other on the different colors of clothes people were wearing. From our points of view, we could see dynamics that were absolutely applicable in art. Not about clothing, but about art, about moving pieces and aspects of color, both kinetic and static. And here our project had been with buildings that were static. But the world we were working in was absolutely in motion. That meant there was always a potential for something new. Our ideas all came from the worlds, plural, that we lived in and experienced. Harlem, in this case, was the center.

James
I'm curious if there was a kind of workshop aspect to things when somebody presented an idea? Was there a back-and-forth around specific compositions before they were painted on the walls?

On a formal level, how was that nego-
tiated among you all?

Ciarcia
We collaborated on just about every
aspect of every piece. I remember
talking about a diagonal and dis-
cussing how we could maximize the
interaction of the passersby at this
particular angle. Is it too much, is it
too little? We really did work together
in every sense.

Williams
The paint we were using was sign
painters' paint. There isn't a lot of
subtlety with that paint. You're forced
into the graphic right away. You're
also dealing with the tactile surface
of the building. These aren't perfect
walls—bricks are protruding out,
there's mortar and everything. So
you have all these other graphic and
sculptural marks present within the
wall. I can remember a number of
times where something was painted
over and the color was changed.
It was on the fly constantly. The pro-
cess, as I remember it, was that each
time we received a new wall, or we
found a new wall and got permission,
or didn't get permission...

Edwards
(Laughs)

Williams
...each member of the group would
initiate a design. From there, we
would discuss what had been drawn
up and talk about what we wanted

to do. How do you fit this within a
given space? That was the key to
it. The site where we go through the
alleyways, on 121st Street between
Second and Third Avenues, is prob-
ably the summation of everything we
wanted to do. We found a space that
was not visible from the street but was
visible from the overlooking apart-
ments on both sides. It formed an
enclosed environment, an ideal place
for total immersion in a work of art.
It's the one place where you have four
different perceptions, or four different
projects, introduced by four different
people. Yet, it works extremely well,
primarily because of those endless
conversations Guy spoke of—how
we thought about the formal aspects
of what we were doing.
 There were discussions about
the human and political aspects of
it as well, about the nature of what
we were doing, and the nature of our
engagement with the community.
Mel mentioned the idea of not impos-
ing ourselves on the community.
If there was a block association, we'd
go to that block association, find out
their interests, how we could sup-
port them, and how they could be
involved. Not once in all the times we
worked in Harlem were we ever given
a design of what they wanted us to
paint, or asked, "Why didn't you paint
flowers?" or "Why didn't you paint a
figure?" That never occurred, I think,
because we were focused on not
imposing something.
 Public art can be an imposition
on a community. What begins to

happen is, years and years later, we'll look up and think, "We've got to take that down." The politics will have changed, or the building or the space will have changed. We were trying to think through all those kinds of things from the beginning. The one thing I had objections to was the idea of a monumental scale. There is an imposition that occurs when the viewer is required to look upward. I always found that objectionable in terms of my experience with a billboard and/or a work of art. And with geometry, an imposition doesn't occur. Geometry, which to me is a neutral language that appears in all cultures, allowed us to talk about and do things other than imposing a message.

Ciarcia
We were storytelling without words. We weren't political. We weren't protesting. It was storytelling with abstract form: color, shape, line, etc. The work was moving, at least for me. I can still remember staring at some of the pieces and going, "Wow," unable to put it in words. It was a visceral reaction.

Edwards
I remember after this project we did an event at Cooper Union under the name of Smokehouse. It involved William reading words with imagery. Walter Jones recited something, if I remember correctly. The poet Jayne Cortez read a poem. And I showed slides of our projects along with other things of interest. This was a collective event presented by members from our group and related people. It sort of expanded beyond the painting projects in Harlem eventually. We all went our independent ways, but at the same time we're always calling or talking to each other and other people with similar sensibilities. We've been asked, "Oh, why did you keep so-and-so out?" Well, there was no in and out. This was not an organization or club where people did or didn't belong because of a political or social reason. There wasn't any exclusion—we were inclusive.

James
Was there ever a time when you nixed an idea because it was too much like a mural or the design wasn't sufficiently centered in the viewer's experience?

Edwards
No, we didn't impose philosophical or aesthetic limitations on one another. We seemed to be of such similar minds that that just wasn't an issue. We went over everything. There was nothing we wouldn't discuss. Other groups and other activities may have had those considerations. We just went past them. That's all I can say.

James
My next question is about the specificity of Spanish Harlem. William, you spoke about the universal language of geometry and the aesthetics

native to the area versus what you all accomplished there. I'm curious how you feel about your methods of painting walls vis-à-vis Harlem, and if it's specific to Harlem? Is it something that could be reproducible in another Black urban context, or do you feel that the walls were tethered to the experience uptown? I'm curious about how much the location related to the philosophy, the aesthetics, and the process?

Williams
The pieces themselves are specific to 121st, 123rd, and so on. The concept is universal. We could have done it in Washington, DC, or Seattle, Washington. It's just a question of the response to a specific space. I think the subtext of what you asked me is the cultural aspect of it. Certainly, the energy of the place was something we were involved in and thinking about and experiencing every day. When Mel speaks about the passing colors that people are wearing in the street, it's an awareness of the specificity of that place. If we go to another town, you'll have a different palette. But primarily, mobility of bodies and things moving past each other will be there. It's the recognition of that transient notion of color as opposed to static color that I think Mel is referencing. Could what we did be done other places? Yes, it could be done, and it has been done. There are huge communities designed that way, housing painted that way; we were responding to a time, a place,

a political context. All those things were in our minds.

We went to Washington, DC, and had a meeting with Patricia Harris, who was Secretary of HUD (Housing and Urban Development), to present our ideas of how what we were doing could be used in relation to the development of housing and communities across the country. This was at the beginning of the one-percent earmark for art in federal buildings. We proposed that it should not only go into government buildings like courthouses, but also the public housing that was being developed. There is an aesthetic concern in a housing project as much as in a courthouse. It could be applied anywhere.

What's happened over a period of time is that more and more places are getting public art because of an aesthetic concern. It's breaking down the idea that art is only suited for some special place in favor of the idea that there are other forms of art and other forms of engagement such as public parks. There are all kinds of things that could be happening. Every subway platform in New York now has some form of art engagement. Whether you like the particular thing that the artist is doing is almost irrelevant to the idea of taking art out of the museum, out of the gallery, and placing it in a public context. I think that's the aftermath of Smokehouse. A lot of the things we talked about, a lot of the things we wanted to do, we began to see happening.

We're seeing a different idea of aesthetic engagement in society today.

Ciarcia

I did a mural project in Trenton, New Jersey, and there was a lot of resistance. I imagine this goes on in different places. In Harlem, we were lucky in that nobody was saying, "Can you paint a flower here?" or "Can you paint a picture of somebody there?" In Trenton there were a lot of questions about what I was doing or what I was painting. People wanted pictures they understood. I would imagine a lot of what goes up in public spaces depends on who's living there.

Williams

And who's controlling the money. I think as a collaboration Smokehouse was successful in that four human beings were able to have thoughts and communicate with each other about where we were as artists and why we were making art. All of the works we did are gone. I think that's good as well. The impermanent nature of what we did is important to the idea that art is always evolving, it's changing. We're getting past the notion of monuments. I think we were successful as a group because we weren't thinking about art, or we had no pretext that we were making art. That allowed it to grow in an organic way.

It organically stopped as well, because in every case we saw other things that were possible. There

was Mel's engagement with public art and his travels that brought him in dialogue with architects around the world. Guy's extension into New Jersey, when he started painting murals. The idea began to expand and expand and expand. Now, you can probably go into any city across the country and you're going to see painted walls. This is 1968 when we started this—there was much less of that then.

I think the important aspect of this, if it's to be memorialized in a book, is that we're pinpointing four of us who were involved, but there were many people behind the scenes helping as well. People who were helping us get materials, fundraising, all of those necessary aspects of a project. Photographers, poets, musicians, were all involved. We were talking with a lot of people during that time and I think there was something in the air about what art engagement could be, and in that sense, it was extraordinarily successful. The cross section of people, of artists, was pretty extraordinary.

James

I want to tease out the one-to-one engagement that happens between a painted wall and a Harlem resident. What does that look like? William, you described this as something that you can't really know. But on a speculative level, what is the hope? Is it about changing an environment and bringing a new awareness to it, as you've said?

Is it about lifting someone's mood? Or shifting someone's relationship to the street? I'm interested in exploring the different ways you saw the painted wall as serving as a conduit for the individual experience?

Williams
In any engagement with the arts there's a transformation that occurs, and that transformation is for the better. With any kind of self-reflection in relation to an experience, the person grows, be it negative or positive. They're making decisions, aesthetic, personal, political. As such, I think, conduit is a very good word. I think that's what Smokehouse was, a conduit to do something. We believed things could be better, and to achieve that the first step is awareness, followed by personal responsibility, and that leads to public pressure and government responsibility. All of these things are interrelated. It became apparent to me, once we left Washington after speaking with Patricia Harris, that what we were conceiving of was very, very complex. We were doing it on a small scale, almost like a little incubator in Harlem. But our thoughts were much more national, global. That required going back to the drawing board and thinking about other ways of reaching those goals.

You have the Studio Museum starting at the same time we're painting these walls. So there's this desire to build institutions and a realization of the importance of the institution. It gives you an anchor in a community, and once you have that anchor, people are less likely to give up territory. Harlem won't disappear. The cultural things we know of and have invested in, the historical importance we apply to Harlem, are not going to disappear when you have those institutions. As a teenager, I used to go to dances in the basement of St. James Presbyterian Church, which started the Harlem School of the Arts. Dorothy Maynor was the person who ran it. And here, fifty years later, there's this magnificent building that's embracing the idea of all the human potential in Harlem. All these kids who have extraordinary possibilities—you just have to place the facility there. Create the opportunity there. You see all of these things coming together in this moment. You have the Dance Theatre of Harlem. The years I spent in the Schomburg library as a kid. All of that's still alive and more important now than ever. Smokehouse was a little grain in all of that. Many people had the same kind of dream. The dream comes first, and then the reality of that dream comes with hard work.

Edwards
Right on the money, William. Right on the money.

Williams
There's a Smokehouse in every community in this country. There's a kid who's drawing on the floor

with crayons, or jumping off the bed dancing, with enormous potential, and it's up to us to provide the facilities and the mechanisms where they can realize those dreams.

James

Can I ask about color in the chromatic sense? I'm curious about the overall palette. You have said it's in part a response to the colors reflected in Harlem itself. There's the perspectival, geometric formal language, and then there's the color. I'm wondering what the concepts behind those color choices were for you all?

Edwards

I think that complicates something really simple. We were all young adult artists in the 1960s who had studied the science of color in school, so we already had that knowledge and we understood our profession. Red, yellow, and blue, black, and white. Any other color you name is some mixture of those. As far as us trying to make some limited significance of some particular ideas of color, you're going up an unnecessary route. The basics contain all the dynamics and potential.

Ciarcia

I think the colors we chose were about pushing the space in the walls, pushing the space around. When we used silver a couple of times, or at least the two times that I can remember, it was wonderful. It made the wall disappear. It pushed the color forward. It was a successful application.

James

As you noted earlier, this question of monumentality is quite topical right now. As monuments are toppled, there is public money going into building new ones. I wanted to go back to how you all were thinking about scale. You mentioned it was about maintaining this human relationship, but I am interested in how that shifted as you moved into conceiving of larger-scale painted walls and projects?

Williams

I think some of it has to do with how wide the streets are, because you only have so much room to back up to see something. If you scale the thing up eight stories high by twenty stories wide, you won't be able to see it. There are these practical things to take into consideration when you work in a New York City grid. If the work is to be visible and holistic, meaning you can experience the whole thing, there are limits to the height and width. I think we were fairly successful in most of those engagements. Sometimes having something long and low at the beginning of the block, and continuing that same linearity farther down the block, maintained a connection. We thought about all of those connections in relation to constructing the pieces. The paint we were using had limitations. It muddied very quickly

when you mixed it. So, the clarity came along with the simplicity of the iconography. The clarity of color worked in relationship to that.

Ciarcia
We weren't looking at the walls as pictures with edges. There was an element of participation—you were experiencing the painting rather than looking at it.

Williams
I think that's really essential to what we were doing.

Edwards
It was environmental at human scale.

Williams
There are some beautiful photographs taken with kids playing on Mel's sculpture during the time we were constructing this. We have ideas about the beauty and the form of the objects we make. Yet, these kids' engagement was totally different. They were experiencing the sculptures physically. They had the sense of freedom to do that. There's another photograph where the kids are posing in front of a wall. Again, they are participating. I think that's when we knew we were successful, when people would come over to where we were painting and stand and watch us. That was remarkable because it suggested hope. All those things made me want to come back the next day and work. Not to mention the engagement with the other three artists.

The most difficult part in all of this, I think, is that when you finish one project, you want to go on to another one. You want to find an environment that offers different engagement problems. Most of the walls we chose were difficult. What I mean by difficult is that you couldn't back up a hundred feet to do it. There were lots of walls on schools where you had a big playground, and you could back up and see the thing at a distance; we never did one of those. They were always almost semi-intimate spaces we chose and worked on, except for the firehouse on 126th Street. When we did that, the firemen thought we were city painters. They were concerned they would not get the other improvements they needed because we had painted it. Their other concerns were what kind of paint were we using, that we weren't putting a flammable material on the side of the building.

Ciarcia
They didn't want anybody to touch that building.

Williams
Right. The other difficult part was making decisions whether to seek permission to paint the buildings or to just go in and paint them. When we did things with the City, we always went through the process of trying to get permission. But it became impossible after a while. It came to a point sometimes where we decided, "Gee, we really like that wall. Let's do it."

In most cases, when the landlord or owner found out, they were thrilled we were doing it.

Edwards
Free paint job.

Williams
We used to leave our materials in buildings close to the sites. Once, we left our paints at a storefront library that a local block association had started. When we came back the next day, a lot of the paint was gone. We rejoiced in this, the idea that someone had taken the paint because they were going to improve their own lives. They were going to change their environment. So again, it was a success. It's like stealing a book from a library. The librarian's happy you stole it. I mean, they're not happy, but they know you're engaged in the process of reading. You're engaged in the process of what they're trying to do, which is present ideas.

James
Hearing you all talk about the negotiations between government entities and community members, I'm wondering what the takeaways were for each of you as artists, but also as people working on a project that required you to be collaborative and scrappy in various ways?

Williams
I normally don't do public things. Primarily because of time constraints and because when I'm doing my own work, it takes me a long time, involving lots of changes. The public discourse requires a direct engagement and execution. You don't have time to go back and change things. You got to have the skills to engage community first and foremost, and bring them on board with your concept. You have to negotiate the contracts and all of that stuff. I don't have that much time left in my life. I like going to the studio and doing whatever it is I want to do. That's what I've done for the last fifty years. There are no compromises. I learned an awful lot working with three other artists. I learned a lot from the community in Harlem. But I really like going to my studio and working.

Ciarcia
It has been a lasting experience for me. I never wanted to see it to end. I was making my own models that proposed building onto the walls or taking it onto the sidewalks. Looking back fifty years, the influences are still with me. Fifty years later, I decided to glue all my stuff together in assemblages. It's just like all of that rubble on the ground in Harlem in those days. What do you do with junk? You repurpose it.

Edwards
I am a bit involved in public sculpture enterprises. You spend a lot of time going through interactions and helping people understand how things need to be done. Those years in Harlem, we worked these things out

among ourselves. I would still love
to do our projects, but I would want
carte blanche. Give us all the money,
the rights to all the space, and don't
bother us until it's finished. Because,
the truth is, in these kinds of situa-
tions, the artist is the expert, both as
participant, as viewer, and of course,
as conceiver. It's our baby, but it's
for our family, our communities, and
our world. It's our small contribution
to the ideas that will hopefully move
the world forward a bit.

 We got it pretty right with the work,
but we couldn't ensure that everyone
had a good living space, that every-
body was employed, that everyone's
children could go to high school and
attend college for free. A college
education should not cost anything,
because it's a contribution to our
society. Our aesthetics are not limited
to red, yellow, blue, black, and white
and city walls. It's much more sig-
nificant than that. It's not limited
to whether or not somebody knocks
down a statue that existed for what-
ever reasons. It has more to do with
what are we constructing that is
significant for now and for the future.
In other words, we're creating artists.
We fostered creativity.

Chronology 1962–78

Eric Booker with Noa Hines, Habiba Hopson, Lilia Rocio Taboada, and Meg Whiteford

This chronology contextualizes the vibrant yet turbulent period in which the Smokehouse Associates collective was active, compiling concurrent histories of artistic activism, Black abstraction, collective projects, city policies, and the civil rights movement. Although the group created its public art projects for just three years (1968–70), the periods preceding and following its activity also provide an important backdrop. The chronology's diverse constellation of events offers a broad framework in which to consider Smokehouse's abstract, environmental, and social strategies, along with the individual artists' careers and those of their peers, during an era that saw the redefinition of artistic practice, arts institutions, and public space.

195

William T. Williams receives his AAS degree from
New York Community College.

Williams enrolls at Pratt Institute in Brooklyn.
Outside class, he works in after-school programs
in public schools and community centers.

Melvin Edwards takes part in the Annual at the
La Jolla Museum of Art.

Guy Ciarcia attends the Accademia di Belle Arti
in Florence during his junior year at Pratt.

In New York City, Mayor Robert F. Wagner Jr.
establishes the Office of Cultural Affairs (OCA),
which predates federal arts agencies such as the
National Endowment for the Arts.

The Umbra Poets Workshop is formed in New
York's Lower East Side. The group of African
American writers hosts readings, performances,
festivals, and workshops, fostering an experi-
mental and politically minded space until 1965.

Harlem Youth Opportunities Unlimited (HARYOU)
is founded by Kenneth B. Clark (later becoming
HARYOU-ACT after merging with the Associated
Community Teams [ACT], an initiative started by
Adam Clayton Powell). The organization focuses
on five areas: community action, education,
employment, special programs, and arts
and culture.

1963

The March on Washington for Jobs and Freedom
draws more than 250,000 people to the capital
on August 28 in protest for racial equality. Martin
Luther King Jr. delivers his famous "I Have a
Dream" speech. The event marks a pivotal turning
point in the movement.

The New York–based collective Spiral is formed
in response to the March on Washington. The
group is composed of African American artists,
including Emma Amos, Romare Bearden, Norman
Lewis, and Hale Woodruff, who are united not by
aesthetic style or political view, but by a shared
commitment to addressing the social and artistic
issues that Black artists face.

Williams is included in the *Art Festival for NAACP
Legal Defense* benefit exhibition at the Brooklyn
Museum alongside artists such as Romare
Bearden and Jacob Lawrence.

Edwards produces *Some Bright Morning*,
his first sculpture in the "Lynch Fragment" series,
in response to the racially tense climate of
Los Angeles in the early 1960s.

Edwards visits New York for the first time.

John F. Kennedy is assassinated on November
22 in Dallas; Vice President Lyndon B. Johnson is
sworn in as president.

The Kamoinge Workshop is founded. Directed
by Roy DeCarava, the group is composed of
African American photographers, including
Anthony Barboza, Adger Cowans, Daniel Dawson,
and Ming Smith, who create images of Black
life from the perspectives of their personal and
collective communities.

1964

The Twenty-Fourth Amendment to the Constitution
passes, protecting African Americans' right to vote
by outlawing the poll tax in federal elections.

Twentieth Century Creators forms under the
leadership of James Sneed and Malikah Rahman.
A coalition of more than fifty artists, the Harlem-
based group stages art projects and initiates
a sidewalk exhibition between 127th and 135th
Streets along Seventh Avenue.

The Harlem Cultural Council, directed by Romare
Bearden, is created, providing public, outdoor,
and mobile performances to Harlem residents.

Architects' Renewal Committee in Harlem (ARCH)
is founded as an advocacy planning group.
Comprising architects and urban planners, ARCH
seeks to ensure that projects planned for Harlem
benefit the neighborhood. The architect J. Max
Bond Jr. assumes the role of Director in 1968.

Congress passes the Economic Opportunity
Act, part of President Johnson's War on
Poverty legislation. The initiative catalyzes the
launch of community action programs and
employment and education opportunities in
impoverished communities.

Artists Noah Purifoy and Judson Powell, along with
local schoolteacher Sue Welsh, found the Watts
Towers Art Center, which offers free arts classes to
the community. It becomes an important gathering
place for Black artists in Los Angeles and an
incubator for socially engaged art.

The Civil Rights Act of 1964 passes. The landmark
bill outlaws segregation in public places and
employment discrimination on the basis of race,
color, religion, sex, and national origin.

James Powell, a fifteen-year-old African American
is fatally shot by a white off-duty police officer in
New York's Upper East Side, sparking protests
across Harlem, Bedford-Stuyvesant, and the nation.

President Johnson signs the National Arts and
Cultural Development Act into law, establishing
the National Endowment for the Arts. The agency
becomes the largest arts and arts education
funder in the country.

The 1964–65 New York World's Fair opens
in Flushing Meadows–Corona Park in Queens.
Led by urban planner and former Parks
Commissioner Robert Moses, it ushers in a new
age for public sculpture, showing traditional
statuary alongside contemporary art.

1965

At the suggestion of his teacher Richard Bove,
Williams visits a Hans Hofmann show at
Kootz Gallery. Williams transitions away from
representation soon thereafter.

Williams attends the Skowhegan School of
Painting and Sculpture in the summer following his
junior year at Pratt and meets the artist and paint
manufacturer Lenny Bocour. Bocour plays a role in
the artist's technical experimentation, introducing
him to acrylic paint and supplying him with the
medium for more than a decade.

Edwards earns his BFA from the University
of Southern California.

Ciarcia attends New York University, where he
eventually earns his MA in arts education.

Malcolm X is assassinated in New York City at the
Audubon Ballroom in Washington Heights.

Edwards's first solo exhibition, *Melvin Edwards*,
opens at the Santa Barbara Museum of Art.

Edwards is included in *Five Younger Los Angeles
Artists*, along with Tony Berlant, Llyn Foulkes,
Lloyd Hamrol, and Philip Rich at the Los Angeles
County Museum of Art.

In Harlem, members of the now-dissolved
Twentieth Century Creators form Weusi (which
means "blackness" in Swahili). Among their
many programs and workshops, the cooperative
forms the annual Harlem Outdoor Festival, an
exhibition staged along the fencing of St. Nicholas
Park. The festival grows to include concerts and
performances, continuing for fourteen years
and laying the groundwork for Harlem Week.

Spiral organizes its first and only exhibition, *Black
and White*, at Christopher Street Gallery.

Edwards joins the faculty of Chouinard Art Institute
(now California Institute of the Arts), where he
teaches until 1967.

Black feminist poet, playwright, and activist June
Jordan collaborates with architect Buckminster
Fuller on "Skyrise for Harlem." Conceived in
response to the 1964 Harlem riots, their plan
proposes a utopic public housing project designed
specifically for Harlem residents to transform the
community from within.

President Johnson signs the Voting Rights Act
into law, prohibiting literacy tests as a requirement
for voter registration and other forms of
voter discrimination.

The Watts Rebellion breaks out in Los Angeles
following the arrest of a young Black motorist.
The insurrection lasts for six days, resulting in
thirty-four deaths and the destruction of a
thousand buildings in the predominately
Black neighborhood.

The Black Arts Repertory Theatre/School (BARTS)
is founded in a brownstone on West 130th Street
by the poet Amiri Baraka (then LeRoi Jones).
Its establishment paves the way for the Black
Arts Movement.

Williams receives a travel grant from the National
Endowment for the Arts.

The Association for the Advancement of Creative
Musicians (AACM) forms in Chicago's South
Side. Started by musicians Richard Abrams,
Jodie Christian, Phil Cohran, and Steve McCall,
the collective fosters a sense of experimentation,
improvisation, and collaboration, revolutionizing
jazz music.

John V. Lindsay publishes the "White Paper"
outlining his plan for parks and recreation in
New York City as part of his mayoral campaign.
The document calls for greater community
involvement in parks and proposes the creation
of "vest-pocket" and "adventure" playgrounds
in vacant lots throughout the city.

Landscape architect M. Paul Friedberg works with
students from Pratt to design murals as part of
his transformation of two vacant lots in Bedford-
Stuyvesant into vest-pocket playgrounds.

Williams earns his BFA from Pratt Institute.
At Pratt he meets future Smokehouse member
Guy Ciarcia, his eventual wife Pat DeWeese,
and the photographer Robert Colton, who later
documents the group's projects.

John V. Lindsay is elected Mayor of New York City.
As part of his plan for the city, he transfers the
Office of Cultural Affairs from the Mayor's office to
the Parks Department.

Lindsay appoints Thomas P. F. Hoving as Parks
Commissioner. A curator from the Metropolitan
Museum of Art, Hoving envisions the "park as
public theater," ushering in a dynamic period for
cultural programs throughout the City's parks
and public spaces. Hoving returns to the Met as
Director a year later.

An initiative of the Artists' Protest Committee,
the Los Angeles Peace Tower is designed by Mark
di Suvero and collaboratively built with a diverse
group of artists including Edwards, Judy Chicago,
and May Stevens. Made in protest of the Vietnam
War, the sixty-foot abstract sculpture is surrounded
by a wall featuring paintings by artists from around
the world.

The First World Festival of Black Arts (FESMAN)
occurs in Dakar, Senegal.

Edwards and Sam Gilliam participate in the
group show *The Negro in American Art* at UCLA
Art Galleries.

Williams is included in group exhibitions at Lenox
Hill Hospital and the Pratt Institute.

Architect Richard Dattner and M. Paul Friedberg design some of the City's earliest adventure playgrounds on West 67th Street and Jacob Riis Plaza, respectively. Avant-garde playscapes, these environments inspire imaginative, free-form experiences for children.

President Johnson's administration passes the Demonstration Cities and Metropolitan Development Act of 1966, initiating what eventually becomes the Model Cities Program.

Huey Newton and Bobby Seale form the Black Panther Party for Self-Defense (BPP).

1967

Edwards moves to New York City.

Ciarcia begins teaching in the Trenton, New Jersey, school system, where he will continue to teach for twenty-five years.

The Visual Arts Workshop of the Organization of Black American Culture (OBAC) creates the Wall of Respect on Chicago's South Side, celebrating Black heroes throughout history and inspiring communities around the country to paint murals reflecting their own stories and achievements.

Seeking to revitalize the urban environment through realizing its work on a monumental scale, City Walls, Inc. begins painting murals on building facades in Lower Manhattan, Brooklyn, and the Bronx. Its members include Allan D'Arcangelo, Jason Crum, Nassos Daphnis, Tania (Tatiana Lewin), Forrest Myers, Mel Pekarsky, Robert Wiegand, and Todd Williams. The group incorporates as a nonprofit in 1969.

Monsignor Robert Fox of St. Paul's Church in East
Harlem conceives Summer in the City, a New York
City antipoverty program with efforts concentrated
in the South Bronx, East Harlem, and the Lower
East Side that intends to change lives through
providing a means of creative expression.

Edwards is included in exhibitions at California
State College and San Fernando Valley State
College.

Edwards begins teaching at Orange County
Community College.

More than a thousand people gather in Newark for
the first National Conference on Black Power.

Sculpture in Environment, an exhibition conceived
by Doris Freedman and organized by the Office
of Cultural Affairs in partnership with the Parks
Department, opens with contemporary sculptures
placed in public parks around the city. Using public
space as an outdoor museum, the exhibition
lets art "loose in the city" to inspire new reactions.

Kenneth B. Clark delivers his speech "The Present
Dilemma of the Negro" at the Annual Meeting of
the Southern Regional Council in Atlanta, where
he addresses the most pertinent problems facing
African American communities.

In response to increasing racial strife, injustice,
and urban decay, 159 cities across the United
States erupt in riots in what is known as the
"long, hot summer of 1967."

Martin Luther King Jr. is assassinated in Memphis,
Tennessee, on April 4, sparking unrest across
the country.

The Civil Rights Act of 1968 outlaws housing
discrimination on the basis of race, color, religion,
national origin, and sex.

Williams graduates with his MFA from Yale
University, where he studied with Al Held.
A number of influential artists are visiting critics,
including Donald Judd and George Sugarman.

Williams moves back to New York City following
graduation. He moves into a studio on Broadway
on the same floor as painter Peter Bradley, another
classmate from Yale.

Billy Rose graduates from Pratt. He meets Williams
following the artist's return to the city.

Edwards has a solo show at the Walker Art Center
following his residency over the summer with
the City of Minneapolis at Sabathani Community
Center, during which he creates his first painted
sculptures. His polychromatic steel works
constitute one of the first outdoor exhibitions
at the Walker.

At the recommendation of Al Held, Williams
and Edwards meet at a party at the artist
George Sugarman's house.

The Smokehouse Associates collective forms
following Williams's invitation to Edwards, Ciarcia,
and Rose. The four artists begin painting walls
at a park on 120th Street and Sylvan Place.

Melvin Edwards opens at Barnsdall Art Center in
Los Angeles.

Williams meets the art critic Dore Ashton.
Ashton gets him an interview with Silas Rhodes,
the founder of the School of Visual Arts.
Williams begins teaching at SVA.

Ashton sends Williams to the Junior Council at the
Museum of Modern Art. He soon interviews with
the Studio Museum's Board of Trustees, including
Junior Council members Carter Burden and
J. Frederic Byers III.

The Studio Museum in Harlem officially opens to
the public in a loft space at 2033 Fifth Avenue, just
north of 125th Street. The Museum's first exhibition,
Electronic Refractions II, features the abstract
light sculptures of Tom Lloyd, eliciting a strong
reaction among members of the Harlem
community and the downtown art world alike.

Williams acts as a consultant for the Studio
Museum until 1970. He establishes the *Artist-in-
Residence* program and serves as a coordinator,
organizer, and installer of exhibitions.

The Brooklyn Museum opens its Community
Gallery within a week of the Studio Museum's
opening, following demands by local Black
artists for greater representation in the museum's
collection and exhibitions. Curator Henri Ghent
is hired as Director.

Smokehouse approaches the Transit Authority
with a proposal to place silkscreened works and
posters on city buses, but Williams says "it fell
on deaf ears."

Mayor Lindsay establishes the Parks, Recreation and Cultural Affairs Administration by consolidating the city's numerous agencies into a few "superagencies."

Doris Freedman, an advocate for public art, is appointed as the first Director of the New York City Department of Cultural Affairs, a position she holds until 1970. Freedman also serves as President of the Municipal Art Society and President of City Walls, Inc., among other positions throughout her career.

The Department of Cultural Affairs' Creative Arts Workshop Program forms. Among the program's local artists in residence that summer is Smokehouse, which realizes its project at 123rd Street and Lexington Avenue; Randy Abbott, Director of the Studio Museum's Film Workshop; and David Henderson, co-founder of the Umbra Poets Workshop.

President Johnson constitutes the Kerner Commission, identifying white racism as the source of the 1967 riots in Detroit and Newark. The commission famously declares, "Our nation is moving toward two societies, one black, one white—separate and unequal."

The New York City Parks, Recreation and Cultural Affairs Administration initiates the New York City Community Arts Project, a beautification and education program for low-income residents of the Lower East Side, with artist Susan Shapiro-Kiok. Under Shapiro-Kiok, the program evolves into Cityarts Workshop, a community mural program.

The African American Day Parade is founded in the spring in Harlem, and will become an annual event.

Following a call originally made by Martin Luther King Jr. for a national demonstration against poverty, the Poor People's Campaign occupies the National Mall in Washington, DC. Roughly three thousand people form Resurrection City, a temporary encampment that lasts forty-two days.

Sam Gilliam begins creating his "Drape" paintings, environmental works composed of unstretched canvas that he suspends from the ceiling or drapes over industrial components such as sawhorses and ladders.

In June, presidential candidate Robert F. Kennedy is assassinated in Los Angeles, just minutes after publicly calling for the removal of American troops from Vietnam.

In August, at the 1968 Democratic Convention, police violently suppress antiwar activists, leading to the arrest and trial of the Chicago Seven. The only Black person arrested, Black Panther member Bobby Seale, will be tried separately.

MoMA announces its exhibition *In Honor of Dr. Martin Luther King, Jr.*, showcasing donated works by American artists to benefit the Southern Christian Leadership Conference (SCLC). The initial roster of artists does not include any Black artists, provoking criticism that results in the inclusion of Romare Bearden, Jacob Lawrence, Tom Lloyd, and Betye Saar, among others.

The Studio Museum in Harlem hosts *Invisible Americans: Black Artists of the '30s* in response to the Whitney Museum of American Art's exclusion of Black artists in the exhibition *The 1930's: Painting and Sculpture in America*.

The Coalition of Black Revolutionary Artists
(COBRA), later African Commune of Bad Relevant
Artists (AfriCOBRA) is formed in Chicago by
Jeff Donaldson, Jae Jarrell, Wadsworth Jarrell,
Gerald Williams, and Barbara Jones-Hogu.
The group, according to Jones-Hogu, aims to
share the truth and beauty of Black identity with
Afro-diasporic communities.

At the invitation of Doris Freedman, Williams
attends a symposium at Yale University where
he advises on the concept for the Festival Truck,
a mobile unit designed for a summer street
festival in six neighborhoods across the city.

Larry Neal publishes his essay "The Black Arts
Movement," advocating for art that speaks to
the needs of Black Americans and aligns with
the politics of the Black Power movement.

Edwards is included in the exhibition *Thirty
Contemporary Black Artists* at the Minneapolis
Institute of Arts.

Smokehouse stages a performative lecture at
Cooper Union, including Edwards, Williams,
Walter Jones, Sam Rivers, and the poet Jayne
Cortez. Consisting of readings, musical
performances, and visual presentations, the
program shares their ideas on communal change
with a wider audience.

Williams is commissioned by landscape architect
M. Paul Friedberg to create a series of enameled-
steel panels for Gottesman Plaza on West 94th
Street between Columbus and Amsterdam
Avenues. The abstract panels are integrated into
a geometric play structure on-site.

The Art Workers' Coalition (AWC) forms after
the artist Takis (Panayiotis Vassilakis) removes
his sculpture from the Museum of Modern Art in
protest of the museum's control over his work.
Members of the AWC, a loose coalition of artists,
writers, and arts professionals, submit a list of
"13 Demands" to reform MoMA's administration,
affirm its commitment to Black and Latinx artists,
and establish a Martin Luther King Jr. wing
for Black and Puerto Rican art, among other
proposals. The AWC grows and remains active
until roughly 1971.

The Black Emergency Cultural Coalition (BECC)
forms in response to the Metropolitan Museum's
exhibition *Harlem on My Mind*, which features
documentary photography but fails to include
the work or input of Black artists. BECC's founding
members include Benny Andrews, Clifford R.
Joseph, Norman Lewis, Romare Bearden, and
Vivian Browne.

Richard Nixon is elected president with a narrow
margin over Hubert Humphrey. Shirley Chisholm
becomes the first African American woman elected
to Congress, serving in the United States House
of Representatives.

The Black Academy of Arts and Letters is founded;
its members include Romare Bearden, Jacob
Lawrence, Gordon Parks, and Charles White,
among others.

Williams serves as a consultant for the City of New
York's Department of Cultural Affairs.

Established in 1949 as a volunteer group under the board of trustees, MoMA's Junior Council convenes from May to July to discuss a proposal for Smokehouse's 121st Street Project. The council anonymously contributes $10,000 to the project. Smokehouse creates its largest environment to date, painting seven consecutive walls among neighboring vacant lots with the help of the 121st Street block association.

Walter Jones stages a play at the 121st Street minipark under the name "Smokehouse Productions" as part of the Department of Cultural Affairs' Neighborhood Street Festivals program.

Williams organizes *X to the Fourth Power* at the Studio Museum, featuring Edwards, Sam Gilliam, Steven Kelsey, and himself. Gilliam, Kelsey, and Williams present large-scale abstract paintings, while Edwards creates environmental sculptures composed of chain and barbed wire.

MoMA acquires Williams's painting *Elbert Jackson L.A.M.F. Part II* (1969) within his first year out of Yale.

Ciarcia is included in an exhibition at the New Jersey State Museum.

Judson Powell starts the Communicative Arts Academy (CAA) in Compton, California, an arts nonprofit and artist collective that transforms underutilized buildings into community arts spaces. John Outterbridge is appointed Director.

Williams is included in the *Annual Exhibition* at the Whitney Museum of American Art. He shows *Sweets Crane* (1969), which Nelson A. Rockefeller acquires from the exhibition.

Between 1969 and 1975, following the demands of the BECC, the Whitney presents twelve exhibitions featuring Black artists. Al Loving is the first African American to have a solo show there. Six solo exhibitions feature Black artists working in abstraction: Edwards, Frank Bowling, Fred Eversley, Loving, Alma Thomas, and Jack Whitten.

Romare Bearden, Ernest Crichlow, and Norman Lewis establish Cinque Gallery to showcase art by Black artists and provide education programs to the community. From 1969 to 2004, the gallery sponsors more than three hundred exhibitions across New York City and the United States.

Artist and Studio Museum co-founder Betty Blayton-Taylor directs the Children's Art Carnival (CAC) in Harlem with support from MoMA. CAC becomes an independent organization in 1972, inspiring teens to participate in the creation of outdoor murals through a summer youth employment program.

Frank Bowling curates *5+1* with Lawrence Alloway and Sam Hunter at the Art Gallery of the State University of New York at Stony Brook. The title references the five American artists and one non-American artist and critic in the show, and reflects the expansive ideology of *X to the Fourth Power*. It includes Williams, Edwards, Al Loving, Daniel LaRue Johnson, Jack Whitten, and Bowling.

The Metropolitan Museum holds the symposium *Black Artists in America 1969*. Romare Bearden moderates a discussion among Williams, Sam Gilliam, Richard Hunt, Jacob Lawrence, Tom Lloyd, and Hale Woodruff about the problems of the Black artist in the United States.

MoMA hosts two solo exhibitions by Black artists: *Romare Bearden: The Prevalence of Ritual* and *The Sculpture of Richard Hunt*.

Police raid the Stonewall Inn in New York City's Greenwich Village, leading to several days of protest that ignites the gay rights movement.

Edwards installs *Homage to My Father and the Spirit*, his first major commission for outdoor sculpture, at the University Art Museum (now the Herbert F. Johnson Museum) at Cornell University. Recurring motifs in his work such as rectilinear and curvilinear shapes and the use of burnished stainless steel originate in this seminal piece.

Smokehouse members Williams and Edwards, with Walter Jones, perform another lecture at the School of Visual Arts. With the lights off, they present statements and readings. Edwards throws black-eyed peas into the audience, characterizing the event as a "dialectic poetic lecture."

Henri Ghent organizes *Afro-American Artists: Since 1950* at the Sixth Floor Art Gallery, Brooklyn College Student Center. The show includes Williams, Betty Blayton-Taylor, Richard Hunt, Al Loving, Raymond Saunders, and Bob Thompson, among others.

A group of young architects, photographers, and psychologists form Environmental Communications, a West Coast collective whose slide catalogues seek to redefine conceptions of urban space.

The Jewish Museum presents *Using Walls (Outdoors)*, an exhibition featuring reproductions of outdoor works by Smokehouse and City Walls, with light boxes and rotating color slides, accompanied by artist audio recordings. A monumental mural on plywood panels by City Walls members Jason Crum, Nassos Daphnis, and Tania is suspended on the museum's facade.

Smokehouse and City Walls demand the closing of *Using Walls (Outdoors)* several weeks early as part of Art Strike. Taking "unequivocal stands on the issue of war, racism, and oppression," the strike marks the largest artist protest since the 1930s.

Smokehouse presents photographic mock-ups of monumental murals for schools in Harlem to the Board of Education. The proposals are never realized.

Industrial Design features the Smokehouse Associates in its April issue.

At the invitation of Dore Ashton, Williams is included in *L'art vivant aux Etats-Unis*, Fondation Maeght, Saint-Paul de Vence, France, where he shows *Sophia Jackson L.A.M.F.* (1969) and *Truckin'* (1969) alongside works by Willem De Kooning and Mark Rothko.

Williams is included in *Recent Acquisitions of Painting and Sculpture,* MoMA.

Edwards becomes the first African American sculptor to have a solo exhibition at the Whitney.

Williams and Edwards participate in *An Exhibition and Sale for The Studio Museum in Harlem*, sponsored by Chase Manhattan Bank, at the Martha Jackson Gallery, New York.

Ciara's watercolor *WALL* (1969) is selected for the Drawing Society's Second Eastern Central Regional Drawing Exhibition at the Philadelphia Museum of Art.

Dimensions of Black, a major exhibition surveying historical and contemporary works by artists of African descent, opens at the La Jolla Museum of Art. Organized in collaboration with students at the University of California, it includes Edwards, Fred Eversley, Sam Gilliam, and John Outterbridge.

Six ex-gang members meet with architect Buckminster Fuller on the Lower East Side. Inspired by Fuller's ideas of changing society through changing the environment, they eventually form CHARAS, a group that alters the housing conditions for their neighborhood by constructing habitable geodesic domes. Fuller observes, "The movement is in the streets, and it is wonderful news for humanity."

Joe Overstreet begins his "Flight Pattern" works, abstract paintings that the artist lifts off the wall and stretches into space via ropes and grommets. Referring to these canvas forms as "tents," the artist draws inspiration from the nomadic shelters that he witnesses in the Bay Area.

Smokehouse concludes its activities in Harlem. Its members go on to implement the ideals of the group's collective work in various individual projects.

Edwards creates *Double Circles* as part of
a project sponsored by the NYC Housing and
Development Administration. Kynaston McShine,
Associate Curator at MoMA, selects three artists—
Edwards, Daniel LaRue Johnson, and Todd
Williams—to create large outdoor sculptures
in front of Bethune Towers, a middle-income
housing project in Harlem.

Edwards produces *Homage to Coco*, his first
"Rocker," incorporating movement in his work.

Ciarcia creates abstract wall paintings in Trenton,
New Jersey, sponsored in part by the New Jersey
Council on the Arts and the Mercer County
Heritage Commission. The positive community
response triggers additional commissions,
including murals on a day care center, a library,
and a restaurant.

The Whitney acquires Williams's *Drawing for
an Epic Idea (Coonograph)* (1970).

Edwards is included in exhibitions at the Rental
Gallery, MoMA, and the William Benton Museum
of Art, University of Connecticut.

Edwards visits Africa for the first time.

AfriCOBRA and Weusi hold exhibitions at the
Studio Museum (*Africobra I* and *Weusi Nyumba Ya
Sanaa: Resurrection*).

The Whitney Museum organizes the exhibition
Contemporary Black Artists in America in response
to demands made by the BECC but stops short
of employing a Black curator to organize it.
The BECC calls for a boycott and presents *Rebuttal
to the Whitney Museum* at Acts of Art Gallery.
Twenty-four of the seventy-eight artists slated
for the Whitney exhibition, including Williams,
Edwards, John Dowell, Sam Gilliam, and Daniel
LaRue Johnson, withdraw in protest and publish
a statement in *Artforum* condemning the show.

Curator Marcia Tucker organizes *The Structure
of Color* at the Whitney. Alongside artists including
Joseph Albers, Helen Frankenthaler, Hans
Hofmann, Morris Louis, and Mark Rothko, Williams
shows *Doctor Buzzard Meets Saddlehead* (1970).

Edwards writes the essay "Notes on Black Art"
in response to *Contemporary Black Artists
in America*. In it, the artist states, "The work can
either take the form of giving and using ideas,
subjects & symbols for radical change, or the
works can be of such large physical scale,
and in the right places, as to make real change."

Larry Rivers organizes *Some American History*
at the Institute for the Arts, Rice University.
Sponsored by the Menil Foundation, the exhibition
features Williams, Ellsworth Ausby, Peter Bradley,
Frank Bowling, Daniel LaRue Johnson, and Joe
Overstreet alongside Rivers, whose own work
and problematic organization of the show elicits
a backlash. The Menil acquires the only sculpture
Williams creates, *George Washington Carver
Crossing the Dupont River, May 17, 1954* (1970).

The De Luxe Show opens in Houston's predominately Black Fifth Ward. Sponsored by the Menil Foundation and organized by Peter Bradley, the exhibition is staged in the De Luxe movie theater and brings a diverse group of abstract artists together, including Williams, Bradley, Sam Gilliam, Kenneth Noland, Anthony Caro, Ed Clark, and Virginia Jaramillo. Williams presents his watercolor *Untitled (Coonograph)* (1970–71). Color intentionally drains from the work when it is exposed to light.

Williams has his first solo exhibition, *William T. Williams: One Man Show* at Reese Palley Gallery. This show features his "Diamond in a Box" paintings, which are hung edge-to-edge, forming the installation *Overkill and American Tradition*.

Williams begins teaching at Brooklyn College, where he eventually co-teaches a graduate seminar with City Walls artist Allan D'Arcangelo. He also becomes a faculty member at the Skowhegan School of Painting and Sculpture. He hires Buist Hardison, a young artist, who helps Williams realize much of his work throughout the 1970s.

Cityarts Workshop incorporates as a nonprofit community mural arts organization (later re-established as CITYarts, Inc. in 1989), employing artists such as Tomie Arai and Alan Okada to work with local communities of color to create murals.

Frank Bowling publishes "It's Not Enough to Say Black Is Beautiful" in the April issue of *Artnews*. He argues that the discourse surrounding Black art centers politics over visuals, thus flattening the multiplicity of blackness.

Al Loving creates *Message to Demar and Lauri* on the east wall of the First National Building in Detroit. The painting is the first large-scale mural on a building in downtown Detroit (later removed in 1989).

Edwards receives the National Endowment for the Arts Fellowship for Visual Artists.

A building fire destroys the Wall of Respect in Chicago.

Doris Freedman serves as President of City Walls, Inc. As a nonprofit organization, it hires artists to revitalize the city through public art, sponsoring more than fifty murals locally and nationally from 1971 to 1980.

Tom Lloyd establishes the Store Front Museum (which opens the Paul Robeson Theatre a year later), a community art museum in Queens. Lloyd serves as Director until 1986.

Artists Dindga McCannon, Kay Brown, and Faith Ringgold found "Where We At" Black Women Artists (WWA). The New York–based collective stages demonstrations and facilitates prison workshops, youth art classes, and other community-focused initiatives focused on empowering Black women and their communities.

Edwards participates in *The Artist as Adversary* at MoMA, as well as exhibitions at the Aldrich Contemporary Art Museum and the William Benton Museum of Art, University of Connecticut.

Alanna Heiss founds the Institute for Art & Urban Resources in New York (later becoming the P.S.1 Contemporary Art Center and then MoMA PS1), which converts abandoned and underutilized buildings into exhibition and studio space for artists.

Studio Museum Director Edward Spriggs develops
Studio in the Streets, a program meant to bring art
to non-museumgoers and provide opportunities
to Harlem artists. Artists including Joseph Delaney,
Folayemi Wilson and Dindga McCannon work
at the Studio Museum before creating two murals
at Fifth Avenue and West 128th Street, and
Seventh Avenue and West 126th Street.

Prisoners revolt against poor living conditions at
Attica Prison, resulting in forty-three deaths.
A year later, Benny Andrews and Rudolf Baranik
edit *Attica Book*, a compendium of responses by
forty-eight artists and prison inmates, with BECC
and the Artists and Writers Protest Against the
War in Vietnam.

1972

Edwards, Gilliam, Williams: Interconnections
opens at the Wabash Transit Gallery at the School
of the Art Institute of Chicago. The project marks
the first in a series of three-person shows where
these artists exhibit together.

Williams has a residency at Minneapolis College
of Art and Design.

Williams joins the board of governors at
Skowhegan, where he serves until 1990.

Edwards is included in exhibitions at Storm King
Art Center, Mountainville, New York, and at the
Art Institute of Chicago.

Doris Freedman establishes the Public Art
Council, an offshoot of the Municipal Art Society,
a long-established organization concerned with
the physical environment in the city.

Edwards joins the faculty of Livingston College, Rutgers University.

Williams begins his "Shimmer" paintings. The complex compositions feature the artist's unique mark-making strategy and build off of his ongoing use of pearlescent paint, creating rhythmic movement across the surface in metallic palettes of similar colors that reflect light from the surrounding environment.

1973

Samella Lewis publishes the article "The Street Art of Black America" in *Exxon USA*, writing, "A principle reason for the revival of street art in urban communities stems from a lack of workable relationships between the public and museums and galleries."

Al Loving creates *Septehedron*, a mural for a building at 42nd Street and Sixth Avenue. Supported by Seymour B. Durst, President of the Durst Organization, and City Walls, it is later removed in 1988.

Edwards serves as a consultant to the National Endowment for the Arts.

The Comprehensive Employment and Training Act (CETA) is signed into law by President Nixon. The CETA Artists Project in New York City is the largest federal employment initiative for artists since the Works Progress Administration, hiring more than six hundred people to provide cultural services throughout the city, as well as creating three hundred CETA positions at cultural institutions. The program lasts until 1980.

1974

Edwards's solo exhibition, *Lines*, opens at the
Carpenter Gallery, Dartmouth College, Hanover,
New Hampshire.

Gilliam / Edwards / Williams: Extensions goes
on view at the Wadsworth Atheneum, Hartford,
Connecticut. The museum acquires *Across
the Limpopo* (c. 1974) by Edwards, and *Skowhegan
I* (1973) by Williams.

Creative Time forms to produce art projects and
performances in unused and unexpected places,
encouraging the public to "look at the environment
with an increased perception of its possibilities."

Linda Goode Bryant founds Just Above Midtown
(JAM), an experimental space that cultivates
Black artists and artists of color through
exhibitions, performances, and professional
development programs.

Joe Overstreet, Corrine Jennings, and Samuel C.
Floyd establish Kenkeleba House, a gallery space
showcasing the work of Black, Latinx, Asian, and
Native American artists, on the Lower East Side.

1975

Williams's solo exhibition, *William T. Williams*,
takes place at the Carl Van Vechten Gallery at
Fisk University, Nashville, where he is an artist in
residence. While there, he meets Aaron Douglas
and David C. Driskell.

Sam Gilliam creates his first outdoor painting,
Seahorses, for the Philadelphia Museum of
Art's Philadelphia Festival. The artist drapes six
canvases across the building's facade.

1976

William T. Williams opens at the Center for the
Visual Arts Gallery, College of Fine Arts, Illinois
State University, Normal.

Resonance: Williams/Edwards/Gilliam opens at
the University Art Gallery, Murphy Fine Arts Center
at Morgan State University, Baltimore.

The New York City Department of Cultural Affairs
is established as a separate city agency,
headed by the Commissioner of Cultural Affairs,
Henri Claude Shostal.

Edwards creates *Homage to Billie Holiday and the
Young Ones of Soweto* (1976–77), for Morgan State
University. The work continues forms found in
his previous monumentally scaled works and
features windows and passageways derived from
his study of African architecture in Nigeria.

1977

Williams, Edwards, Ed Clark, and architect
W. Joseph Black travel to Washington, DC, to
present their ideas on art and public housing
to Patricia Roberts Harris, Secretary of Housing
and Urban Development. They cite the existing
one percent of funds for art in federal housing,
and the success of art in the courtyard of the
Dunbar Apartments in Harlem, built in the 1920s,
as precedents for integrating art throughout
housing projects. Their proposal goes unrealized.

Williams travels to Africa for the first time with
Edwards and his wife, the poet Jayne Cortez.
They participate in the Second World Black and
African Festival of Arts and Culture (FESTAC)
in Lagos, Nigeria.

William T. Williams opens at the Miami-Dade
Community College Art Gallery.

Freedman establishes the Public Art Fund (PAF),
an organization that commissions artists to create
temporary public art projects throughout New York
City. PAF forms out of the consolidation of City
Walls and the Public Arts Council. Its advocacy
eventually results in the City's adoption of Percent
for Art legislation in 1982.

1978

Williams and Edwards are included in Linda
Goode Bryant and Marcy S. Philips's foundational
catalogue *Contextures*, published by Just Above
Midtown Gallery.

Edwards has a solo exhibition, *Melvin Edwards:
Sculptor*, at The Studio Museum in Harlem.

226–37 Photographic mock-ups for unrealized works in Harlem,
 New York City, c. 1970

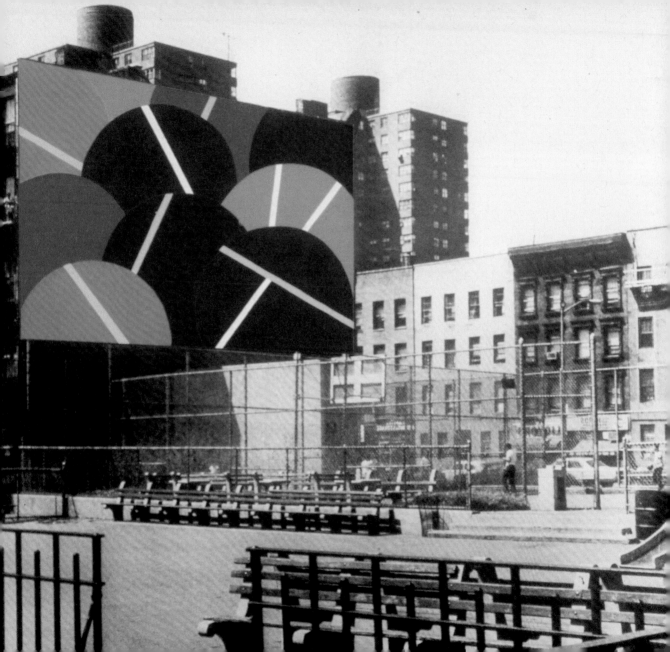

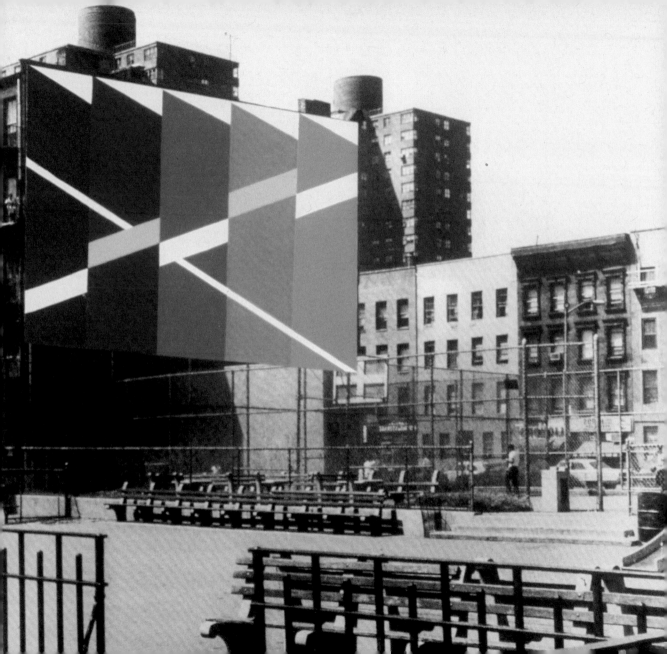

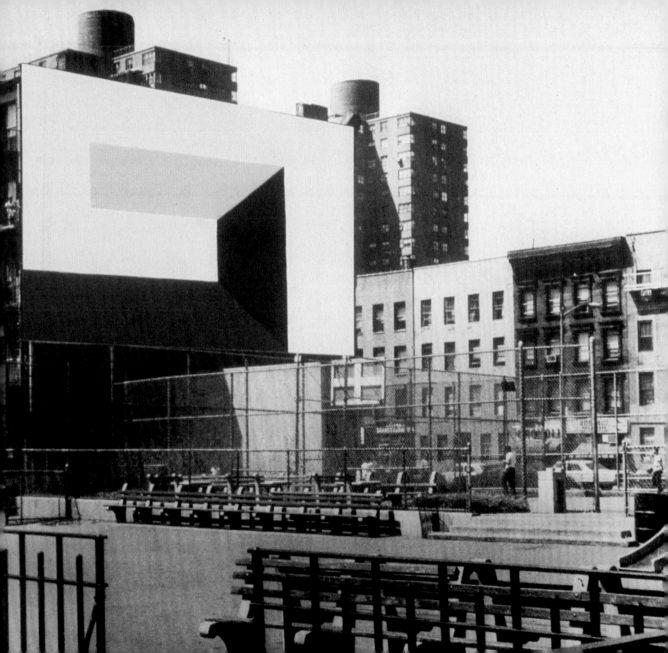

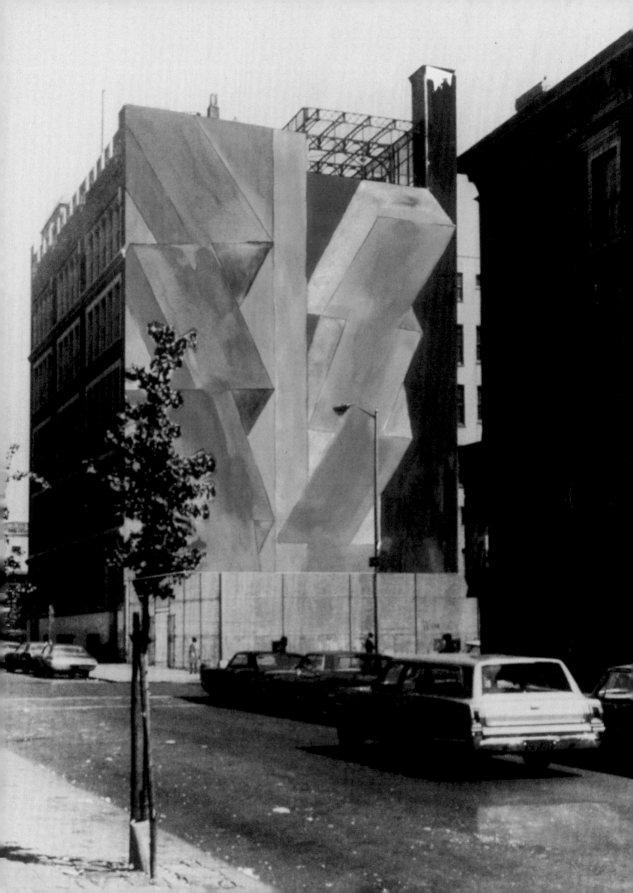

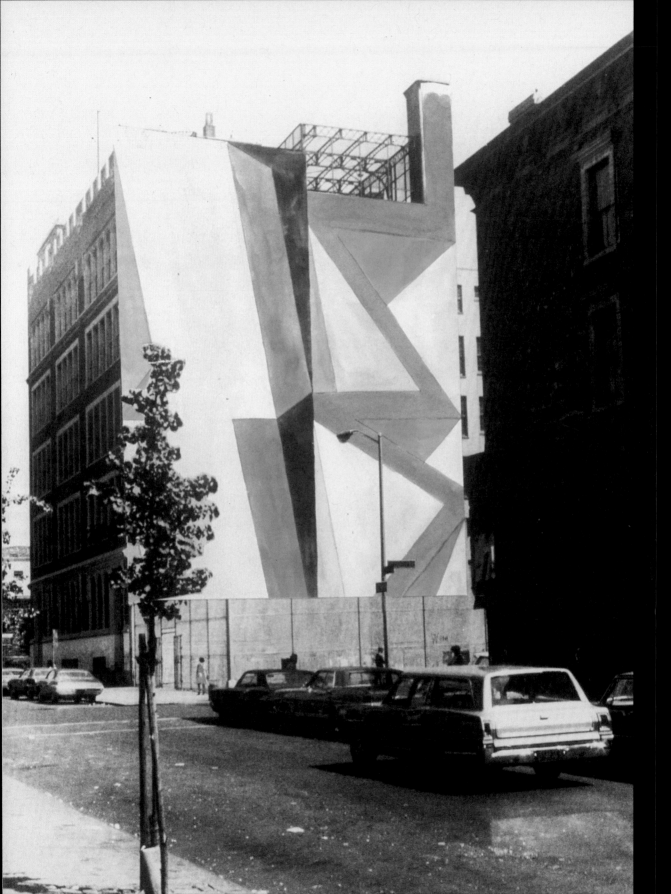

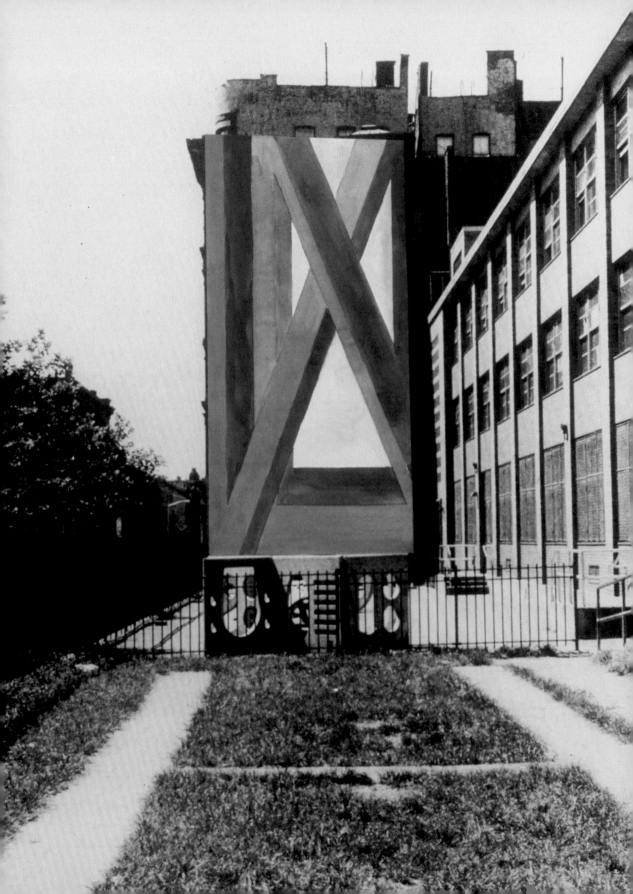

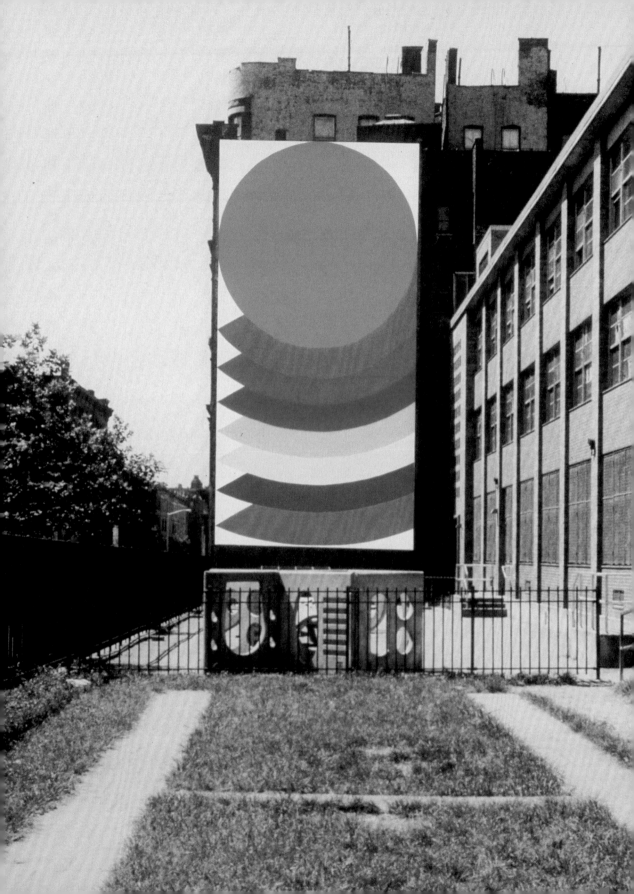

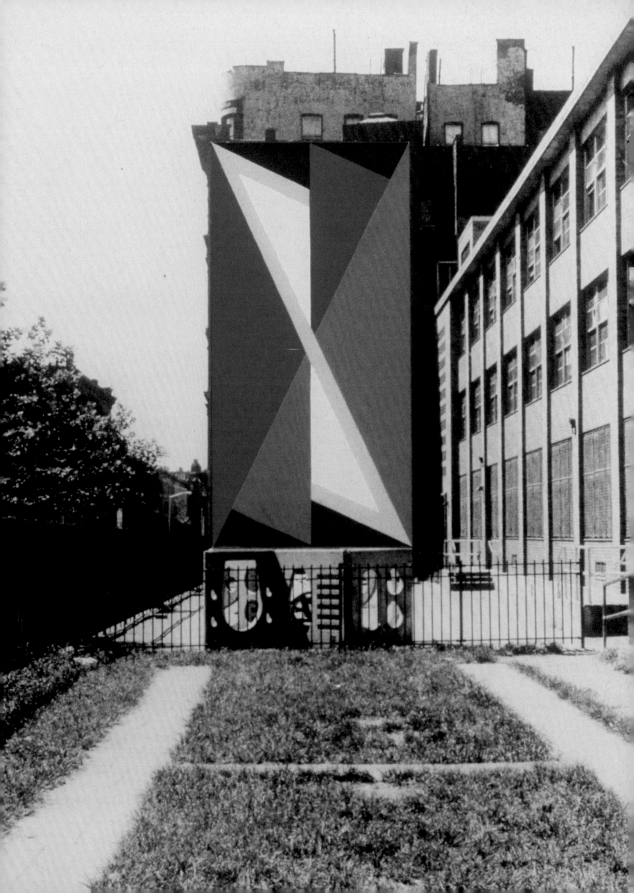

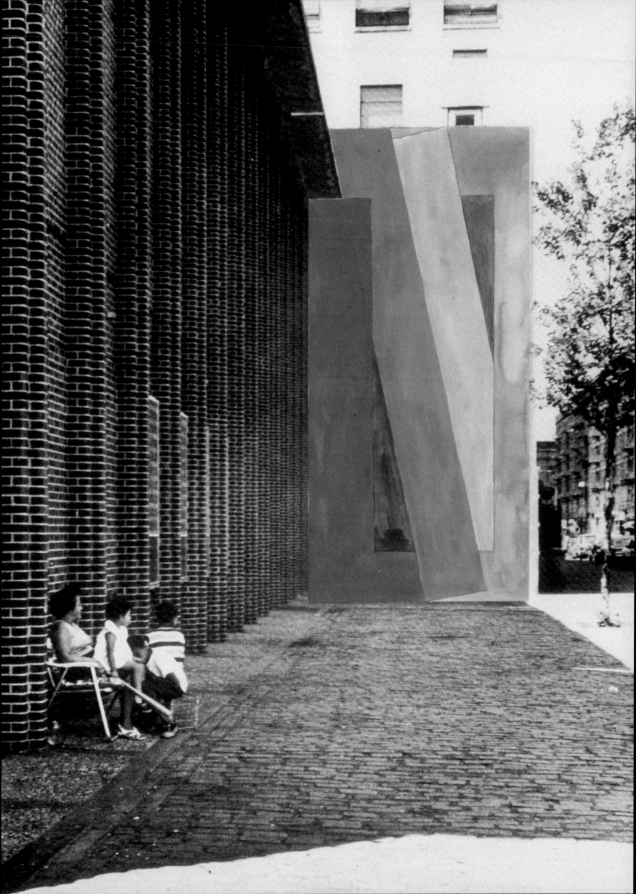

E. 123rd St. and
Lexington Ave.

Smokehouse's early
banded designs,
created in collaboration
with a local block
association, amplified
the community's efforts
to create public spaces
in Harlem. Here, a series
of kaleidoscopic murals
on luminescent silver
walls run the length
of two interconnecting,
architecturally designed
lots—a basketball court
and courtyard with
a fountain.

83
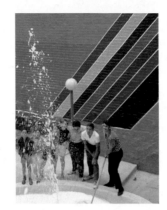

84
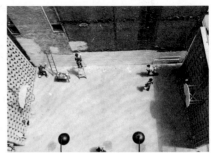

86
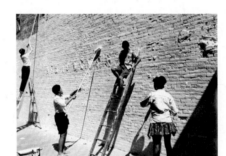

88
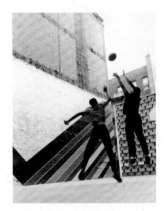

89
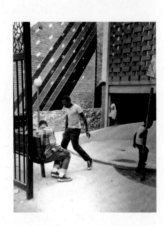

Sylvan Place
(E. 120th St. between
Lexington and 3rd Aves.)

The Smokehouse
Associates (left to
right in the first image:
Edwards, Ciarcia, Rose,
and Williams) work
on two perpendicular
walls within a park
lined with benches.
Children peel tape off
one, while the artists
paint another from
fifteen-foot ladders.
One of its first projects,
this park exemplifies
Smokehouse's
application of chromatic
zigzags, bands, and
chevrons on silver walls,
bringing color, energy,
and light back into
public space.

90

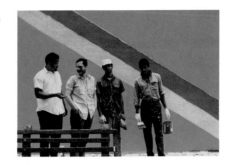

92

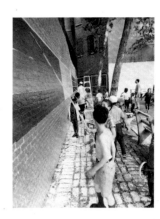

93

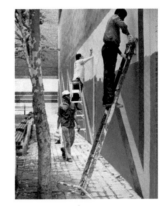

94

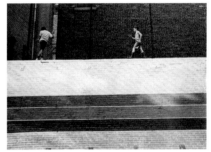

96

98

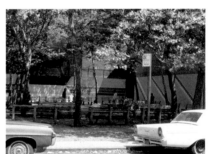

E. 121st St. between
2nd and 3rd Aves.

100

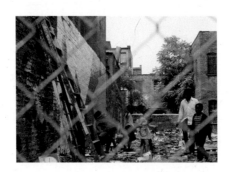

Williams works with
local children to clean
out a trash-filled site,
whose neglected state
is indicative of the
environments in which
Smokehouse often
realized its work. A wall
of yellows, blues, and
greens emerges from
behind the fence.

NE corner of
E. 121st St. and 3rd Ave.

102

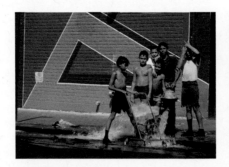

104

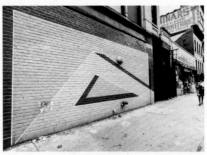

A triangular composi-
tion forms a dynamic
backdrop for life along
121st Street. A baseball
league's uniforms
echo the wall's colors,
a woman walks by with
her groceries, and
children play near an
opened fire hydrant.
Smokehouse's angular
forms correspond with
those of a mural down
the block, whose edge
is visible in the black-
and-white photograph.

106

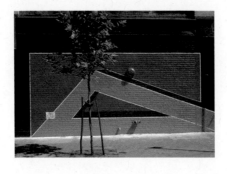

108

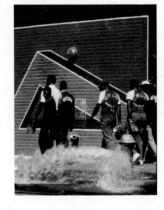

Super Berg's Market
(E. 121st St. between
2nd and 3rd Aves.)

109

110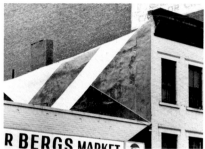

One of the few instances
of a Smokehouse work
above street level,
the mural above Super
Berg's Market reflects
the collective's engage-
ment with vernacular
signage. Diagonal
forms recede above
the store and continue
down across the store's
facade. Williams is seen
completing the final
portion from a ladder.

112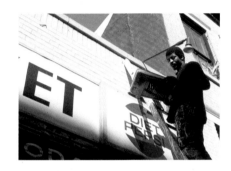

E. 135th St. and
Lenox Ave.

114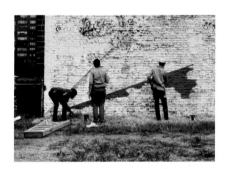

116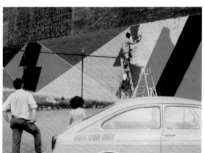

The Smokehouse artists
begin by painting a
weathered brick wall
beside a power plant
near the Lenox Terrace
apartments (left to
right: Williams, Ciarcia,
and Rose). In the other
photograph, Ciarcia
and a child look on as
Williams and Rose near
the completion of a bold
geometric composition
that stretches the length
of the building's facade.

NW corner of
E. 121st St. and 3rd Ave.

118
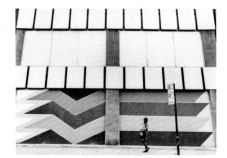

120
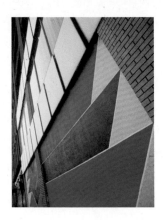

The group completed
a series of murals along
121st Street, forming
a corridor of geometric
compositions that
could be seen as one
walked down the block.
At the intersection of
121st Street and 3rd
Avenue, a wall featuring
rhythmic, stacked
forms leads the eye
across the paneled
building's facade.

Minipark off E. 121st St.
(between 2nd and 3rd
Aves.)

121
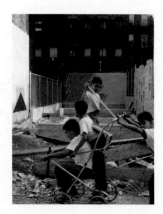

122
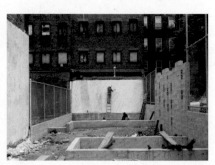

In Smokehouse's most
ambitious project, seven
consecutive walls with
colorful geometries and
the collective's distinct
metallic silver paint form
a complete environment.
Williams, Edwards, and
Ciarcia work with locals,
including the 121st
Block Association, while
Robert Colton docu-
ments the abstract paint-
ings and sculptures.
Edwards welds, Ciarcia
paints, and Williams
takes in the work.

124
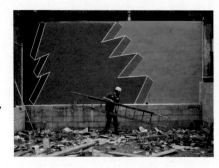

126

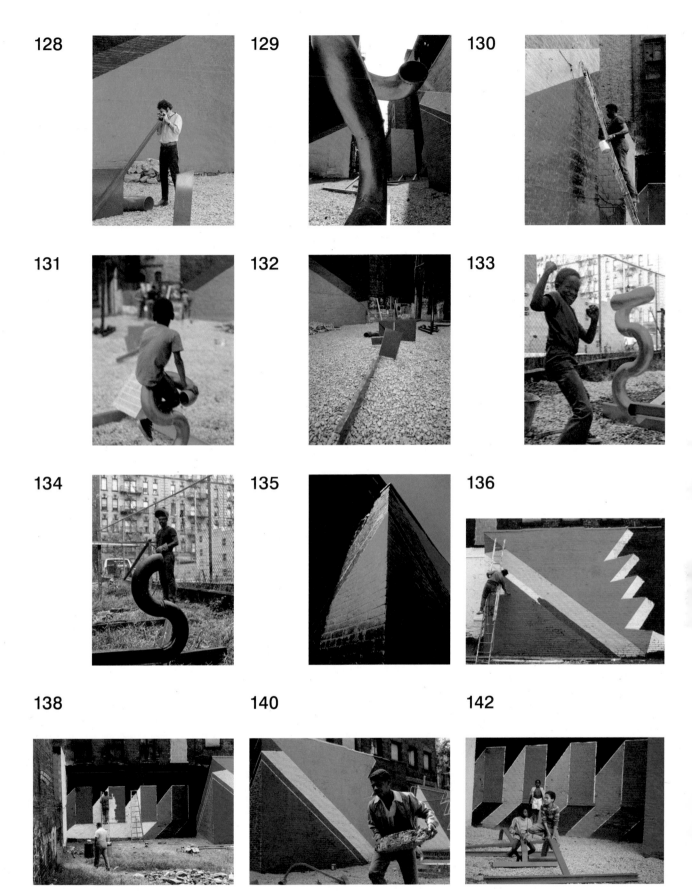

128 129 130

131 132 133

134 135 136

138 140 142

Photo Index

144

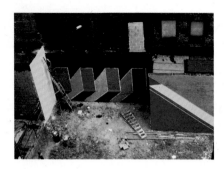

146

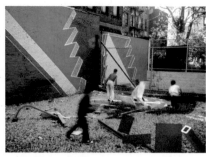

148

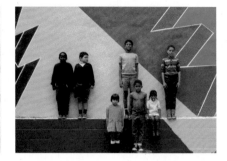

150

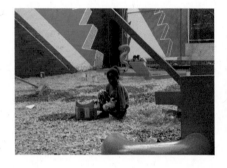

152

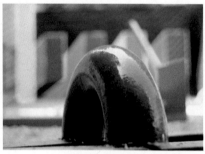

154

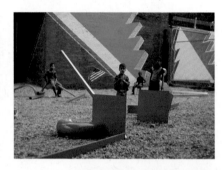

156

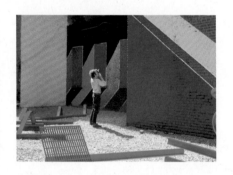

158

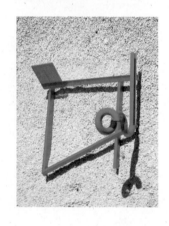

159

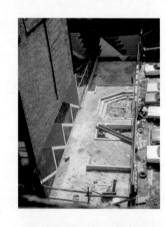

160

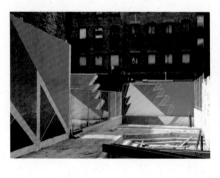

162

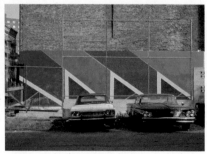

164

165

166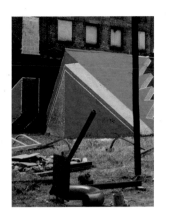

267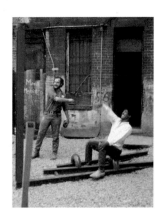

168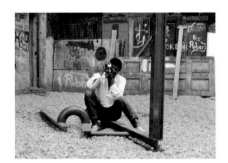

170

172

173

174

176

Photo Index

Artists and Contributors

William T. Williams (b. 1942, Cross Creek, NC), known for his bold color and daring compositions, has been committed to abstraction for more than fifty years. An alumnus of Pratt Institute, Yale University, and the Skowhegan School of Painting and Sculpture, Williams has cultivated a process-based approach to painting that synthesizes autobiographical reference, social narrative, and formal motifs sourced from specific cultural histories of the American South as well as New York. The recipient of numerous awards of distinction, Williams has garnered critical and institutional attention throughout his career. He has continually sought to engage his communities in dialogues about art through various undertakings, including a forty-year teaching career, initiation of the *Artists-in-Residence* program at The Studio Museum in Harlem, and his founding of the Smokehouse Associates. Williams is represented by Michael Rosenfeld Gallery.

Melvin Edwards's (b. 1937, Houston, TX) practice reflects his engagement with the history of race, labor, and violence, as well as with themes of the African Diaspora. From colorful painted sculptures, barbed-wire installations, and tangled amalgamations of agricultural and industrial elements, his work is distinguished by its formal simplicity and powerful materiality. Shortly after he received his BFA from University of Southern California in 1965, the Santa Barbara Museum of Art organized his first solo exhibition, launching his professional career. After he moved to New York City in 1967, his work was exhibited at The Studio Museum in Harlem, and in 1970, he became the first African American sculptor to have a solo exhibition at the Whitney Museum of American Art. Edwards is represented by Alexander Gray Associates, New York, and Stephen Friedman Gallery, London.

Guy Ciarcia's (b. 1942, Union City, NJ) artistic practice is rooted in principles of the Italian Renaissance and classical Greek art. He attended Pratt Institute, New York University, and the Accademia di Belle Arti in Florence, Italy. Spanning more than fifty years, his expansive body of work encompasses painting, murals, photography, film, digital drawings, sculpture, ceramics, crafts, and jewelry. Ciarcia received early recognition for his contributions as a member of the Smokehouse Associates in the late 1960s. His work has been exhibited at many institutions, including the Jewish Museum, New York (1970); New Jersey State Museum, Trenton (1969); Philadelphia Museum of Art (1969); and Smithsonian Institution, Washington, DC (1988). He has taught in the Trenton, New Jersey, school system for twenty-five years. Ciarcia has received grants from the Museum of Modern Art and the New Jersey State Council on the Arts in Mercer County.

Eric Booker is Assistant Curator and Exhibition Coordinator at The Studio Museum in Harlem.

Charles L. Davis II, PhD, is an associate professor of architectural history and criticism at the University of Texas at Austin. His academic research excavates the role of racial identity and race thinking in architectural history and contemporary design culture. He is the author of *Building Character: The Racial Politics of Modern Architectural Style* (University of Pittsburgh Press, 2019) and co-editor of *Race and Modern Architecture: A Critical History from the Enlightenment to the Present* (University of Pittsburgh Press, 2020). His current book project recovers the overlooked contributions of Black artists and architects in shaping the built environment from the Harlem Renaissance to Black Lives Matter.

Ashley James, PhD, is Associate Curator, Contemporary Art at the Solomon R. Guggenheim Museum. She is the curator of *Off the Record* (2021) and co-curator of *The Hugo Boss Prize 2020: Deana Lawson, Centropy* (2021). Previously, James served as Assistant Curator, Contemporary Art at the Brooklyn Museum, where she curated its presentation of *Soul of a Nation: Art in the Age of Black Power* (2018–19) and *Eric N. Mack: Lemme walk across the room* (2019), and co-curated *John Edmonds: A Sidelong Glance* (2020–21). James also served as a Mellon Curatorial Fellow in Drawing and Prints at the Museum of Modern Art, where her work focused on the groundbreaking retrospectives of Adrian Piper (2018) and Charles White (2018–19). She has held positions at The Studio Museum in Harlem and at the Yale University Art Gallery, where she co-organized the exhibition *Odd Volumes: Book Art from the Allan Chasanoff Collection* (2015). James holds a BA from Columbia University and a PhD from Yale University in English literature and African American studies, with a certificate in Women's, Gender, and Sexuality studies.

James Trainor is a writer, educator, and scholar of the history of contemporary culture, design, architecture, and urbanism. His writing has appeared in numerous publications, including *Artforum*, *Art in America*, *BOMB*, *Cabinet*, *Metropolis*, and *Frieze*, where he was US editor and a senior staff writer. The author of multiple monographic essays and exhibition catalogues, Trainor has lectured at numerous institutions such as Columbia University, Cornell University, and University of Southern California. He is the recipient of an Arts Writers Grant from Creative Capital/Andy Warhol Foundation for the Visual Arts, a Graham Foundation for Advanced Studies in the Fine Arts grant, and two MacDowell Colony fellowships, among other awards. He is currently working on *Steal This Playground: New York City and the Radical Play Movement, 1960–1978*, forthcoming from Princeton Architectural Press in 2023.

Studio Museum Staff

Allen Accoo
Naomi Amenu-Fesseha
Laura Betancur
Tim Ballard
Theo Boggs
Eric Booker
Sydney Briggs
Kendell Burroughs
Starasea Camara
Kevin Carter
Christina Cataldo
Kevin Chappelle
Connie H. Choi
Leon Christian
Katherine Claman
Monisha De Quadros
Ivette Dixon
Murray Doumbouya
Frederick Ellis
Zainab Floyd
Simon Ghebreyesus
Thelma Golden
Malanya Graham
Mckenzie Grant-Gordon
Geoffrey Greene
Gina Guddemi
Jodi Hanel
Chloe Hayward
Maya Herdigein
Habiba Hopson
Daonne Huff
Joliana Hunter-Ellin
Elizabeth Karp-Evans
Yelena Keller
Shanna Kudowitz
Ashley Mackey
Betsy McClelland
Jariah McFadden
Stacie Middleton
 Crawford
Christopher Mittoo

Yume Murphy
Shay Palmer
Chakshu Patel
Terrence Phearse II
Sebastien Pierre
Reynold Ri Boul
Lisa Richardson
Robyn Richardson
Quin Sakira
Madison Smith
Timothy Stockton
Jane Sun
Arese Uwuoruya
Thomas Webb
Debra Alligood White
Meg Whiteford
Lucretia Williams-
 Melendez
Ilk Yasha

Credits

The Studio Museum in Harlem would like to acknowledge everybody who granted permission to reproduce images throughout this publication. Every effort has been made to identify copyright holders and obtain their permission for the use of copyright material. Notification of any additions or corrections that should be incorporated in future reprints, editions, or digital files of this publication would be greatly appreciated.

Booker

31 Fig 11. Photo: Fred W. McDarrah /
MUUS Collection via Getty Images
Fig 12. Digital image © 2022
Melvin Edwards / Artists Rights
Society (ARS), New York /
Whitney Museum of American
Art / Licensed by Scala / Art
Resource, NY

33 Fig 13. © 2022 Sam Gilliam /
Artists Rights Society (ARS),
New York. Courtesy the
Philadelphia Museum of Art
Fig 14. Photo: Robert Colton.
Courtesy William T. Williams
Archives and Michael Rosenfeld
Gallery, LLC, New York, NY

35 Fig 15. Photo: Smokehouse
Associates. Courtesy William T.
Williams Archives
Fig 16. Photo: Smokehouse
Associates. Courtesy William T.
Williams Archives

Archival Reproductions

MoMA Junior Council Records
40–42: 11 × 8 ½ in. (27.9 × 21.6 cm).
Photo: Robert Gerhardt. Digital
Image © The Museum of Modern
Art/Licensed by SCALA/Art
Resource, NY
43–44: 10 ⅞ × 8 ½ in. (27.7 × 21.6 cm).
Photo: Robert Gerhardt. Digital
Image © The Museum of Modern
Art / Licensed by SCALA / Art
Resource, NY
45–46: 11 × 8 ½ in. (27.9 × 21.6 cm).
Photo: Robert Gerhardt. Digital
Image © The Museum of Modern
Art / Licensed by SCALA / Art
Resource, NY

Street Art / N.Y.: A Photo Essay
47 Public Art Fund Archive,
MSS 270; Box 7; Folder 7;
Fales Library and Special
Collections, New York University
Libraries. Courtesy NYC Parks
Department

NYC Parks Press Release, August 13,
1969
48 Courtesy NYC Parks Department

Using Wall (Outdoors), 1970
49 Courtesy The Jewish Museum,
New York

Michel Oren interviews with artists,
1979–1991
50–55: Archives of American Art,
Smithsonian Institution

Davis II

60 Fig 1. Peter Cook, © Archigram
1969
63 Fig 2. Public Art Fund Archive,
MSS 270; Box 3; Folder 1;
Fales Library and Special
Collections, New York University
Libraries. Courtesy NYC
Parks Department
Fig 3. Photo: Smokehouse
Associates. Courtesy William T.
Williams Archives
65 Fig 4. Photo: Brooklyn Museum.
© 2022 The Estate of Ilya
Bolotowsky / Licensed by VAGA
at Artists Rights Society
(ARS), NY

69 Epigraph: Sly Stone to audience
 at the Harlem Cultural Festival,
 Mount Morris Park, June 29,
 1969, *Summer of Soul*, directed
 by Questlove (2021; United
 States: Searchlight Pictures),
 Hulu, 1:48:04–1:48:09.
74 Fig 1. Photo: Smokehouse
 Associates. Courtesy William T.
 Williams Archives
77 Fig 2. Photo: M. Paul Friedberg.
 Courtesy M. Paul Friedberg
 Fig 3. Photo: M. Paul Friedberg.
 Courtesy M. Paul Friedberg

Photographic Documentation

89 Photo: Nancy Rudolph. Courtesy
 Nancy Rudolph Archives
102–07, 112–13, 118–20, 132, 135,
 170–71: Photo: Robert Colton.
 Courtesy William T. Williams
 Archives
132, 134, 176: Photo: Robert Colton.
 Installation of the 121st Street
 Project, 1969. Color slide,
 1 15/16 in. × 1 15/16 in. (5 × 5 cm).
 Junior Council Records,
 V.40. The Museum of Modern
 Art Archives. Digital Image
 © The Museum of Modern
 Art Licensed by SCALA / Art
 Resource, NY

Published by
The Studio Museum
in Harlem

144 West 125th Street
New York, NY 10027
studiomuseum.org

Smokehouse
Associates is made
possible thanks to
support from the
Graham Foundation
for Advanced Studies
in the Fine Arts and
Terra Foundation
for American Art.

Additional support
has been provided
by the New York City
Department of Cultural
Affairs and the New York
State Council on the
Arts with the support
of the Office of the
Governor and the New
York State Legislature.

Editor
Eric Booker

Director of Media,
Communications and
Content at The Studio
Museum in Harlem
Elizabeth Karp-Evans

Managing Editors
Habiba Hopson
Meg Whiteford

Copyeditor
Joanna Ekman

Design
Studio Lin

Printed and bound by
die Keure, Belgium

10 9 8 7 6 5 4 3 2 1

Distributed by
Yale University Press
302 Temple Street
P.O. Box 209040
New Haven, CT
06520-9040
yalebooks.com/art

ISBN 978 3 980 40708 3

The Smokehouse
Associates, left
to right: Melvin
Edwards, Guy Ciarcia,
Billy Rose, and
William T. Williams